1998

To Alasd

From Keith & Euphemia.

A BIRD ARTIST
IN SCOTLAND

A BIRD ARTIST
IN SCOTLAND

Donald Watson

H. F. & G. WITHERBY LTD

Acknowledgements

While many of the illustrations have been done especially for this book I am most grateful to the undermentioned owners of paintings who kindly loaned them for possible inclusion: Dr and Mrs Henry Adam, Mr and Mrs Richard Agnew, Mr and Mrs Jim Aitken, Mr William Austin, Miss Margaret Baird-Smith, Mrs H. P. S. Burton, Mr and Mrs H. F. Cameron, Mr Ian Cooper, Mr and Mrs Douglas Craig, Mr F. Dalziel, Lady Isabel Duncan, Mr and Mrs Robin Dunlop, Mr Robert Gillmor, Sir Ian and Lady Caroline Gilmour, The Viscount Gough, Maj.-Gen. J. R. Holden, Miss Joan Howie, Mrs Katharine Ignatieff, Miss Alice Maclagan, Mrs Margaret McLean, Mrs Ann Maxwell, Mr and Mrs A. J. Peace, Dr and Mrs J. Rhymer, Mr and Mrs Jack Russell, Mr and Mrs M. Spernagel, Mr Louis Urquhart and Mr and Mrs J. Young. I apologise to those whose pictures could not after all be included. I am also grateful to all who took or supplied transparencies of paintings: Mr Bob Caldow, Mr David Clugston, Dr Robin Griffiths, Mr Tom Phin, Dr Derek Ratcliffe, Mr John Savory, The Misses Alice and Margaret Slater, Dr and Mrs K. Lamont Smith, Dr Kathleen Watson and especially Miss Davina Graham for all the work she did in this respect. Most of the small illustrations in the diary part of this book were done in 1987–88 but the larger colour plates and some small ones span the years 1946–87.

I have had much helpful comment on the text, especially from Derek Ratcliffe, my brother Eric and my son Jeff. I would also like to thank Marc Kéry, Ian Langford, Dr Derek Langslow, Louis Urquhart and my daughters for their interest and comments during the progress of the book. David Burnett has been a most sympathetic publisher — I thank him especially for his warm response to my original suggestion for a book of this kind and for making it a reality and I am grateful to Mrs Janice Chamier for her helpful editing.

Above all, I thank my wife Joan for her inestimable contributions in a variety of ways. So much that I have described has derived from experiences shared with her. She also found time to type the manuscript.

17th May, 1988 *Donald Watson*

First published in Great Britain 1988 by
H. F. & G. Witherby Ltd, 14 Henrietta Street, London WC2E 8QJ

Text and illustrations © Donald Watson 1988

British Library Cataloguing in Publication Data
Watson, Donald, *1918 –*
A bird artist in Scotland.
1. Scottish paintings. Watson, Donald, 1918–
I. Title
759.2'911

ISBN 0–85493–167–8

Typeset at The Spartan Press Ltd, Lymington, Hants
Printed and bound in Great Britain by Butler & Tanner Ltd, Frome

Contents

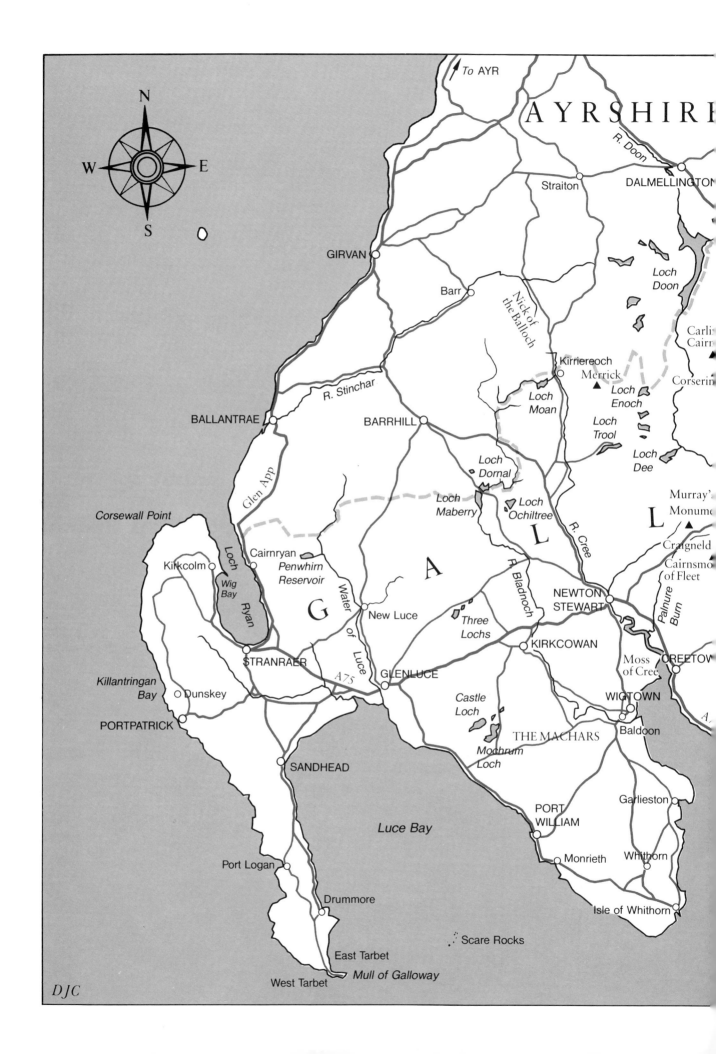

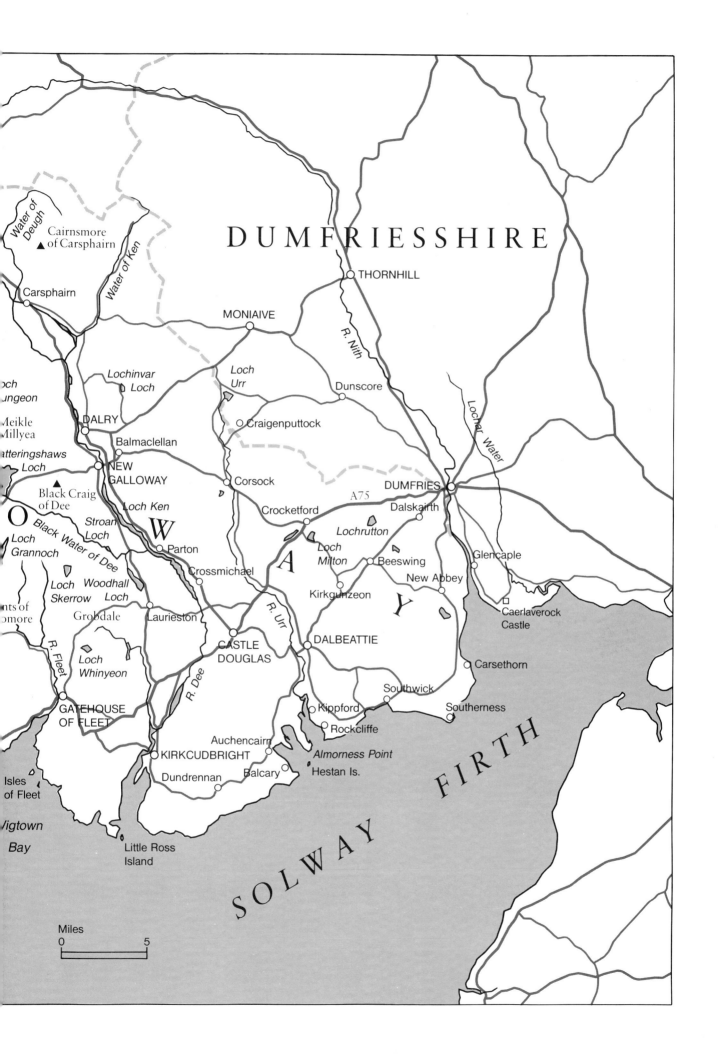

Illustrations

COLOUR ILLUSTRATIONS

BLACK AND WHITE ILLUSTRATIONS

I

Birds in Childhood

My first bird drawings were copied from the early Thorburn pictures in the only bird book we had, Swaysland's *Familiar Wild Birds*. I was then less than five years old and could not write the birds' names. When I had been right through the book I would start again at the beginning so that it became a family joke. I also copied pictures of all kinds of animals, especially the big African ones which my father talked about when he came home from his work in the Congo. My mother had never taken to life in Central Africa and for years at a stretch I never saw my father. As a child I enjoyed Arcadian surroundings, deep in the Surrey hills, with a large garden, shrubberies and thickets to explore and vistas of fruit orchards which my father had optimistically created, believing that they would make money and occupy him on his retirement. When he did come home he did not mix easily with local residents, who tended to regard him as an uncommunicative Scots 'colonial'. My mother's prodigious energy was expended on her marvellous, but over-ambitious garden and coping with recurrent disasters to the fruit crops — as well as apples, pears, plums, raspberries and other soft fruit, there were enormous greenhouses full of tomatoes. The sweet smell of the apple store especially pervades my memory of those days and I recall being an unwilling participant in jobs like picking and packing apples. Past the line of Lombardy poplars at the bottom of the meadows, little steam trains plied between Guildford and Horsham; beyond, fields and woods sloped gently up to Hascombe Hill. In drawing birds I was following the example of my brother Eric, who was four years older. My eldest brother Bruce, the most generous-natured person I have known, leaned towards more useful activities.

It must have been early in the 1920s that I began hunting for birds' nests around the garden. In those days red-backed shrikes and wrynecks were annual summer residents on our ground, both of course long since vanished from that countryside. I remember being frightened by a hissing and writhing wryneck sitting on eggs in a nest-box. No sound is more evocative of childhood summers than the ceaseless purring of turtle doves, whose flimsy nests with their polished eggs I so often climbed to in the fir trees. The crazy yaffle of a green woodpecker, the chittering of house martins nesting above bedroom windows and the monotonous drawling of greenfinches early on spring mornings, these too bring instant recall. The tiny, neatly-lined nests of goldfinches, plentiful some years in the older apple trees, were special favourites.

Like most country boys at that time I made a modest egg collection. When Jim Collin scythed the long grass in the meadow he would bring me an assortment of thrilling eggs of small, ground-nesting birds tucked into the lining of his cap. When I was about eight I was proud of a red-legged partridge nest I had found in the garden and eagerly showed it to my teacher; alas the eggs were so well camouflaged that she stepped on them before I could stop her. At that time song thrushes' nests were slightly more numerous than blackbirds' in our

garden — nowadays it is certainly the other way round almost everywhere in Britain. In the spring of 1928 Eric inspired me to take a proper look at the birds themselves, rather than their nests and to keep an illustrated diary as he did. I was not yet attempting to draw birds in the field, but had given up copying from pictures in books. My juvenile efforts were simpler and truer than those done a little later, when I started using Chinese white mixed with transparent watercolour to get more feather detail. Trying to paint from memory was good training in getting to know birds.

T. A. Coward's *Birds of the British Isles and their Eggs* became our treasured guide. I still marvel at his vivid personal descriptions, so readable in their narrative style and there is no doubt that his writings taught me the essence of conservation as it is known today. There were also, of course, the fine coloured plates by Thorburn, Keulemans and others. We discovered that Thorburn actually lived quite near, at Hascombe, and our local doctor arranged for us to visit him. One November afternoon in 1930 we arrived at his house on our bicycles. Would I remember that evening so clearly if I had not later devoted so much of my life to bird painting and ornithology? He was then in his late 60s, smallish and with white hair and a neat white beard. He took us into his large studio, talking quietly in a perceptibly Scottish voice about his paintings and sketches. He was then working on a plate of a bird of prey for *The Birds of Somaliland* and I recall my youthful astonishment when he explained that he was not happy with the rock the bird was perched on and was about to change it into a tree stump (it might have been the other way round). I did not understand how easily he could do this in his body-colour technique. I noticed a pile of sketches of raptors by George Lodge on a side table and Thorburn told us he had borrowed them for reference as his friend Lodge was such a master of these birds. Inevitably we had brought our notebooks with our own efforts at painting birds, hoping for praise from the great man. At least by this time my pictures were no longer copies from his own work. We joined his wife and a friend for tea at a long table rather dimly lit, I think by oil lamps. Nobody had recognised how short-sighted I was at the age of 12 and, overawed, I guessed wrongly that there were scones on one of the more distant plates. Mrs Thorburn apologised that there were no scones today and my blushes had hardly subsided before tea was over. Disappointment followed embarrassment when it was clearly indicated that 'Archie' would be going back to work now and it was time for us to ride back. I desperately wanted more time in the studio.

Uncle Harry, my mother's brother, was an architect working in London but a notable painter as well, an RBA and sometimes exhibitor in the Royal Academy. As a young man he made painting trips to France and Holland and I still have his sketchbooks from those times, full of powerful drawings of people, buildings and landscape. Late in life he became a full time artist and his paintings of young girls in Twenties costume often appeared on the covers of women's magazines; he was also commissioned to paint a miniature child study for Queen Mary's dolls' house. Sometimes he joined us on family holidays by the sea and would sit on the beach with a tiny box of oil paints propped in front of him. Some of his small beach pictures, with figures brilliantly touched in, were among his best work. Years after his death, when his sister was rather short of money, I took some of these little pictures to a West End gallery where they aroused some interest. 'If only you could say that he worked with Sickert,' said the gallery owner, 'I think then the Leicester Galleries might put on an exhibition of his work.' A revealing comment on the London art world, I thought! Uncle Harry (he signed his pictures

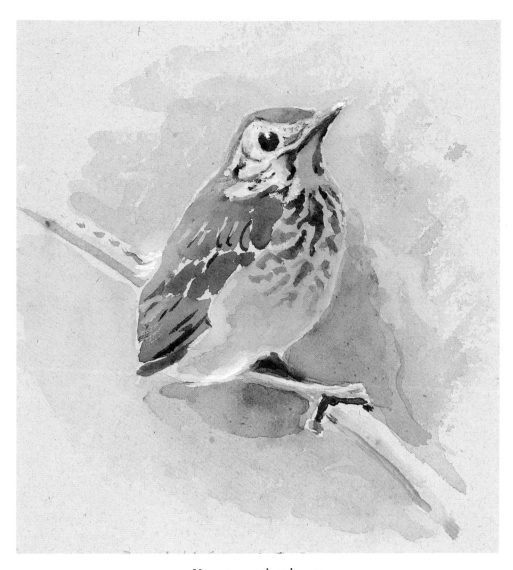

Young song thrush, 1954

H. John Pearson) was, nevertheless, a well-known figure as President of the Langham Sketch Club in his day. Neither he nor Aunt Margaret (my father's sister), another talented artist, approved of my youthful obsession with what they considered 'mere illustrations' of birds. Uncle Harry did offer some good advice, extolling Crawhall as a master of animal painting, but it was years before I fully appreciated how right he was.

My school art teacher, Mr Clinton, saw some aptitude in my drawings and allowed me to draw birds and mammals in class. He was a kindly, sad-faced man who made us draw lines of perspective and mark 'the vanishing point' meticulously. Peter Conder, lately the Director of the RSPB, was in the same class and nearly half a century later I heard him recall how envious he had been of me for being allowed to draw birds while he, like the rest of the class, had to draw 'Cows in a grassy field'. I went to a prep school for an English public school, the sort of place which Waugh, Orwell and others have described as horrific. Mine was about par for the course — we had a sadistic maths master whose greatest delight was to whack the fleshy backs of boys' legs with his big blackboard compasses. I could easily spin a yarn about sufferings

endured, but it wasn't really an unhappy experience. I was robust and greatly enjoyed games like cricket and rugger, which had an almost religious significance.

During long summer holidays we sometimes had visits from three young Irish girls of about our own ages, whose parents had known ours in Africa. They came from boarding school in Brussels where they spent years without seeing their parents far away in Africa. Uncle Harry thought the youngest, Joan, a gamine-like child with huge dark eyes, would make a good subject for a painting. Sadly he never managed this but 20 years later I did far better by marrying her. In the years between our lives had drifted far apart. Braver than I, she had volunteered for the South African Nursing Service in the war and endured the rigours of the Italian campaign.

To return to youthful birdwatching — I sometimes think that youngsters today with their field-guides and telescopes must miss some things that we enjoyed. Nowadays a ruff or a black redstart would scarcely raise a beginner's eyebrow, but both were almost unbelievable rarities to us and my first encounters with them are as clear as yesterday. In 1931 Eric and I visited Cley in Norfolk and found a tired wader sheltering on the shingle — it was a ruff but with Coward's book our only guide, for a long time we could not believe that we had found what he said was such a rarity. Sitting on the East Bank at Cley we watched a heron stab and swallow a passing house martin. To us this seemed little short of incredible — surely herons lived on fish and frogs? Today with books like *The Birds of the Western Palearctic*, such an observation is shown to be unexceptional.

The house where I was born and lived for the first 12 years of my life still stands but its surroundings are unrecognisable. Bird-rich commons, like Smithwood Common with its red-backed shrikes, stonechats, whinchats and wheatears, were ploughed up in the wartime agricultural revival. The finest bird spectacle we ever enjoyed was an immense gathering of crossbills, redpolls, siskins, goldfinches, greenfinches, chaffinches and bramblings, all apparently feeding on seeds of Scots pines at Witley Common, on 9 April 1931. Chaffinches and goldfinches were in hundreds, the rest in smaller numbers. Many crossbills were red males, cock bramblings were in glossy breeding plumage and all the birds looked exceptionally brilliant in the clear April sunshine — a sight that can live only in the memory, beyond art or photography.

That same spring my father, an intensely reserved man, became ill and seriously depressed. The economic crisis of the time and skulduggery of business associates had brought him almost to financial ruin. Although I never felt close enough to him I was fiercely proud of his Scottish Highland origins and his adventurous life in Central Africa, dating back to pioneering days in the 1890s. He had left Aberdeen for Africa at the age of 19, but long before that had been to India and back on a great sailing ship, of which my grandfather was master. When in May 1931 he died very suddenly our lives were totally changed. With great courage my mother ignored uncles' advice that my brothers should immediately look for work in London and they both started at Edinburgh University. Within a few months my childhood home became a distant memory as I too began a new life in the city of Edinburgh.

2

A View of the Firth of Forth

From the back windows of our Edinburgh home we could glimpse the Firth of Forth beyond a neighbour's trees which held a small rookery. Five minutes' walk down winding steps took us to a dirty little beach and Granton Harbour. That first winter I was down there every week-end and often after school when not playing rugby. The sea was scoured for ducks, grebes and divers and purple sandpipers were discovered poking through the seaweed along the breakwater. In a few weeks Eric and I had become familiar with a whole new range of sea- and shorebirds and had decided to make a special study of this little area. We made counts of all the birds and drew monthly graphs of fluctuations in numbers. I made large-scale pictorial maps and painted all the birds into the various habitats. Glaucous and Iceland gulls, including a beautiful adult bird, came scavenging among the herring gulls when trawlers were in harbour. A north-easterly gale brought an exhausted little auk, and an immature little gull tested our powers of identification — it seemed so small and delicate among the black-headed gulls that at first I thought it was a grey phalarope.

Memories of my first months in Edinburgh are as much of sounds as sights — the fog-horn from Inchkeith when the haar blew in, ships' sirens, whining or groaning trams and the mournful cries of coalmen with their horse-drawn loads, which punctuated the hours of incarceration in classrooms. I travelled by tram to the Edinburgh Academy where most were also day boys and at first received much taunting for my Sassenach accent. Miraculously I soon found a special friend in George Kilgour and we began to spend holiday week-ends camping or at a youth hostel, he photographing birds, I with my binoculars and sketchbook. We were about the same age; he was tiny in stature but far more resourceful and worldly wise than I.

The winter of 1931–2 was exceptional for the abundance of snow buntings in the Lothians and in February my brothers and I saw a large flock which flew around the Murrayfield rugby pitch during an International, even settling on the ground during play. At Granton I became fascinated by plumage details of seabirds, making careful paintings of herring gulls and trying to age them from first winter plumage to maturity. Goldeneye were usually close inshore, giving marvellous opportunities to observe the details of their various plumages.

I spent so much time drawing, painting and writing notes about the birds I saw, that it is a mystery how I did any school work except when I was actually in class. That summer Bruce and I stayed with friends at Crianlarich and had our first experience of the Highlands, fishing on Loch Dochart, birdwatching and narrowly surviving a descent of Ben Lui by a mistaken route. During his years as a geography and geology student at Edinburgh Bruce became the owner of an extraordinary succession of old cars. He would pick them up from scrapyards for £5 or less and care for them with great skill and affection. He drove them long distances and was always totally optimistic even when the Fiat shed a front wheel in the middle of Newcastle

or the Wolseley ran a big-end after serving as transport for the University Biological Society in Barra. I took part in a memorable expedition to tow it back from Oban through a summer's night. Over the years he acquired grander cars, Lagondas and even a Hispano Suiza — some still survive as vintage specimens but the Hispano almost disintegrated in the garden during the war.

In April 1933 Eric and I spent a fortnight's holiday in Arran. We walked 30 miles one day and nearly as many two days later. In Glen Rosa we had a magnificent view of a golden eagle being mobbed by a crow and saw our first great northern diver on the sea near Corrie. The gorse blazed, soft rain swept in from Kintyre and on a day-long road walk we saw only two or three cars. Surprisingly we saw no buzzards, probably their numbers were kept down by gamekeepers, while hen harriers had been persecuted out of existence. We were perhaps fortunate that our inexperience of fickle April weather in the mountains did not land us in trouble. So little had been published at that time that *The Scottish Naturalist* welcomed a short paper on our observations. In June of the same year I spent the half-term week-end of hot sunny weather camping in the sand dunes at Gullane with George Kilgour and two other boys. It was an exciting new experience to find 20–30 nests of common terns and many of lapwings and ringed plovers close to our tent. Apart from a party of older schoolfellows, also camping, we scarcely saw another human being. In those days there must have been little disturbance to the nesting birds there and they were pretty successful in spite of being so open to predation. A nightly raid by a fox could have caused havoc, but foxes and crows would have been kept in check by keepers on neighbouring estates. We saw no sign of anyone hunting for eggs and none of the numerous clutches we found disappeared over the week-end. Hides were set up at two or three nests and we probably caused one eider duck to desert. Photography was George's main objective but I had my first experience of trying to sketch a nesting tern from a hide.

At the Edinburgh Academy I was exceptionally lucky in having as Rector (headmaster) a man who was sympathetic to many out of school activities and especially interested in natural history. Lionel Smith, son of a former Master of Balliol College, Oxford, had only recently retired from being Director of Education in King Feisal's Iraq and one day he brought King Feisal to visit the school. To the boys he was rather a glamorous figure, especially because he had played hockey for England and was the best squash racquets player in the country. The tale that he had refused the headmastership of Eton to stay at Edinburgh gave him an added mystique. He was the antithesis of a conventional headmaster. When addressing a boy, or indeed the whole school, his eyes rarely left his boots and I wondered how he ever found anything on the littered desk in his study. His tall figure, with fine craggy head, suggested some large solitary bird. He would often go out of his way to tell interested boys how he had seen a kingfisher or a grey wagtail as he crossed the Water of Leith on his way to morning school. Later, I was one among several boys lucky enough to be invited to stay with him and his family on the island of Islay.

At this time I spent a good many hours at the Royal Scottish Museum in Chambers Street. Eagle Clarke, the pioneer of migration studies, had retired but many of his specimens were on display, firing my imagination. The old method of showing a multitude of species in crowded cases has long been scrapped but it was much more fascinating to me than the modern fashion of showing only a few well-spaced specimens. There were also some fine cases of specially

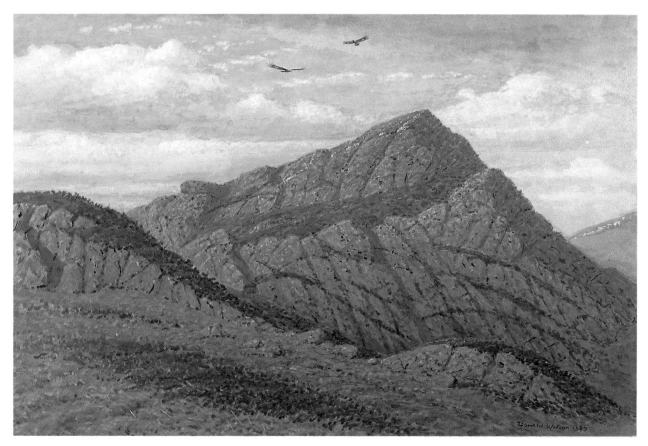

Golden eagles over a crag, southwest Scotland, 1987

Scottish birds in their habitats. I did some drawing from the displays, but the best taxidermy is no substitute for the living bird. I think, nevertheless, that drawing the open wings of specimens in simulated flight was particularly useful. We were never taken on organised visits to museums or art galleries and it was a school friend of my own age, Alan Davidson, who opened my eyes to the artistic richness of the National Gallery of Scotland.

At 14 I had endless patience for my self-appointed task of drawing and painting birds but the results showed little improvement. Would first-rate teaching have made the difference? At this stage art had no place in my school timetable. During free periods in the library I drew likenesses of Merle Oberon, Marlene Dietrich and other female film stars, some of which my friends bought for half-a-crown. I briefly fancied my prospects as a cartoonist. Pen and ink drawings, mainly of birds, appeared frequently in the school magazine and were occasionally promising enough to catch an artist's eye. An invitation to visit E. S. Lumsden, the brilliant interpreter of Edinburgh scenes, came through a master. How foolish I was not to go! Perhaps I feared that he would discourage me from drawing birds. I had one notable success, winning the RSPB's public schools essay competition when I was 16. My essay on 'Wings and their Uses' was heavily illustrated with pen drawings and paintings, including many done from wings collected from birds found dead on the shores of the Firth of Forth and elsewhere. My prize was a splendidly bound copy of Kirkman and Jourdain's *British Birds* in which A. W. Seaby's plates were an inspiration.

A lively group of young bird enthusiasts chanced to be growing up in Edinburgh at the beginning of the 1930s. Some of them as schoolboys had started the Inverleith Field Club in

1929 and in 1933 George Waterston, Frank Elder and a few more who had become especially keen ornithologists founded the Midlothian Ornithological Club. That I, so young, was allowed to become a member was probably an indulgent gesture by the others. From the start George's personality and drive ensured that the 'MOC' would have influence out of proportion to its small size. It was a time of new ideas in bird study, fostered especially by the writings of E. M. Nicholson which started us making bird censuses. Most of all, perhaps, we were fired by awareness of the migration studies made by Miss Baxter and Miss Rintoul on the Isle of May. George and Frank paid their first visit to the island in September 1932, 'by permission of the Northern Lighthouse Commissioners' and returned with tales of bluethroats and other rare migrants. The following year Eric and I stayed with the head lighthousekeeper, Lachie McInnes. At the start of our visit we met the Misses Baxter and Rintoul, who were ending their final visit after nearly 30 years. I fear we seemed like brash young invaders to them and they never quite lost their reservations about catching migrants for ringing. We, on the other hand, belonged to the generation which set its face against the old policy of shooting rare birds to clinch identification.

In January 1934 W. B. Alexander, at that date probably the only professional ornithologist in Britain not working in a museum, came from Oxford to give a lecture on the Heligoland Bird Observatory, stimulating our plans to build a 'Heligoland trap' for catching and ringing migrants on the Isle of May. W.B.A. was a round little man with a pink complexion, who seemed to me quite elderly, though he was not yet 50. He had an international reputation for his work on biological control of the prickly pear in Australia and on many long sea voyages had gathered the material for his pioneer sea-bird guide, *Birds of the Ocean*. Many generations of Oxford ornithologists remember him with affection and gratitude, not least for his willingness to drive them to the best bird locations in his comfortable car. He had an unflagging passion for lists, birds he had seen in a day, a month or a year, and had been known to persuade his younger companions to coax a bird across a county boundary to secure it in his lists for two counties. He had a quizzical way of looking through his round spectacles which made him appear extremely learned, as indeed he was.

After an appeal for funds by the MOC had raised £83 (to everyone's astonishment) the way was clear for starting work on the Isle of May. The Lighthouse Commissioners gave permission for us to use the old coastguard look-out as living quarters and in the same autumn a Heligoland trap was built by Frank Elder, my brother Eric, W. B. Alexander and Ronald Lockley and the observatory was launched. Ronald Lockley's experience in setting up the first British Observatory on Skokholm island was of great assistance. Over 40 years later Ronald, who had emigrated to New Zealand, called at our home in Galloway on his way to Iceland and we reminisced about starting the Isle of May Observatory. More recently the island was celebrated in Keith Brockie's fine art book *One Man's Island* and an evocative television film. What was the fascination that drew me back year after year for over half a century? Basically, the mystery and romance of bird migration. Tales of great rushes of migrants swirling round the lighthouse lantern on dark drizzly nights were fuel to boyish imaginations. With its basalt cliffs rising sheer from the cold waters at the very entrance to the Firth of Forth it offered an accessible yet remote enough escape from conventional living. Over the years hundreds of bird watchers have come under its spell although others found it too bleak and treeless. In anticipation the hope of the migration watcher was always that the wind would blow from the

east, drifting the migrants across the North Sea. If the dice were too often loaded in favour of west winds and birdless days there was always the chance of a sudden change.

In those pre-war days I often had school friends as companions. Some came more for the freedom of life on an island than any serious interest in birds. I don't think anyone was ever bored and occasionally there was high excitement, as when we woke up one April morning to find that a Danish passenger ship had been wrecked on the rocks just below. It was a still, foggy morning and for a long time we could not see the ship at all. I have never forgotten the sadness of the old captain's face, his career disastrously ended on his final voyage before retirement. Happily no lives were lost but the ship stayed fast on the rocks and for weeks we were climbing down into the holds and bringing up all sorts of trophies, from tins of mysterious fish to fine crockery. It was widely believed that the head lightkeeper made a cache of whisky at the bottom of the island's loch. From frequent visits to the Isle of May I became more knowledgeable about rare birds like barred warblers, red-breasted flycatchers and ortolan buntings than about many common Scottish birds. All this suddenly came to an end, when in 1938 the Munich crisis led to the occupation of the island by the Royal Navy. None of us lost hope of returning one day. No one was more dedicated to the island than my friend Maxwell Hamilton who became a wartime naval officer and was twice rescued from the sea when his ship was sunk, once within sight of the Isle of May.

I first met Maxwell on Granton breakwater in 1932. Our feelings for birds and natural history generally had a special bond in our enjoyment of W. H. Hudson's writings. They were not much read by young people of our generation. Hudson was one of those rare nature writers whose mastery of prose avoided the commonplace and was, at its best, marvellously evocative. For a number of years Maxwell and I made Sunday expeditions together, bird-watching throughout the Lothians, leaving Edinburgh by bus. When I read today of Stan Da Prato's discovery of a sizeable population of lesser whitethroats in that area it is tantalising to speculate whether we overlooked their presence in the 1930s. I do not think I could have missed the song which I knew so well from Surrey days, but it is possible that we were never in precisely the right spots, while it has been found that the song period may be very limited. I incline to the view that in those days they were not there — if they had been, most likely the old egg-collectors like David Hamilton would have found a few nests. We sometimes met him, often with his friend Willie Watson — a much older and very different pair, whose surnames we chanced to share.

David Hamilton was a toolmaker by trade, employed all his working life in a Musselburgh factory. Many rated him the best field naturalist in the Lothians. He was a dedicated collector, of birds' eggs, moths, butterflies and beetles. Blunt and rough-spoken, he was friendly enough, if cagey, to us boys. I remember one evening when he and Willie Watson agreed to come to the Edinburgh Academy and help us out of a difficulty. Someone had left a large but nameless collection of eggs to the school and Maxwell and I were expected to be able to name them. This was a task quite beyond us, but we knew we could rely on the two collectors to save the day for us. Even now I re-read the account of his discovery of a pair of bee-eaters in 1920 and their attempted breeding at Musselburgh, with wonder. He and his friend found kittiwakes nesting on the west harbour wall at Granton in 1931. Over the next two seasons I spent many evenings perched on the roof of a warehouse watching this unusual little colony — one of the first to be recorded nesting on a building — but they never succeeded in rearing any chicks. In

the autumn the same roof was the gathering place for up to 800 kittiwakes in their grey-naped winter plumage.

September was always an interesting month at Granton; Eric and I were excited to find two young black terns among the many other terns which crowded the small boats in the east harbour and by endless scanning with binoculars I saw all the British skuas from the breakwater at one time or another. We found that in spring and autumn there was a fair amount of visible migration including small passerine birds. The call of a grey wagtail or a skylark led the eyes to a bird passing quite high overhead. Redstarts, wheatears and stonechats visited the wilderness in the ship-breaking yard where rose-bay willowherb was rife. In those days it was quite an uncommon plant. By 1935 Eric was a qualified botanist and had an outstanding knowledge of the flora of the Lothians. Sometimes Maxwell and I took the ferry steamer, *William Muir*, which then sailed between Granton and Burntisland whence we would walk to Aberdour. On the crossing we might see large flocks of Manx shearwaters, rarely visible from land. In 1932 roseate terns were found nesting on Inchmickery island and on 18 July 1933 some of us went there by boat from Newhaven. We found 12–15 pairs of Roseates on Inchmickery and over 20 on neighbouring Carr Craig. There was much anxiety about the danger of egg collectors finding this, the only colony then known in Scotland, and it was not until many years later that it was considered safe to publish the location.

About 1936 I began to think seriously about the possibility of a career in art. A. C. Dodds, the school art master, took me under his wing and encouraged me. I joined a small group of boys for outdoor painting sessions on Saturday mornings, when Mr Dodds taught me the basics of watercolour technique. He thought I was good enough to try for Edinburgh College of Art and one day it was arranged for me to take a portfolio to show the principal, Hubert Wellington. I should have known that my bird drawings were not promising art school material; Mr Dodds afterwards gave me a dressing-down for not taking my landscapes, but I was not sure that I really wanted to go to art college and was reconciled to the prospect of working for a possible history scholarship to Oxford. Nevertheless Mr Dodds was right in forecasting that I would 'come back to art' later in life. As soon as I knew that I would not be going to art college my private ambition centred increasingly on becoming some kind of writer, although neither writing nor painting seemed to offer any real prospect of a career. Fluency in writing essays was often a means of disguising how little I knew about a subject, but it was good enough to gain me an Exhibition to St John's College, Oxford, which I entered as a history undergraduate in October 1937. I began to look back on ornithology and bird painting as boyish pastimes, to be grown out of, though I did not lose all interest.

Indeed my diary of a walking holiday in Western France with my friend Bernard Richardson in summer 1937 is full of birdwatching. We discovered the charming pastoral countryside of the Auvergne, where little had changed for centuries, tourism hardly existed and village *auberges* were friendly and inexpensive, providing memorable meals. The roadsides were alive with butterflies I had never seen at home — Camberwell beauties, swallowtails, large tortoiseshells, white admirals, clouded yellows and many more. Here too was a richness of birds of prey such as Scotland had not known since before the advent of nineteenth-century game preservation. There were many families of goshawks and innumerable buzzards. Often hen and Montagu's harriers sailed over moors and cut hayfields. I did a few amateurish watercolours, but recorded my impressions mainly in writing. Perhaps the

following extract from my diary, if too self-consciously descriptive, still evokes something of a distant afternoon in the Auvergne.

St Genés, 7 August 1937. Through the long hot hours we lay in an ocean-depth of shade, looking out on sunlit meadow land. Fritillaries skipped from one thistle to another and were quickly lost to sight. A bullfinch family piped dreamily down by the stream, the male wearing his beautiful plumage unflauntingly. Nature is unassuming on these late summer days. The leaves seem devoured by the light. We ate grapes and pears and said little. Our little haven of shade had almost gone when sounds of driven cattle came from the slope above. Only a pair of willow tits remained feeding on the drooping ash boughs in the sunshine. The cows, driven by two girls and their dogs, moved slowly down the pasture munching collectively at the lush grass. The girls fitted naturally into the scene, it was we who were caught out of place.

So we left this picture of browsing cattle with the girls leaning in conversation against an old gate. We climbed back onto the dusty road, heat still burning its loose surface. The way wound on to yet another level plateau, fence wires alive with little birds — whinchats, meadow and tree pipits. At last among far off clumps of trees in the lap of the big mountains we could see the tall gleaming spire of Chastreix Church.

After a night out in a monumental thunderstorm we made the long hot climb to the top of Mont Dore. It was rather a disappointment to find there was a funicular railway up the other side.

I hated my first few weeks at Oxford but much enjoyed the next two years. In the summer vacation of 1938 I had been advised to spend a month in Italy to see the wonders of Renaissance art, which I was studying for my degree. A friend (Gerald Neligan) and I had a crazy plan to hitch-hike through France on the way and paddle a canoe down the Rhône to the Camargue before going on to Florence. Wisely the canoeing part was abandoned. M. Le Mans at Arles arranged for us to stay with keepers on the bird reserve in the Camargue — one of them showed us a fan-tailed warbler's miraculous nest. We spent a night in a derelict boat on an *étang* and woke up to flamingos all around us as the sun rose. It was the same year that George Yeates photographed stilts and other Camargue specialities, but we hardly met anyone. My final year at Oxford was completely overshadowed by the outbreak of war.

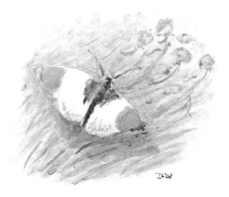

3

Artist in Wartime

In September 1939 in Edinburgh I had tried to get into the Army and even the Navy (I had no prospect of that because of short-sightedness), but was told to go away and wait. At Oxford a few weeks later I probably could have taken the chance of immediate enlistment in the Army as a potential officer, though in a low medical category. Instead I waited for inevitable call-up in the ranks. I have a hazy recollection of arguing the case for becoming a stretcher-bearer before a board of officers and dons; naturally they thought I was wasting their time. Strangely enough, perhaps something I said was noted as when, months later, my call-up arrived it was to the RAMC depot at Crookham that I had to report. In the interval I had taken my final exams, which in 1940 seemed an exercise in futility.

Much as I hated the prospect of life in the Army it was weirdly exciting as the train from Edinburgh entered London on the night of 8 September 1940. Bombs were falling uncomfortably close. Eastward a great orange glow was thrown up by the terrible fires in dockland. At the RAMC depot day followed day of boring square drill, stretcher drill, gas drill, relieved only by splendid days out in the country digging an enormous anti-invasion ditch. There was pleasure in discovering how easy it was to make friends with fellow recruits thrown together from every kind of background. In my barrack room we had one or two self-confessed petty criminals, an illiterate busker, an ex-Naafi manager, a huge Cockney gigolo and a re-enlisted regular soldier who taught me a lot about how to get by. On a November night down in the air raid shelters we listened for what seemed like hours to the drone of Nazi bombers overhead. It was the night of the raid on Coventry. Many of my companions were Londoners and were greatly distressed because their wives or families were in much greater danger than they were. Somehow on our trench-digging days I secreted my small monocular in my gas mask container and did some casual birdwatching when the sergeant wasn't looking. Fatigue duty burning rubbish gave other opportunities. I got one week-end leave and had a splendid party with friends in Oxford, only slightly spoilt by a spiked railing making a large hole in my thigh which was stitched up in the middle of the night at the Radcliffe Infirmary (they said I had enough alcohol in me so didn't need an anaesthetic). After two or three months the prospect of spending the rest of the war as a private soldier in the RAMC seemed too boring to contemplate and I put in a general application for a commission, but was posted to a Field Ambulance in the Highlands before any response came.

I was glad to be back in Scotland. The best days were when we went on route marches for long distances through the glens north of Strathpeffer. These were sometimes led by Major Alan Frazer, well-known as a writer on hill farming. He had a mighty stride and could be a terror, but I thought him rather a romantic figure with his shepherd's crook. That winter was bitterly cold in the north of Scotland and rations were not generous. It was a memorable sight to see a huge, but usually mild-mannered London bank clerk losing all self-control as his great

hands grabbed all the food he could get at the canteen. I was put on a charge by Staff Sergeant Hardie for scorching my denim trousers when I became absorbed in watching coal tits instead of keeping my attention on the incinerator I was supposed to be minding. Two weeks in the office drawing aircraft for recognition charts was as good as a holiday.

As spring approached I again began to look for a move out of the RAMC. It happened that the Army Education Corps wanted men with degrees to train as instructors. I think I had heard that Ken Williamson, already known as an ornithologist and author, was in the AEC on the Faroe Islands. Suddenly there was a vision of doing something enjoyable in a far away outpost. After a brief course in Wakefield, next door to the prison, I emerged as a callow Sergeant supposedly in charge of everything that passed for education in a huge RA training regiment in Ayrshire. So much for dreams of birdwatching on distant islands. Looking back on the year I spent in the AEC I was obviously too young, irresponsible and self-indulgent to do what might have been done. It was all rather bizarre — I had a great deal of freedom, especially when promoted to warrant officer (Sgt Major). For the first time I had a splendid feeling of superiority to red-capped Military Policemen when I was travelling. One day a brigadier came to listen to a lecture on the causes of the war which I was giving to a roomful of recruits. Afterwards he mounted the platform in a frenzy to contradict most of what I had said. I organised debates and discussion groups, a music group under a bombardier who was a cellist and even an art exhibition, opened by old George Houston RSA who sent one of his own works. Perhaps I did help to make life a little less bleak for some people but increasingly I realised that, if only for my own peace of mind, I had to take a more active part in the war. So in 1942 I went to an officer selection board in Edinburgh where it was rumoured that not eating like a gentleman at dinner might result in failure. However I passed (officers were badly needed) and survived the horrors of training at Wrotham and Catterick to become a 2nd Lieutenant in the Field Artillery.

At this period of the war civilians were inclined to be scornful of men in army uniform. There had been lots of air raids on civilian populations and the Army didn't seem to have done much fighting. I remember my cousin welcomed as a hero in a Yorkshire pub because he was wearing the blue uniform of a navigator in the RAF. We were involved in a major exercise on the Yorkshire moors in October, christened 'Blackcock' by some general dreaming of pre-war shoots. This was 1943 and we guessed that the invasion of Europe was close. We all had our private memories of home leaves, framed by partings on crowded station platforms.

It turned out that India, not Europe, was to be my destination and the first stage was a posting to a holding regiment at Cromer in Norfolk. Early morning parades in front of empty seaside boarding houses resounded with Sgt Major Proud's four-letter invectives. His extraordinarily straight, close-cropped neck and sour expression made him look like the ultimate caricature of a Sgt Major but underneath lay quite a sensitive soul. We went out on night-firing exercises along the north Norfolk coast. Once in the dawn light the view of Little Walsingham Church, half-shrouded in mist, was so compelling that I *had* to make a sketch on the spot. Afterwards Sgt Major Proud asked almost shyly if he could come to my billet and look at my paintings. The routine was not very demanding and I found time to build up quite a collection of watercolours of Norfolk countryside, its churches and villages, which were rather popular with my fellows. I wrote home that for two days the main topic of conversation in the mess was about whether I had spoilt a picture by painting a horse in the foreground. We

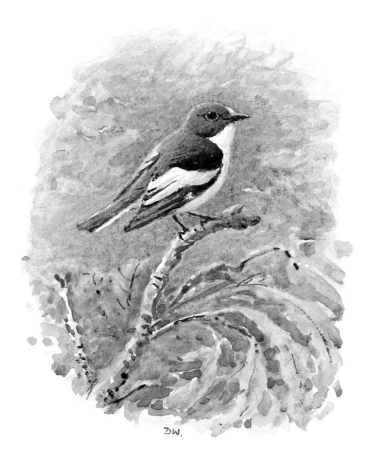

Cock pied
flycatcher,
1987

played bowls on the deserted sea-front, while overhead the bomber fleets roared out over the sea, not all returning hours later in ragged skeins. I spent a night out at Blakeney Point enticed by the thought of bird migrants, but only found a beautiful, freshly dead, cock pied flycatcher. I looked nostalgically through the windows of the pre-war warden's hut with its rows of bird books still on the shelves. Spring came bringing the nightingales to Salthouse heath, although our guns and vehicles had ravaged much of the best bird habitat. On 24 April, at the end of a night exercise, I was asleep out on the heath dreaming that many nightingales were singing and awoke to the realisation that it was true.

At last, just as the buzz-bombs began to trouble London, my draft for India collected at Woolwich and we travelled by night train to the Clyde, still in but no longer part of familiar surroundings. We passed the majestic shape of Arran and there was a far glimpse of the lonely west coast of Islay, before the convoy took a wide sweep into the grey Atlantic. Our morale soared when we found we could spend our days with a party of RAF nurses, one of whom my friend Bob Snodgrass married soon after arrival at Bombay. Late at night some of us broke the rules of a 'dry' ship by drinking beer with the bosun in his paint store, up on the top deck. We saw a lighted city for the first time for five years as we passed the coast of North Africa: Mediterranean and Cory's shearwaters followed the ship's wake. Crossing the Indian Ocean under a grey monsoon sky we watched flying fish and at night on deck an Australian pilot played his records of Beethoven's Fifth Symphony over and over again, peculiarly haunting against the sounds of the wind and the rain. Bombay docks in teeming rain did not seem a propitious welcome to India.

On the last page of his Indian masterpiece, *Staying On*, Paul Scott wrote of poor bereaved Lucy, 'alone . . . here as I feared, amid the alien corn'. How alien India seemed to the wartime British soldiery, most of whom had never before left their homeland! On our first short train journey to the Royal Artillery depot at Deolali, everyone was shocked, or horrified, by the squalor and poverty as we cleared the suburbs of Bombay. Most of my fellow temporary officers had grown up with a hazy, but vaguely critical, vision of the British Raj in India, but now they had been sent across half the world to fight for its survival against the Japanese. The great majority of India's vast population would continue to live their subsistence lives, the realities of which we, in our military cocoons, were unlikely to learn much about. Nor were we likely to make more than minimal contact with British civilians. However, as I discovered on my first long train journey to Calcutta and onward to join a regiment in Bihar, there would be plenty of opportunity to use my eyes. At once I realised that my visual enjoyment of birds and landscape, which had slightly faded in Britain, was going to be renewed. The train travelled slowly enough across the plains for me to identify a great variety of birds perched on telegraph wires, including green bee-eaters, black drongos, white-breasted and common kingfishers, rufous-backed shrikes, Indian robins, Brahminy kites, various doves and, best of all, Indian rollers (or blue jays). About every three or four telegraph poles, I noted, one would float down to the ground with a flash of those unbelievable turquoise wings.

There was apparently no particular deadline for completing my journey so I took a couple of days to look at Calcutta, where an RAMC major talked over dinner about his appalling experiences in the recent Bengal famine when he continually fought against bureaucratic corruption. In a dark little shop with scarcely room to turn round for the number of assistants, I found a stock of Winsor and Newton's art materials such as had not been seen at home since before the war. At Ranchi, deep in the Bihar countryside, the guns and vehicles of 6th Medium Regiment were parked among scattered trees beside a dry stream bed. In the evening sunlit rice fields made a brilliant patchwork of green and yellow. In a month or so we would be leaving these peaceful surroundings to take part in the autumn offensive in the Arakan, the coastal part of Burma, about which I soon heard many tales of the last campaign. I had reason to be grateful to a good friend, Mike Lewis, who had arrived a few weeks earlier and fed the CO a tale which resulted in my filling a vacancy in the regimental establishment. In October, after a few days living like peace-time sahibs in Calcutta, we sailed down the ochreous waters of the Hoogli River bound for Chittagong. Out at sea I spotted a party of dazzling white birds with long pointed tails and coral-red bills, rather like miniature gannets. Unfortunately their appearance coincided with a summons to boat drill, but I knew they were tropic birds, the first I had ever seen. Later I discovered they were called, inappropriately, short-tailed tropic birds. The setting sun turned a great expanse of calm sea to red and gold, like a lake of oil, and lightning flashed like gunfire from a great purple cloud bank on the horizon. After dark I heard the sharp chirping of migrating bee-eaters — which for a moment I thought were bats — and briefly saw two silhouetted on the ship's rail.

I have no intention of attempting a military history of the Arakan Campaign of 1944–5. Anyone who is interested can look up the bare bones in appropriate source books. I knew from the start that I would not excel as an artillery officer but I think I was only once responsible for shells dropping too close to our own troops. What I had not anticipated was that living in holes in the ground and firing guns in anger would be far more tolerable than all

previous army experience. Of course comradeship, a sense of purpose, physical fitness and the totally outdoor life in beautiful weather, were all part of this. In the battery command post I had the good fortune to be assistant to a wonderful boss (sadly he was later killed) and we had a happy relationship within our small team, which included a bombardier and three gunners. I know that for most wartime soldiers Burma was a place that had to be endured. I was enormously lucky in being able to find so much satisfaction in birdwatching and drawing and painting. Together these interests, trivial though they seemed to most people, meant that free time was never boring. Although the war against Japan was very far from won and there was reason to believe that the worst still lay ahead, nobody seemed to feel pessimistic. For myself there is no doubt that the months in the Arakan did more than anything else to open up the possibility of becoming a professional artist after the war. One of my luckiest breaks was finding that the GOC, General Christison, was a keen and expert ornithologist. When he came down to have a look at our regiment the CO dragged me out to talk to him. In this way I discovered that there was a network of people who were in touch about the wildlife of the area. Major Maitland Emmett, now a distinguished entomologist, was a liaison officer, which seemed to me the perfect job as he appeared to wander all over the jungle on his own. I think his visits to our command post were purely to report some bird or butterfly he had found — once, I remember, he had just been watching a gold-fronted chloropsis, a splendid bird. He was very kind to me, a mere lieutenant, and introduced me to Aubrey Buxton (now Lord Buxton), who was also a major and a battery commander in a neighbouring field artillery regiment. One night I was given permission to ride over on a motorcycle to see him. He showed me his copy of Smythies' *Birds of Burma*, one of only about 20 copies of the first (1940) edition known to have survived the Japanese invasion of Singapore. It had fine colour plates and was the only book that was at all up to date and complete on Burmese ornithology. I only had about 10 minutes to glance at it but vowed there and then that my prime objective, if we ever got to Rangoon, was to find a copy for myself. A little later one of my friends was going to do a stint at Major Buxton's observation post and obliged by taking my bird list on a bundle of army message forms. These eventually came back with Buxton's comments and corrections — most helpful, if cutting me down to size a bit. Some of these people were old hands in the Arakan and I was just a beginner. The fourth member of the 'top team' was Dillon Ripley, the American expert. Years after the war he was joint author with Salim Ali of the *Handbook of the Birds of India and Pakistan*, for which I painted some of the colour plates.

My painting materials were minuscule. I had one of those tiny black boxes with pans of artists' watercolours, two or three sable brushes, pencils, Indian ink, a mapping pen or two and postcards made by Reeves of stout watercolour paper. I also had some rather bigger watercolour boards. If I was off duty I might manage an hour or so's landscape sketching on quiet days. It was especially good early and late in the day, when big forest trees threw long shadows on to sunlit paddy and the air was almost cool. Through midday hours it was really hot, with barely a cloud in the sky and everyone shirtless. The Arakan district of Burma may not have the most spectacular bird-life in the world, but what made it very exciting was the rich mixture of resident species and migrants from the Palearctic. We often spent weeks in the same spot followed by a sudden sea and river (*chaung*) voyage on landing craft perhaps 100 miles down the deeply indented coast. In this way I saw something of many different habitats, from mangrove swamps to dense evergreen forest and scrubby jungle interspersed with

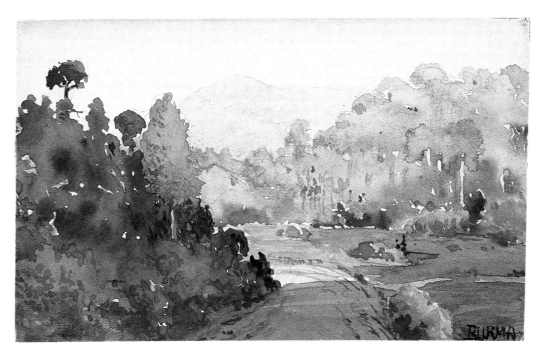

Maungdaw–Buthidaung road, Arakan, Burma, 1944

cultivation or rank grassland. Many of our gun positions would have been completely inaccessible except from the sea. This little war in the Arakan must have been totally unlike the great battles in Europe. Ours were the only medium artillery guns in the campaign and we were much split up. During the bloody battle of Kangaw I was in a small party landed at the toe of Myebon peninsula with orders to report to our gun position many miles to the north. Why we were directed to the area where the commandos were still landing, we never discovered. I recall that the commandos gave us a great welcome until they discovered we hadn't brought any more guns. To get to where we should have been, though only a few thousand yards as the crow flies, involved more than a day's journey on a landing craft back down one side of the promontory and up the other. The naval crew of the landing craft enjoyed the comfort of clean living conditions which seemed wonderful to us. I'm sure this little episode never reached the ears of higher authority which must have been as well for whoever was responsible. One day two of us spent several hours exploring a defensive position on a scrubby hillside which had been very recently evacuated by the enemy. It was absolutely honeycombed with diggings, all interconnected. From main arterial trenches side branches led to little fox-holes with beds of dry grass for sleeping. We learned quite a lot about how the occupants had been living and decided they had a more varied diet than we did — apparently plenty of fresh vegetables and fruit, including melons. They had also been trapping birds for food. Scattered bundles of picture postcards of birds and flowers lay pathetically abandoned. There was a lovely one of an azure-winged magpie, obviously a familiar bird of the Japanese homeland. We had the impression that a substantial force had lived here for weeks or months and they had left a lot of military equipment behind including a light field gun. Here and there we encountered gruesome testimony to the effectiveness of our own shelling.

There were also moments of sheer farce; who could forget the time a certain Captain, leading a long column of vehicles across a deserted sandy beach, could not resist the

temptation to go for a swim? This involved halting the column without warning while he sprinted naked and alone into the sea some 400 yards down the beach. Or the nights when the signallers were busy reporting the progress of an obstreperous elephant around the gun positions? This may have been a solitary bull in a state of 'musth', or frustrated sexuality! Indian elephants feed most actively during the early hours of darkness; a herd was very noisy in forest just across a belt of paddy from one of our rear positions. I once had a trip in a small aircraft flying at low level for many miles over swamps and jungle. As in some Outer Hebridean islands there was more water than land and most of that uninhabited except for an occasional cluster of huts. The plane disturbed dense packs of wading birds and duck, including a flock of ruddy shelduck. It was hard to imagine anywhere more inhospitable to man. Re-reading my diary (no place names allowed) it is hard to remember how limited the time usually was for off-duty ploys like birdwatching or butterfly hunting. To spend two hours along the creek at Maungdaw, while others watched an open-air film show, was sometimes possible, as this was a back area at the time. These muddy creeks swarmed with northern waders, either on their way further south or spending the winter, familiar species like redshank and greenshank as well as new ones like the Terek sandpiper. For most of my fellow officers such birds were only interesting to shoot. When 'the bag' was brought in it was admittedly rather exciting to check what it contained. So it was that I examined many an unfortunate Asiatic golden plover and learned how to distinguish the different kinds of snipe and several beautiful pigeons and doves.

One day returning from a foray through the mangrove I found my only way back was across a single plank bridge over a forbidding channel. Far from confident of my balancing skill I might have felt less uneasy if there had not been a party of Burmese waiting deferentially on the other side until I crossed. Mangrove swamps were rich in kingfishers, not shy of man, none more beautiful than the black-capped with deep blue back and the white-collared, pastel green and white. Many of the common birds of Burma were not listed in Whistler's *Popular Handbook of Indian Birds*, my only reference for a long time. I was so naive that on first sighting a flock of gorgeous chestnut-headed bee-eaters I wondered if they might be some undescribed species! Even if a modern field guide had existed it would have been nearly impossible to distinguish all the warblers in the field — *The Birds of Burma* lists 17 kinds of willow warbler (*Phylloscopus*). There was a special pleasure in recognising migrants such as yellow-browed warblers and red-breasted flycatchers which I had seen on the Isle of May and better still new ones like rubythroats and yellow-headed (Citrine) wagtails. The rubythroat is truly named. The females of certain kinds of blue flycatchers which feed on the ground could be very confusing — at the time I thought one was a kind of robin. These identification puzzles were frustrating — it was a long time later that I realised a thrush which rose quietly from a forest track was an eyebrowed thrush, a species which occasionally wanders as far west as Britain on migration. It had a light stripe over the eye like a redwing, an almost unstreaked breast and buff on the flanks. A sketch in my diary, showing a row of white spots like tiny pearls on the wing coverts, meant it was a yearling. I never saw another. On fast-flowing streams the charming, fairy-like black-backed forktail was quite common.

High forest could be very quiet through the day, but in the early mornings or in the evenings it was as if an aviary had suddenly been thrown open. There were many brilliantly coloured and bizarre resident species. Some were altitudinal migrants, between the hill country and the

lowlands. Among the tiny sunbirds and flowerpeckers were some particular gems — the scarlet-backed and orange-breasted flowerpeckers, the Malay rubycheek (or ruby-cheeked sunbird) and the incomparable Van Hasselt's sunbird. This was quite rare. Watching a flock of them feeding high up among the flowers of a trailing creeper one day, I became slowly aware of being surrounded by a group of silent, green-uniformed figures with sten guns at the ready — and their faces were Asiatic, but not Indian. It was a moment before I realised they were a Gurkha patrol, and not Japanese as they well could have been, the battle front being rather fluid (to say the least) in that area.

Many forest birds like rosy minivets and fairy blue birds were in loose flocks, appearing suddenly and moving on quickly, just as parties of tits do in winter at home. The male fairy blue bird (the size of a big thrush) has a glossy ultramarine back which shines in sunlight. The parties keep up a continuous merry whistling. Wherever fig trees were in fruit there were gatherings of green pigeons, hornbills, leafbirds (*Chloropsis*) and others. The common oriole of the Arakan was the black-headed, a brilliant cadmium yellow and black bird, but I was lucky occasionally to find the more secretive black-naped oriole, more like the European golden oriole. Alas I never found the fabulous green magpie, but I did see a few species not recorded by the 'top team', perhaps most notably a heart-spotted woodpecker and a fine pair of lesser kestrels which had probably migrated from China. Of birds of prey, harriers were most commonly on view whenever we were not in heavy forest. A cock pallid harrier is one of the most lovely as it skims the ground in buoyant searching flight, but I thought the cock pied harriers even more breathtaking. Once I stalked one feeding on a kill until I got within 10 yards and clearly saw that the colour of its long legs was closer to pink than yellow — a feature which most descriptions seem to have missed. Along the rivers there were magnificent white-bellied sea eagles and Pallas' fishing eagles. I wonder how the birds of the Arakan are faring today. Certainly they would not be deliberately harmed by the local Burmese and I should not imagine that the countryside has changed dramatically; it has not suffered the terrible defoliation which destroyed so much forest in Vietnam during the war there. Probably the northern migrants, exposed to pesticides and even more sinister modern hazards, are those most likely to have declined in numbers.

My friend Mike Lewis and I had some good times, especially in search of butterflies, of which we made a small collection. As we moved further south and the weather became hotter the numbers and variety of butterflies increased. There were many superb kinds of swallowtails, the largest as big as $7\frac{1}{2}$ inches across. Months later an entomologist at the Bombay museum identified them and we had apparently made a few interesting discoveries. He was impressed by Mike's method of preserving them in cellophane envelopes.

In the spring of 1945 I became so ill with infected jungle sores that I was sent to hospital for a few weeks. When I was allowed out of bed I went along to a sort of anteroom to paint little pictures from memory in the evenings. I did one of our guns firing at night, when their incandescent flashes seen against a background of dark mysterious hills had great pictorial qualities. We were fussed over by kind and delightful young nurses. At this stage of the war the Japanese had few aircraft for bombing raids, but each month at the full moon they sent a lone bomber over the hospital area. Once there were casualties in another ward, but most nights were peaceful enough and sometimes I heard the clear whistling of whimbrel flying north to the Siberian spring.

The last phase of the Arakan campaign was the landing at Rangoon. An invasion fleet gathered off Ramree Island to make the long slow journey down the coast and into the Gulf of Martaban. The sea was rough and the rain relentless. We still did not know what if any resistance to expect, but we were fortunate — the enemy had gone. A crowd of Burmese and some Indians, the latter obviously the more enthusiastic, gave us a muted welcome as we squelched ashore. The great Golden Pagoda rose ahead reducing all humanity to lilliputian scale. Forward troops released emaciated British and Australian prisoners from the gaol. An Australian told me that one or two of his Japanese guards had been friendly. I had a brief excitement when a friend discovered an Irishman living in the city — his wife was Burmese — who owned a copy of *The Birds of Burma*, the book I had vowed to find if I ever reached Rangoon. It seemed incredible but it was true. I was allowed to borrow it but no amount of money would have induced the Irishman to part with it. I expect he knew it was valuable but it was clear that he would never have done a favour for anyone in British army uniform. By this time, however, I was beginning to receive the volumes on birds in Oates' *Fauna of British India, Burma and Ceylon*, published between 1889–98. My mother had cleverly found them in a secondhand bookshop in Edinburgh and sent them out in no less than eight separate parcels, all of which arrived safely. In spite of being so old and without colour plates these books were very useful. Discarding my camp-bed helped to make room for them.

When we landed back in Madras in June 1945 there seemed to be no indication of what would happen to us next. While we had listened to Churchill's VE Day speech in May, back in Rangoon, many felt they belonged to 'the forgotten army'. Now there was a trickle of men going home to be demobilised. We would miss the friendly smile and rock-like steadiness of men like Gunner John, a stocky red-haired Welshman, whose parting words to me were that he would be returning to work for the Communist Party in his peacetime job at the Cowley motor factory. I spent another year in India mainly in Hyderabad State — perhaps most of it is best forgotten. I certainly drank too much for my own or anyone else's good. Life alternated between periods when the war seemed to be forgotten and bursts of renewed military exercises. During inactive spells I found myself in charge of a sketching class and giving talks on European history. There was a lot of sport and a regatta; in the bath-tub race mine sank at the start. In the evenings I sat alone outside the officers' mess absorbed so long in trying to capture the brilliant fugitive light on the maidan that those drinking inside began to chant 'Watson, why are we waiting'. Two or three of us enjoyed memorable expeditions, staying overnight in forest bungalows far out in the countryside. I agreed to join a shooting party on condition that I could go off on my own to watch wildlife. The Indian guide promised lots of game and the party decided there was no need to take any food. They returned empty-handed except for a hare, which was made into a curry too hot to eat. I had a fleeting view of a leopard.

While we were based on Secunderabad racecourse it was possible to drive into town and browse through the excellent stock at the 'Oxford bookshop', where the Indian proprietor gave us tea and cakes on the counter. I helped him unpack a new stock of artists' materials, just arrived from London, and purchased among other items three enamel palettes which I use to this day. Shortly before the traumatic and totally unexpected end to hostilities came I flew to Delhi on leave and enjoyed early morning birdwatching on the River Jumna with Archie Bryson, an old friend from Edinburgh who was working at Naval (RIN) GHQ. He knew but could not tell me that my regiment was detailed to take part in the Malayan invasion, only

weeks away. We saw a great variety of birds, but for me the most surprising were the stone curlews which Archie showed me feeding on the well-cut grass in the cemetery. He arranged for me to spend a week of my leave with a family in the foothills of the Himalayas near Simla. Every day I wandered up and down steep terraced hillsides and was entranced by distant views of the great mountains which seemed to climb for ever into the clouds. Always the hill people, cultivating their incredibly narrow terraces of ground, gave me friendly glances. How delightful it was to hear the call of the European cuckoo from far away across the Himalayan valley. It seemed surprising that the cuckoos were still so vocal in mid-July, especially as Whistler said in his book that they stopped about June. Apparently these cuckoos only migrate to Southern India for the winter. When big blue cloud shadows crept across hillsides dotted with pine trees I might have been at home in Rothiemurcus for a moment. At 6000 feet, in summer I was apparently just too low for the beautiful white-capped redstart which I so wanted to see. There were plenty of good birds, though, with paradise flycatchers, red-billed blue magpies, spotted forktails, golden orioles and scarlet minivets outstanding. Once a speckled piculet, tiniest of woodpeckers, came into view among a roving band of tits, warblers and flycatchers. I decided not to make closer acquaintance with a brown bear which I surprised.

A few weeks later, in Bombay, I had lunch with the great Indian ornithologist Salim Ali and met Mrs Cowen who was illustrating one of his books. They listened politely while I poured out my absurdly ambitious plan to paint the birds of India in their habitats. They advised me to study George Henry's fine series of plates of the birds of Ceylon. Looking now at some of the many pictures I painted in India and Burma I realise that the landscapes were generally superior to the birds, which were often too posed and not well enough observed. If I had realised this at the time I would probably have abandoned any thought of becoming a bird artist, and in retrospect I am glad I was overconfident.

For my final months in India we were stationed far out in the Hyderabad countryside, not far from Medak. Some of us spent a few days by the big Nizam Sagar Lake which held great flocks of duck, mostly pintail and garganey. Bluethroats poked among the bushes on the shore and as always in India where there is mud and water there were wading birds. Any little pool (*jheel*) might attract several species including common, wood, green and marsh sandpipers, greenshank, little and Temminck's stints. Yellow wagtails with differing head patterns swarmed over the grass and often marsh and pallid harriers swept past in low hunting flights. Back at base my happiest times were early mornings spent painting evocations of home scenes in poster colours on poplin for the mess hut. The open country was quite heavily populated. How beautifully the peasant women walked, their saris making brilliant notes of colour in a drab landscape.

In April 1946, while I was out on a firing exercise, word came that I was to go home. With two friends I opted for a flight back on a Liberator bomber. (Someone said it would be OK as fully 50 per cent made it.) We sat sprawled in the bomb bays, breaking the journey in Palestine and Tunisia. I have two unforgettable memories of this journey. One is of flying low over the craggy peaks of Corsica, which seemed an enchanted isle, and the other is of landing somewhere in East Anglia. After two years in Asia the greenness of the English countryside in early May was almost unbelievable.

4

Becoming a Bird Artist

Back at my mother's house in Edinburgh, in the summer of 1946, I had no clear idea how to become a professional bird artist. A few weeks' leave offered the chance to explore possibilities. A neighbour asked me to do two copies of a painting I had done of sunbirds in Burma and George Waterston, ever ready to help a young friend, suggested I design a new cover for *The Scottish Naturalist*. A start perhaps, but I got bogged down with the cover picture and George didn't think it would do at all. I was depressed for other reasons and was finding it hard to adjust to a post-war civilian life, though my mother did her best to be understanding. One day, out of the blue, George phoned to say he wanted to bring Arthur Duncan and his friend the Rev. J. M. McWilliam to see what I had been doing. Both were well-known ornithologists in Scotland at that time. Nervously I showed them a few pictures I had brought back from India. By great good luck 'the Minister' was a sucker for bird paintings and it did not need a masterpiece to make him burst into superlatives, with which Arthur generously did not quarrel. So it happened that a few weeks later I began a long stay at the little village of Tynron in Dumfriesshire, to work on a series of paintings of birds in their habitats for Arthur Duncan. The Minister lived close by, with his splendid wife Alice, scout-mistress and friend of all. He liked to persuade himself that his parish of Tynron was the Scottish Selborne. The world at large might think that it had a more contemporary claim to fame through the frequent visits of Michael Powell, the film director, to his mother's house along the river bank. I was once cheeky enough to argue with him about art.

As Arthur Duncan wrote in a brilliant obituary, 'In life, as in art, there are many copies and few originals. John Morell McWilliam was an original.' He was in every way a big man, with an elephantine head. He was a compulsive talker, witty, outrageous and deeply serious by turns, at his best and most expansive late at night surrounded by a group of friends. Many of his anecdotal tales were very funny, but they depended greatly on the manner of the telling in his rich throaty Irish accent and on his own hilarious enjoyment of them. I never tired of the saga of the adventurer Talbot Clifton, said to be the only man to have eaten mammoth steak (in the Gobi Desert).

The Minister belonged to the old school of collector naturalists. I doubt if he could ever have resisted a beautiful clutch of eggs. In his sixties when I knew him best, he had largely ceased to be active in the field, but was still game for boat trips to the Scare Rocks, where in 1939 he had found the first gannet chick, 'this and its parents constituting the 21st gannetry in the world'. On a wartime visit he and Arthur Duncan survived being machine-gunned from a low-flying plane. In later years his extraordinary library of bird books and old children's books was his greatest joy. He was proud of his friendship with David Lack, with whom he shared an equal devotion to the literature of the robin and the study of bird populations. One winter he invited me to stay with him at the manse, while Alice was away, and I did some of my

best painting there, fortified by hot soup when I came in frozen to the core. I was rather pleased with his comment that a large picture of blackcock on the hill above Tynron was like a rich fruit cake. He would talk the night away and after a late breakfast and lighting the first of endless cigarettes the talk would start again exactly where it had ended the previous night. He kept a sharp look-out for pheasants straying within shot from his study window and I still have a study of one I did at the manse before it was plucked.

One day he suggested I might like to see Sir Hugh Gladstone's unique library containing every published title on British birds. He was anxious in case I might think Gladstone's library better than his own, insisting in advance that 'he has quite a good *small* library'. I had no transport and walked ahead to the big house at Capenoch while the Minister passed me on his bicycle. It was great fun being shown the books, with their personal fly-leaf inscriptions and the collection of bird paintings by leading British artists. Gladstone, however, was much put out when McWilliam started pulling books from the shelves and making remarks like 'I have this one in a much nicer binding'. As we left Gladstone whispered apoplectically to me 'Come again but not with that man'. McWilliam wrote two bird books himself; of these *The Birds of the Island of Bute*, where he was minister for a time, was the more important. With his love of rural sports, natural history and books, the Minister might seem like an eighteenth-century cleric, but he was deeply concerned about the modern world and quite free of religious bigotry. Perhaps the last word on him should be light-hearted; having taken his degree at Trinity College Dublin he always referred to himself as 'BA, TCD' so that 'the ignorant would think he had two degrees and the informed would know he had the best'.

In my inexperience I was at once faced with technical problems of how to tackle the kind of work I had to do. I had no experience of oil painting so that was ruled out. Some of my first subjects involved painting flocks of birds in shorescapes or on the sea. To do these in transparent watercolour on white paper — as Tunnicliffe might have done — not only seemed too difficult technically, but to retain the freshness of pure watercolour the drawing and placing of relatively small-scale birds in landscape would have to be very carefully pre-arranged. Looking for instance at a flock of scaup riding a choppy sea I thought my only hope, after making some preliminary colour sketches, was to go first for a convincing sea effect and then build my birds into this. The only way I could manage this was to use watercolour fairly opaquely, freely using body colour white. This method does not work well on white watercolour paper so I tried out all sorts of toned papers, especially greys, to obtain an overall unity of tone values. I had some inhibition that this was a short-cut method but was encouraged by the example of many fine bird artists like Crawhall, Seaby, Eric Ennion and Thorburn. (I still remember Eric Ennion saying that he was terrified of white paper! Some of his most delightful work was in fact done on those speckly grey backs of writing paper blocks.) So gouache, or watercolour used a bit like oil paint, became the technique with which I was most at ease. It could be used in a variety of ways: sometimes when working quickly out of doors textures could be suggested with dabs of almost solid paint (very expensive and ruinous of watercolour brushes), but especially for broad effects of sky, distant hills and woods or water, it was best to work very fluidly using large brushes. At first I mixed poster colour white with watercolours, but Stanley Cursiter wisely warned me against this as where used solidly it was liable to flake off the paper in time. Then I used pots of Chinese white, moving on to designers' permanent gouache white. I continued, as well, to use transparent

watercolour on both white and slightly toned papers, especially when painting close-up pictures of birds.

During the memorable cold spell of early 1947, as the days lengthened and the lying snow barely receded under continuing cloudless skies, conditions for painting outdoors seemed as good as they would ever be. Arthur wanted a river picture of goosanders, so what better chance than to set up an easel at a good spot by a curve of the River Nith? By mid-March it was even better with the sun almost warm through the midday hours. I knew where to find the goosanders and how wonderful they looked, especially the creamy salmon-coloured drakes in snow-reflecting water. I was then too naive to know that the water bailiff would shoot them if he could. Above and beyond the dark river banks where the snow had melted the landscape was simplified by snow cover. Once I had decided on a basic composition I became totally absorbed and excited at how quickly I began to progress. It was undoubtedly the anticyclonic weather of that arctic winter that enabled me to find new confidence in landscape painting, although in a month or so, when spring came with all the intricacies of trees bursting into leaf, I was close to despair again. Priorities for my commissioned pictures were then pied flycatchers and wood warblers in the oak and birch woods — both were nesting a few minutes away from Arthur's house and he was beginning to have great success with pied flycatchers occupying his numerous nest-boxes, while wood warblers sang and performed their lovely slow 'butterflying' close by. I was torn between making field sketches to be used for studio paintings and exploiting my new faith in tackling the habitat on the spot, and introducing the birds later. I remember telling Arthur that I felt unable to do what he wanted and perhaps I should abandon the whole project, but he was patient and encouraging. My pied flycatchers, worked at for a week or two indoors, were really a failure, mainly because I did not get the drawing of the birds right, and I was far away from conveying the sense of being *in* the woodland. It was not until the following spring, when I spent many days with my easel set up in clearings among the trees (sometimes day-dreaming of Corot), that I felt any achievement in woodland painting, but even then the results would have been much better if I could have resisted the compulsion to include a bird interest — tiny restless birds, hardly bigger than the leaves which they search for food, belong to just a few square feet of environment which in a painting should somehow not seem isolated or static, but ought to convey the sense that it belongs to a big vibrant woodland world.

In October that year I began a very large outdoor picture of pheasants at a woodland corner. This was a subject I was confident of managing. Day after day I carried my easel, big board, paints and stool to the same spot close to a mossy dry-stone dyke. In quiet still weather these were happy days; as I was staying with a keen pheasant shooter I had no problem in picking days when the seemingly ubiquitous shooting parties would be elsewhere. An old larch had cast a golden mantle over the dyke. Papery oak and sycamore leaves carpeted the entire foreground except where the bole of a solitary Scots pine rose sheer to its canopy. Tree trunks, stone dyke and fallen leaves provided fascinating textural variety. I am ambivalent about pheasants. Both cocks and hens are superlative subjects to draw and paint and need no romanticising, far less turning into flying clichés in the hope of pleasing the sportsman. For all the good things about a pheasant their popularity for sport has bedevilled attitudes to predators which have been part of our native fauna since long before the pheasant was brought here. Joseph Wolf, the great nineteenth-century animal painter, said to his

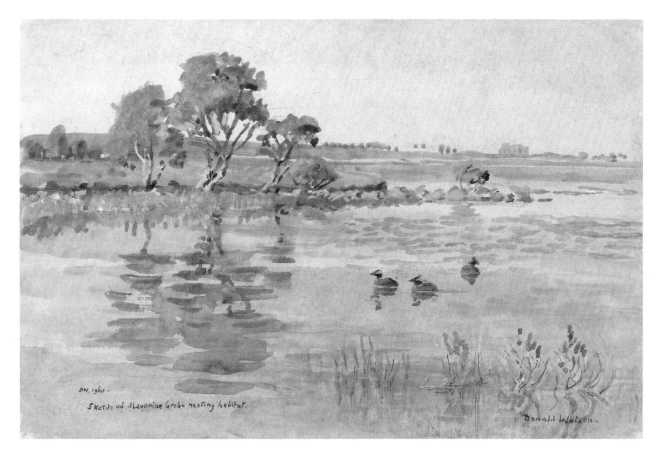

Slavonian grebes on a Highland loch, 1960

biographer, 'I hate a Pheasant . . . his call seems to say "I am a Pheasant and I am under the protection of Lord So-and-So and I may come into your garden and scratch it all to pieces if I like and you mustn't touch me".' He added 'You want a few Goshawks here [in Surrey] to thin down those Hares and Pheasants over there', which must have been an extremely shocking thing to say in 1895. Professor Meiklejohn was another who did not love pheasants and delighted in putting a note in an ornithological journal about one he saw swimming in the sea near Dunbar, adding (a little unfairly I think) that this was the only time a pheasant had been seen 'doing anything interesting'.

Anyone who reads the biographies of the artists in Nicholas Hammond's *20th Century Wildlife Artists* cannot fail to be struck by the extraordinary number who admire the work of the Swede, Bruno Liljefors, more than any other in this field. Even today I find more often than not that artists who are not 'wildlife artists' have generally never heard of him and it is the same with the majority of birdwatchers. This of course is not true of Scandinavia, where he has long been recognised as the father figure of wildlife art, and the Americans, through Fuertes and others, gave him early acknowledgement. I was glad to hear that two of his paintings were included in a recent major exhibition of Scandinavian art in London and a few have been seen in wildlife art exhibitions in this country. I believe the very large size of much of his work has been a problem in sending it out of his native Sweden and reproduction in the few books in which they have appeared has been of variable quality. I was lucky in being lent a copy of the earliest and still perhaps the best book of Liljefors reproductions just after the

1939–45 war, when I was trying to make up my mind whether to embark on full time bird and landscape painting. This first book was largely a picture book, with a brief introduction in Swedish, but later I acquired Russow's book with an excellent commentary in English. Many a Liljefors aphorism stayed in my memory, like 'When painting as I do it is a confession of weakness to make a thing more distant than it really is'. There was also that marvellous observation by a critic: 'in Liljefors' paintings as in nature, you see the animal approach, stop and again disappear'. Liljefors was sometimes accused of being photographic in his early more finished works. Of the great 'Capercailzie drumming' Russow wrote, in defence of the artist, 'the verisimilitude of the rocks, their mossy covering and the landscape as a whole depends on purely impressionistic painting, not on apprentice-like copying of details'. It was no surprise to learn that the artist carried this picture out night after night into the forest to work there for half or three-quarters of an hour at a time.

Helping to organise a small exhibition of contemporary Scottish bird art, sponsored by the Scottish Ornithologists Club, for a big conference in Edinburgh in 1947 was fun. Ralston Gudgeon arrived at the last minute and threw a load of his pictures on the gallery floor, suggesting in his outrageous manner that we might make a bonfire of them. Actually they were among the best we had which perhaps did not say much. James Fisher expressed a memorable view that some of the artists were 'ghastly passengers'. Through young Chloë Talbot Kelly, whom I had met in London, I persuaded her father, R. B. Talbot Kelly, to send some work which, alas, was not properly appreciated by some of the more fustian conference-goers. Peter Scott came and was kind about my picture of wigeon and greylag geese, pointing out usefully that I had made my geese rather pale and too like the Eastern race. This drew my attention to a common pitfall when painting in watercolours mixed with body colour, which can make grey too cold and bluish unless care is taken to counteract this. Vincent Balfour Browne, well-known for his deer paintings, showed some meticulous but charming bird studies — his prices of eight or nine guineas seem modest even for those days. Some of the titles surprised English visitors — J. Murray Thomson's 'Gowdspinks on Thrissils' and Mabel Dawson's ringed plover called 'Dotterel and Daisies'. This must have been one of the first art exhibitions held in conjunction with an ornithologists' conference.

I had introduced myself to Murray Thomson the previous year. A friend had suggested that he might give me some lessons on bird painting since he had been a teacher of bird and animal drawing and painting at the Edinburgh College of Art. He was a pillar of the old establishment in the RSA and RSW, best-known for his paintings of domestic animals. He gave me a sharp look when I named the wrong breed of spaniel in one of his pictures. He began by asking to see my sketches, which was obviously sound thinking on his part, and rather than offer any formal teaching he would be happy to discuss any work I cared to show him, a kindness of which I often took advantage. He also advised me to look at the work of Edwin Alexander, a fine Scottish artist whose restrained watercolours, many of wildlife and flowers, have recently become internationally recognised. A few can be seen in the illustrated edition of St John's *Wild Sports and Natural History of the Highlands* and other books. A journey to see his large pictures in Kirkcaldy Art Gallery was well worth while. An Edinburgh gallery with which his daughter was connected usually had a lot of his pictures for sale, but in those days there was not much interest in them and we were able to buy a lovely little one of a dipper very inexpensively.

During the 1947 exhibition Christopher Dalgety offered to mention my name to Aylmer Tryon, then at the Rowland Ward gallery in Piccadilly. One day in November, carrying a rucksack and a bulky package of paintings, I started hitchhiking from Edinburgh to London. Charles Evans, a friend from Oxford days and later famous for almost reaching the top of Everest in 1953, found a bed for me in the staff quarters of the Liverpool hospital where he was a junior surgeon. The only rather bad moments I remember involved losing my way at Redditch in drenching rain just as a horde of factory workers left work. I felt sad to think that this was the life which many of the young men I had known in the war must be living. I eventually reached Oxford and spent a nostalgic evening with my old friends Gerald and Marley Neligan. Next day my aunt in Ealing was not at all put out either by my unconventional appearance or my arrival a day later than expected. My objective was to find a London gallery which would take my pictures. It was probably at Chloë Talbot Kelly's suggestion that I went first to the Fine Art Society's gallery in Bond Street. The urbane Mr Grouse and his partner must surely have thought of putting me out on the street when they saw my tattered Army motor cyclist's leather jacket — a bit like a Soay sheep shedding its winter coat. In fact they were extremely courteous and only became slightly ruffled when I cheekily explained that I also wanted to take my work to show Mr Tryon at Rowland Ward's. 'What?' they said. 'Surely they are just animal stuffers.' Back at my aunt's that night I was faced with a decision — to my complete astonishment both galleries had offered to take my work, but each would of course insist on handling it exclusively at least in London. I had entered a world of which I knew nothing and I might as well toss a coin. Finally I decided not to take up the Fine Art Society's offer, chiefly because I thought that among their huge array of nineteenth-century watercolours I would be a very small fish in a very big sea and my work might languish in drawers. So I began an association with the Rowland Ward Gallery which lasted over 10 years, taking part in exhibitions with other young wildlife artists in 1948 and 1950 and having one of my own in 1955.

All this resulted in further visits to London, mostly in the winter, and the opportunity to view the London art scene. I looked at everything, from Francis Bacon's screaming popes to the great permanent collections, but undoubtedly my most treasured memories are of the Winter Exhibitions at the Royal Academy. Most exciting of all was 'Landscape in French Art' (1949–50). Leaving the still bomb-scarred streets of London's West End on a dark winter's day to stand before those early Corot pictures, aglow with Mediterranean sunshine, was a dream-like experience. How disarmingly simple and perfect in tone they were! Here too were masterpieces by a galaxy of landscape painters from Claude Lorraine to Cézanne. As a wildlife artist I was fascinated by the sheer virtuosity of animal painting in eighteenth-century hunting pictures by Oudry and others. At a later show of Flemish art it was fun trying to count the bird species in the numerous seventeenth-century pictures of 'dead game', which included many familiar birds of field and garden, so realistic that they might have been killed yesterday. Then in 1961 there was a Landseer exhibition, which was so much more exciting than expected. It was amusing to read highbrow art critics praising works by Landseer, so long their favourite butt. Certainly his humanised doggy pictures still looked horrible, but the marvels of this exhibition were his small Highland landscapes rivalling Constable and Bonnington. If he had lived a century later and painted *living* animals in their environment, with his wonderful grasp of modelling and textures — as in the astonishing dying ptarmigan

— I doubt if there is a living wildlife artist who could have rivalled him. A small study from life of a falconer's peregrine could not be bettered.

At Rowland Ward's I used to meet Frank Wallace, whom I always thought the best painter of deer in the Highland scene. Once at an exhibition which he was sharing with Vincent Balfour-Browne, he whispered to me in front of one of the latter's pictures, 'He's only got one colour in his box — brown'. F.W. really captured the colours and tones of the Highlands in autumn. He gave me a lot of good advice, once pointing to a fault I had quite failed to see, that in some of my pictures I had not got the distance to 'go away'. I have seen the same fault in the backgrounds of pictures by some young wildlife artists today — the tones of the background marching forward because they were too strong. Lionel Edwards was a friend of Frank Wallace. You do not have to know a lot about horses and hounds to enjoy the illustrations in his *Reminiscences of a Sporting Artist*. How beautifully he painted weather, especially when skies were grey and rainy. In such scenes the touches of bright colour made by the hunt could easily become trite, but Edwards rarely overstated them and always had a wonderful eye for scale. 'Wintry scenes', he wrote, 'are usually low in value — sombre skies, dark fences, mud, water and rotting leaves — but if the picture is painted in too high a key it will inevitably look like a Christmas calendar.' His effects owed much to a cunning use of toned papers.

I saw some of Munnings' best pictures in Ian MacNicol's gallery in Glasgow. I never cared much for his flashier commissioned horses and riders, but especially when young he painted stunning outdoor subjects. In his extraordinary, breathless autobiography, he wrote nostalgically of the pony Augureau which he painted about 1911. I saw this picture or one very similar at MacNicol's and still remember the astonishing sunlit effect, the white pony radiantly painted against the light. MacNicol liked to tell the tale of driving down to Suffolk just after the war and (so he said) buying all the paintings in Munnings' studio. Certainly he acquired a lot of his pictures and must have made a handsome sum selling them to his clientele around the West of Scotland.

About this time there was a major exhibition of Van Gogh in Glasgow. Before the war at Oxford I had never been wholly enthusiastic about the Van Gogh prints that seemed obligatory on the walls of many undergraduates' rooms. Although I must have seen quite a few originals in galleries the Glasgow show was a revelation. Here was the whole development from the dark brooding early work to the dazzling intensity of the Arles pictures. I read widely about the lives and methods of favourite artists like Constable, Turner and the Impressionists, but if I were the castaway on a desert island the art-book I would take would be Delacroix's *Journal*. How the man lives through its pages! Here is everything about how a great artist thought, worked, lived and loved. Delacroix's dilemmas are as relevant to any genuine artist today as they were in his lifetime. Like his special hero, Rubens, he did many dramatic paintings of large animals — lions and tigers and of course horses. He was forever observing with a painter's eye — here is a typical entry in the journal (translated from the French): 'Coming home in the omnibus [1847!] I watched the effects of half-tones on the horses' backs; that is to say on the shiny coats of the bays and blacks. They must be treated like the rest, as a mass, with local colour lying halfway between the sheen and the warm colouring. Over this preparation, a warm glaze should be enough to show the change in plane for the parts in shadow, with reflected lights. Then, on the parts that project into this half-tone colour, the highlights can be marked with bright cold tones. This was very remarkable in the

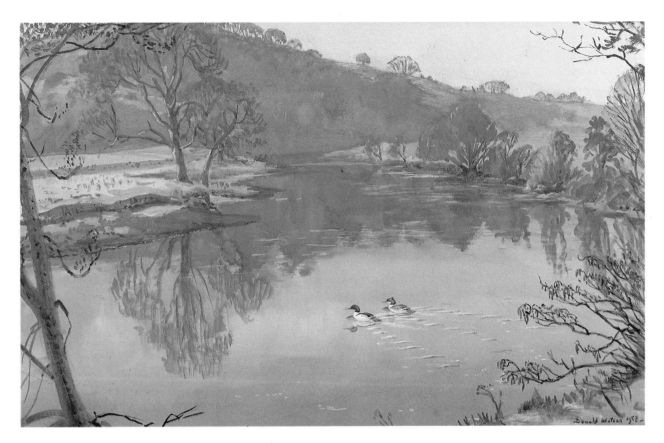

Goosanders, River Ken, 1958

bay horse.' Delacroix's mind ranged back and forth between nature, art and music. Here he is on the song of the nightingale: 'If it were possible to convey this song to the mind through the medium of the eyes, I should compare it to the twinkling of stars seen through the trees on a beautiful night; these notes, so light or vivid or flute-like and full of unbelievable energy coming from so small a throat, seem to me like those fires, now sparkling, now faintly veiled, that are scattered like celestial diamonds over the great vault of the night.'

From 1948 into the 1960s I sent pictures to the major exhibitions in Edinburgh and Glasgow, regularly to the Water Colour Society (RSW) and sometimes to the Glasgow Institute and the Royal Scottish Academy. I had had a few pictures in the RSW's wartime exhibitions. For years my pictures were never rejected by the RSW or the RGI, but the RSA was always more difficult. In time, as new winds blew through the councils of these societies, I felt increasingly out of step in an art-school dominated world and gave up the hassle of sending in work.

Doig Wilson and Wheatley's gallery at 90 George Street, Edinburgh, was the venue of the first of many solo exhibitions in a number of cities. If I had not met old Ronnie Wheatley one day when I called with some pictures for framing I might never have had this stroke of good fortune. 'Wheatley's' as we always knew it was an old family business of picture dealers, also famous for craftsmanship in framing, gilding and restoring. The premises were extensive and included a fine big gallery which normally housed a fascinating mixture of mainly good quality paintings, of all sorts excepting the avant-garde. There might be pictures by Allan Ramsay, Raeburn or David Farquharson, perhaps in for restoration. There were always lovely little pictures by Tom Scott, the unpretentious Border artist, and I remember being

struck by a large landscape by Sir David Murray which I discovered was priced £60 — that seemed a lot of money to me. Crippled with arthritis, Ronnie Wheatley often seemed gruff and disgruntled but he had a delightful boyish smile. He was well known among Edinburgh artists and considered to have a good eye for a picture. If he admired a painting his favourite comment was, 'it has quality'. At the second Edinburgh Festival in 1948 he put on an exhibition of Epstein bronzes which must have been quite a coup. It was very exciting to be offered an exhibition in his gallery. One day when I had been telling him how I lacked confidence that I would ever be a real artist he advised me to go along to the National Gallery and see Stanley Cursiter, then the Director. I admired how Cursiter, an Orcadian, could handle spacious landscapes of sea, cliffs and sky and decided to take some work along and ask his advice. By some extraordinary flair, he knew exactly how to lift my confidence, told me to have no misgivings about 'just painting things as I saw them' and in a quick tour of the gallery gave me an unforgettable lesson on how Raeburn painted the edges of his sitters' heads. That hour with Stanley Cursiter did more to make me believe in myself as an artist than any other I have ever spent.

One day I met an Italian called Mr Luigi. He told me that in his house on the outskirts of Edinburgh he had a collection of live British birds, and perhaps I would like to see them and make some sketches or paintings from them. I went along out of curiosity and was astounded to find in quite a small room an extraordinary variety of birds, including many insectivorous species in cages of various sizes. It was a long time ago and I cannot remember much detail, but there were long-tailed tits, snipe and a dunlin or two, which I quickly sketched, apparently happily probing a miniature saltmarsh provided for them. No doubt he was catching wild birds, but perhaps in those days he was not doing anything illegal and I clearly remember that the captives looked in high condition.

When I was based in Edinburgh I often took a bus down the coast to Aberlady, Gullane or Tyninghame for long days painting, sketching and birdwatching. Sometimes I headed inland to the Pentlands when the first part of the journey was on a slow tram, or took a stopping train from the old Caledonian Station to Cobbinshaw Reservoir. Winter and early spring were my favourite seasons for outdoor painting, wearing layers of clothing, and brushes could be managed even with woolly gloves, though it was frustrating when watercolours froze on the paper. Passers-by always stop for a look at an artist at work; some want to watch or talk — they can be an occupational hazard but I was not much bothered by them in winter. Before starting out papers had to be stretched on boards, usually two or three as many a beginning might be abandoned. I carried them in a groundsheet against the rain. Many a time after walking round Aberlady Bay loaded with boards, rucksack, easel and painting stool it was hard to find enough shelter from the wind to use an easel. I usually took at least one large board, about 30in × 20in. Staying in one spot for hours results in wonderful chance encounters with wildlife. Once on the East Lothian shore a pair of garganey pitched in a seapool a few yards away, unaware of my presence. Another time I found a pectoral sandpiper, the first record of this American wader in the Forth area.

My wanderings at this time took me further afield, to the Orwell estuary in Suffolk where brown-sailed Thames barges still passed daily beyond mud flats rich in wildfowl and to the bare clean coast of Northumberland, where I painted the trim fishing village of Craster and the fairy-tale skyline of Dunstanburgh Castle sprouting from its cliff. In June or July I was

often back on the Isle of May working among the seabird colonies. One September Eric asked me to join him on a trip to Harris, my first experience of the Outer Isles. In spite of almost incessant rain some painting was done at magical Luskentyre, with its green sea and misty offshore islands, and on wild rock-strewn moorlands smouldering with autumn colours. In Perthshire I stayed with Edwin Ker whom I came to call 'The Hermit of Balquhidder'. A Glasgow man, he was a nephew of an Oxford professor of poetry, W. P. Ker, and himself an astringent mixture of poet, intellectual, mountaineer and yachtsman. In his later years he lived alone for a long period in a hut beneath a towering mountain which he climbed almost daily, at the run, until he was about 60. He was good to me but I felt I did not measure up to his requirement of being 'first rate', certainly not on the one occasion he took me sailing round Arran and Bute. On his mountain, Meall an t-Seallaidh, known to him as 'Sally', I painted outdoors in bitter March weather. It was thrilling to be among the ptarmigan in their grey and white spring plumage as they ran belching among huge, lichen-encrusted boulders. One day I hauled a large painting board to the top of the mountain. The solitude was as palpable as the cold, and I worked for hours at a big landscape with that wonderful snowy peak of Schiehallion on the northern skyline, the only sounds a raven's croak or the mournful piping of golden plover. Afterwards I drank too much of E.K.'s whisky. He had an old-fashioned formality and only the greatly honoured were permitted to address him as Edwin. One of the books he encouraged me to read was George Orwell's *1984*, then newly published. Quite an antidote to painting bird pictures you might say.

In April 1949 I showed over 100 pictures in my exhibition at Wheatley's gallery in Edinburgh. It was called 'Scottish Birds and Landscapes' and was successful enough for me to continue what I had begun.

5

Landscape and Bird Painting in Galloway and the Western Isles

A couple of pictures in my Edinburgh exhibition had been bought by Ian MacNicol, whose gallery was in West George Street, Glasgow. Shortly before Joan and I were married in June 1950 we went to see him. MacNicol was a tough businessman, but I always found it difficult to take him completely seriously because he looked so much like Dave Willis, the popular Scots comedian. He was small and dapper with bright eyes that always seemed to be half-smiling, possibly a little mockingly. His eyes grew wider when I told him we planned to go to the Outer Isles on a working honeymoon and please would he put on an exhibition of the resulting pictures in the autumn. He took to Joan and agreed to my request with a rather incredulous look. Archie Bryson gave us a cheque for a wedding present on condition that we spent it on the comfort of a hotel for a night or two, but the unforgettable part of our three month stay began when we pitched our tent on the machair at the Griminish road-end on Benbecula within sound of the Atlantic waves. We had another even smaller tent for stores. It was the beginning of July when the flowering of the machair was reaching its peak. Lapwings and ringed plovers were everywhere with their chicks, dunlins and red-necked phalaropes close by. Soon time seemed as meaningless as it obviously did to our crofter neighbours. Our encampment became a local landmark, and the bus driver cheerfully drove out on the machair to drop our occasional mail. J. soon became practised at the three mile walk to the shop at Creagorry where we sometimes went for a bath at the hotel.

Paintings quickly multiplied, often interrupted by a dash for the tent as rain or hail swept in from the west. It was an exceptionally wet summer even for the Outer Isles. Some nights we nearly lost the tent. When it was dry enough for the crofter to make a little hay he strolled over to watch me painting a picture of the sea which he criticised with a practical eye. We made a good friend in Donald John Mackinnon, the keeper at Griminish, and after a while he allowed us the use of a partially roofed old croft across the road. We joined Donald John for a long hike over the rough moorland to the eastern coast, searching for divers and other birds.

Now and again a hen harrier came across from the heather country to hunt a field of oats or around the bird-rich machair lochs, where families of greylag geese gathered. In August and September hours passed watching and drawing migrant waders, black-tailed godwits, ruffs and wood sandpipers inland, sanderlings, turnstones and greenshanks on the shore minutes from the tent. On clear evenings the Monach Islands lighthouse was a black pencil against the after sunset sky.

At last, one September day, we looked back sadly on the bare brown patches of ground where the tents had been and climbed into the bus for Lochboisdale.

In October we returned to Glasgow, staying with Joan's uncle and aunt — we had not yet

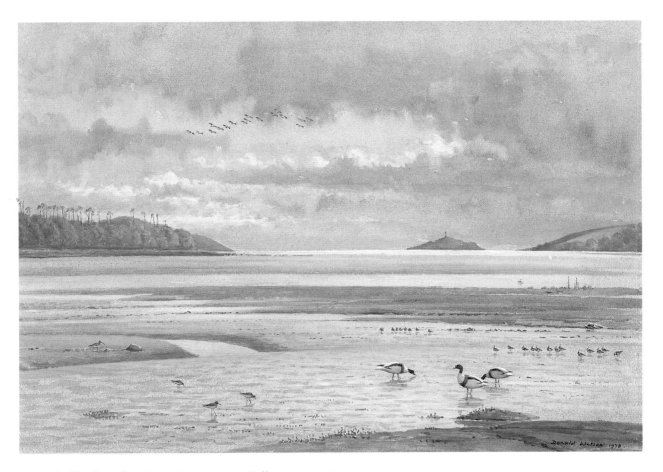

Shelduck and waders, Dee estuary, Galloway, 1978

got a home of our own — and hung the exhibition, which was to run for a month. The attention of passers-by on the busy street was attracted by a big advertising banner. My pictures were certainly not great art but most were sold. We spent that winter in Galloway, on the Solway coast, at first in a bungalow kindly lent by a friend who was abroad, and later in a wooden chalet which was flimsy and cold and could only be reached through a field with an Ayrshire bull in it. The local GP, Dr Milne-Redhead, was an expert botanist and enjoyed looking for plants on his way to visit us, when he confirmed that Joan was pregnant. We had no car and travelled on bus or train in search of a more permanent home. In March we were in Perthshire where I had a commission for a painting and we looked at one or two houses for sale. The landscape around Doune, with its vistas of snow-covered mountains, tempted us but Galloway had a more intimate appeal. There was a house on the market at Dalry in the Glenkens and the owner, a rather eccentric doctor, who was emigrating to Australia, was becoming desperate to sell. I think he really did drop the price because I was able to talk affectionately about his birthplace, the Dumfriesshire village of Tynron, which I knew so well. The house was much too big and rambling but at the back it had an irresistible garden, a slope with a grove of aspens and a mass of daffodils, and an outlook to the Rhinns of Kells, a range of mountains with the most beautiful profile in southern Scotland. I had not had a home in the country since I was a child. Selfishly I also had my eyes on the doctor's bedroom with a north light for a studio. Dr Carmichael belonged to a largely vanished breed of country doctors. His patients either loved him, even naming their sons after him, or hated him for his rough,

hard-drinking ways. Parents whose unmarried daughter was found to be pregnant hardly appreciated being told, 'I can tell you what's wrong with *her*. She's been out with the tups!'

Even today Galloway is less widely known than much of Scotland. In England it is often confused with Galway. Most visitors from the south come by turning west from Dumfries, but before the days of motorways it retained a certain remoteness, still not quite lost. Some 85 miles separate Dumfries from the Mull of Galloway, the cliff-bound headland which is the south-western extremity of Scotland. Between lies a remarkably varied landscape covering the old counties of Kirkcudbright (properly The Stewartry) and Wigtown (known as the Shire). Broadly, much of the south and far west is good farmland, especially rich in dairy cattle, but everywhere there are enclaves of wilder hill country. Inland Wigtownshire, a region of peaty flows and rather featureless moorland, differs greatly from the high rugged uplands of The Stewartry, which even now retains a quality of wilderness not found elsewhere in southern Scotland. In the early 1950s most of these uplands were only accessible by dedicated hill-walking, but since then plantations of conifers have spread into the remotest parts, and there is a network of forestry roads, although these do not generally give public access for vehicles. When we settled in our hill village of Dalry in 1951 the mountains and their wildlife were still mysterious to me, though not entirely unknown, as I had walked the Merrick area with Arthur Duncan in 1948. By Highland standards the Galloway mountains are modest, not a Munro among them, and the biggest, the Merrick, is only 2770 feet. In late years the old name, St John's Town of Dalry, has become popular again and has been used on road signs. However, the post mistress says that its use on mail has not lessened the number of letters wrongly sent to the larger town of Dalry in Ayrshire. A historical link with the Knights of St John has never been fully explained to me, but the name Dalry is said to mean 'king's field'. Certainly the village was at times a stopping place for royal pilgrims travelling between Edinburgh and St Ninian's shrine at Whithorn. The Rev. C. H. Dick, in *Highways and Byways in Galloway and Carrick* (Carrick, once part of Galloway, is the most southerly part of Ayrshire), saved his superlatives for the attractions of Dalry as a village and for its setting. Seventy years on who could disagree with him?

There are still quite a few people who remember the River Ken above Dalry before much of its natural course disappeared beneath the lochs created by the hydro-electric scheme in 1935–6. These have so long been accepted and even admired that it is worth recalling that the Rev. Dick, in the 1938 edition of his book, wrote with anguish about what seemed to be the rape of a beautiful river. I never saw the gorge of Earlstoun with 'its light grey crags reflected in the long linn where the water settled after the plunge', nor the island with its clump of pine trees before they disappeared beneath the waters of Earlstoun Loch, but the likeness of the island and the swirling river, with a leaping salmon in the foreground, is perpetuated in one of Ernest Briggs' watercolours in his delightful *Angling and Art in Scotland*, published in 1908.

I shall always remember the unexpected pleasure of finding a large exhibition of Briggs' pictures in a London gallery in 1966. Most of the subjects were Galloway landscapes obviously painted within a few miles of Dalry. They were remarkable descriptive pictures celebrating Edwardian Galloway and there was even one (also reproduced in the book) of the village street which must have been painted a few yards down from our house.

The summer of 1951 was an eventful time for us. In the weeks before our first daughter was born there was a mad rush to put together another exhibition, this time as part of the Festival

of Britain celebrations in Dumfries. Financial necessity and over-confidence following the popularity of the Glasgow show were blinding me to the pitfalls which await the free-lance artist. When Mr Farries (who ran the best bookshop in the south of Scotland) suggested the exhibition and booked St John's Church Hall it was clearly a chance not to be missed, but it was really too soon. I had done a fair amount of work on the Solway through the winter, but I needed much more time for a long look at Galloway. So it was really cheeky to call myself a Galloway artist at this stage and I sensed that one or two of the old Kirkcudbright artists felt this, though E. A. Taylor — then perhaps the doyen of this group — gave kindly encouragement. Although the exhibition was by no means a failure I had to learn that a Church Hall in Dumfries was a very different venue from an established gallery in a city centre. One lady who came in told me that she never had pictures in her house because they gathered so much dust. An art dealer suggested that I should paint pictures of wildfowl in landscapes, which he would take to the United States. We were short of money and it did not take much to persuade me to give this scheme a try, though I drew the line when he wanted actual shooting scenes. It took several years to realise that this was a wrong direction; it was not just that I was not particularly good at drawing ducks in flight — it should have been obvious straight away that the pressure to produce highly photographic pot-boilers would be intolerable. For the most part I just continued to paint in my own way, but a few pictures were sold to American dealers specialising in 'sporting art'. Now and again a welcome, if small, cheque arrived. It is difficult after so many years to remember how important all this seemed at the time.

Most fine days I was outdoors. Spring was very late that year and the hills were well flecked with snow late into May. The garden was productive, having been well manured and tended by Dr Carmichael. We were innocent of how much work it would take to keep it like that! The entire slope was golden with daffodils and one day I recorded it in a large painting. Over the dyke at the end of the garden, where there had been a nine-hole golf course, lapwings and curlews were nesting and down in the boggy patch by the burn there were snipe and a pair or two of redshank. The close proximity of these birds of the open hill was for me one of the most immediate and lasting joys of living in the village. On soft spring nights when the big wych-elm, laden with flowers, was etched in black against the sky, snipe came bleating over the garden and a woodcock crossed on its roding patrol. The substance of many pictures lay in or around the garden. In the early years, too, the rasping cry of the corncrake could be heard from the house. The farmer at the head of the village told me of one with a brood of chicks at his front door and I sketched it standing lankily on top of a dyke, with the downy black mites trying to find a way between the stones. When the dandelions began to seed below the back windows, finches gathered — goldfinches, greenfinches, redpolls, siskins and linnets were sometimes all there together, drawable from the house.

Outdoor painting days were at first confined to local spots; I either walked or cycled with my equipment, but in 1952 we acquired an old Morris in which we were able to explore much more of Galloway. The shores of the Scottish Solway were not then peppered with caravan sites as they are today. In late September we were down at the Mull of Galloway for a week with our 16-month-old daughter. In cool autumn weather we took picnic lunches to East or West Tarbet according to wind direction, where in the low sunlight the slabby cliffs took on a rich variety of warm colours. Across the sea to the south-east lay the mountainous shape of the

Isle of Man, westward the coasts of Ireland and Kintyre. I seized a few opportunities to set up my easel and paint the landscape in sheltered spots — one of the best being below the steep ivy clad cliff at West Tarbet, where we had a sense of seclusion. This little trip to the Mull was one of many occasions when ornithology and painting pulled in different directions. There were many signs that birds were migrating in large numbers. All one day flocks of skylarks flew south, a movement involving thousands of birds. Large wheatears, presumed to be from Greenland, bounced up and down from the roadside dykes — one smaller one with an almost white head may have been a much rarer wheatear. Whins and bracken slopes were alive with stonechats, robins and goldcrests, and once I put up a ring ouzel, while on 2 October we were astonished to see a nightjar hawking up and down Maryport farm road in the middle of the day.

Down at Lagvag Point, the tip of land beyond the lighthouse, we watched kittiwakes and gannets over a great expanse of turbulent sea. The gannets came from the Big Scare, visible to the east far out in Luce Bay, where the Rev. McWilliam had found the first nest, as I have described.

This was long before the days of Bed and Breakfast signs. We just enquired for accommodation at roadside houses. An old couple, the Moffats, were pleased to have us, especially the baby, and making a four at whist each night was small penance for us. We drove back to Stranraer and found Loch Ryan mirror calm in sparkling light. It was too late to paint that day so we found somewhere to stay another night. Next day the wind blew down the loch and the wigeon flock bobbed on grey waves. In those days painting outdoors was so much a routine that I was not deterred by the kind of boisterous weather which was the norm for autumn in Galloway. It must have been much more trying for Joan and Pamela, waiting for me to pack up so that we could complete our journey home. The A75 road, now a Euroroute busy with container traffic, was then one of the loneliest roads in the south of Scotland and I doubt if we met another car as we crossed the moors beyond Newton Stewart to Dalry.

In the 1950s I spent countless hours in winter drawing, painting and watching down the beautiful valley of the Ken. The variety and accessibility of the large numbers of wildfowl were a great attraction, none more so than the flock of about 500 Greenland white-fronted geese which arrived in October and stayed until late April. I began to acquire a special knowledge of them, recording numbers, distribution and behaviour. I also spent many hours making drawings of them in sketchbooks. Geese are difficult birds to draw convincingly — Peter Scott is one of the very few bird artists to get them right. For a long time I tended to make their necks too thin and swan-like. Painting a flock of geese in flight is a very special problem. They so easily become a cliché unless the artist can convey much more than the sum of the individual birds. Detail must be sacrificed to the unison of the flock and a picture should evoke their massed voices too, as the artist, R. B. Talbot Kelly, said.

Throughout the 1950s I had one-man exhibitions in several cities. Pictures usually sold well (at modest prices) but a show in Bristol was a flop. By 1956 we had four young children and for many years we had memorable summer expeditions to islands where I combined working with holidays. Tiree and Coll were both exciting for birds and seascapes, with incomparable beaches for the family. In those days an island cottage cost £5 a week — on Tiree we had one which was barely habitable even in summer and had a scare when we found the children dancing on top of an unsafe well. Tiree was the only nesting place of red-necked phalaropes in

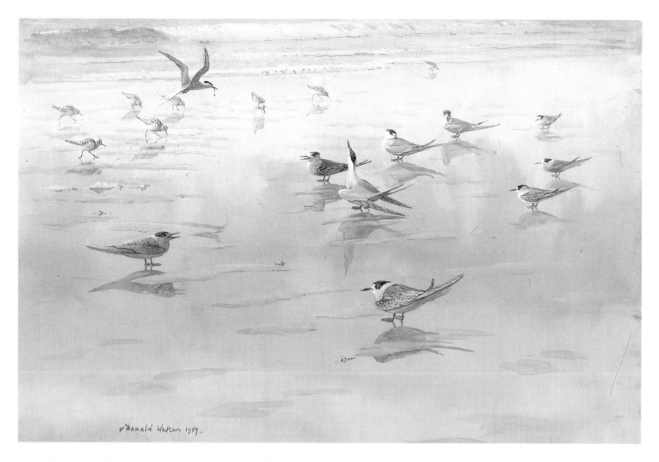

Arctic and little terns with sanderlings, Tiree, 1957

the Inner Hebrides and I counted at least six adults and one chick. As cattle liked to gather along the margin of their nesting loch, nests and chicks were in danger of being trampled. Among the pebbles and shell sand at the head of Balephuil Bay little terns and ringed plovers bred, and out on the wet sand, imitating a seal, I crawled close to the running sanderlings. Over at Sandaig we made friends with Henry Y. Alison, the pawky old Glasgow artist, who summered in his studio by the sea. He encouraged me to do more oil-painting, which I was beginning to enjoy. What a view he had from his studio, all the way up to the Small Isles, Rhum and Skye! Coll was a wilder and more hilly island. When we were there, in 1964, there was no pier and J.'s 75-year-old mother had some hair-raising moments being transferred from a little boat to the island steamer in a heaving sea. With her and my brother Eric we made a party of eight in the old school at Arinagour. I recall the gabbling of red-throated divers as they came in from the sea to their nesting lochans and how I enjoyed the fine colony of Arctic skuas up on the moor. In other summers we were on Islay, Skye and the Irish Aran Islands.

In 1958 I spent three weeks as temporary warden on St Kilda. The journey was by landing craft from Stranraer and took nearly a week as a result of a force 10 gale, which drove us back to shelter at Lochboisdale where the ship was damaged on the rocks. When we finally reached St Kilda I had not got my land legs before being led away by Joe Eggeling, to help mist-net a migrant wood sandpiper. Later there were unforgettable nights among shearwaters and petrels at Carn Mhor, including one when my companion and I were lost for hours in the

cloud which came down over the cliff tops. I lived with the RAF sergeants who were doing construction work. The only problem was getting back in time for a meal when I was far away painting on the cliffs in the long light of a June evening; sometimes I went hungry. A fortnight on the Isle of May with the family in July was quite a contrast. Living in the old lighthouse was voted fun and a pocket handkerchief of sand and shells, with an old boat to climb over, almost as good as the beaches of Tiree. Although there was not much bird migration in July I caught and ringed a subalpine warbler, a pathetic stray which should have been in southern Europe. A sketchbook was almost filled with drawings of turnstones and purple sandpipers. In the golden light of a summer evening they seemed as integral to the multi-coloured rocks as the encrusting barnacles and lichens. As Keith Brockie also discovered years later the Isle of May is a marvellous open-air studio for a nature artist.

Many people will remember 1959 as the year of the ospreys, when George Waterston opened the hide at Loch Garten to the public. It was a great experience, but for me this was above all the summer of the hen harrier. For years I had hoped to find a pair nesting in Galloway but I was not successful until 1959. These elegant but sadly persecuted hawks cast their spell on me that exceptionally fine summer and it has not faded. They turned me into a more specialised kind of birdwatcher and did much to freshen my eye as an artist for the hill country and its wildlife. I have tried to explain the fascination I felt for hen harriers in another book, *The Hen Harrier* (Poyser, 1977).

Over the last 25–30 years I have done an increasing amount of book illustration, by no means all of which has involved birds. I began to discover that it was possible to convey some of the feel and atmosphere of landscape without using colour at all. I was fortunate in being asked by Trevor Poyser to illustrate quite a few of the fine bird books he has published. The greater part of my illustration work had to be done in one or other black and white medium. Some of the earliest scraperboard drawings I did were for *The Countryman* and I have continued to illustrate its articles from time to time. The challenge of working to a deadline and trying to interpret written descriptions by other people can be stimulating but difficult. I have also continued to paint pictures as much as ever.

In this book I have the opportunity to bring together my own text and paintings. Since Galloway has been my home and working ground for so long it provides the locale for most of what follows. I doubt if there are many better places for a naturalist or artist. I have taken a selection from one year's experience as my platform, but have often referred back to times past. If it seems odd to start a diary in February I have done so because January unquestionably belongs to winter and sometimes in the first days of February spring suddenly becomes believable.

DIARY

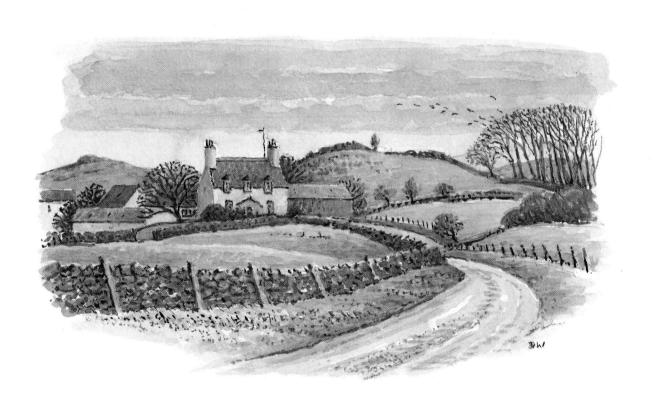

8 February 1987 *Dalry*

Opening the back door this morning I at once heard the wandering voice of a mistle thrush. On wild windy days the song ebbs and flows with the gusts. On this almost windless day it sounded flat and continuous, quite unlike the mellow phrasing of a blackbird. Yet it is always a welcome sound, as prophetic of approaching spring as any. By midday a gentle sunlight broke through the clouds and I suddenly realised that it was becoming one of those rare magical days which do not come every year in early February. An afternoon walk above the village confirmed this. The air was indeed mild and spring-like. Eastward, above Bogue Moor, patches of sky were clear bright blue from the sun in the west, further south the blue was more smoky. The light cloud tops were nowhere sharply defined — it was a day of soft lights. Only towards evening a cloud bank settled along the ridge of the Kells range, a sure sign of rain before dawn, and momentarily the dun-coloured mass of Bogue Moor stood out pale in sunlight against a darker cloud base.

We walked up the track that is now signposted as part of the Southern Upland Way. Up here the rough pasture, criss-crossed by green-grey stone-dykes, is a land of knowes and hollows, quintessential Galloway. Sedimentary rock is never far below the surface and forms miniature cliffs on the bigger knowes. The rock is grey, the grass somewhere between a neutral green and yellowish ochre, while down in the hollows lie sodden mats of brown rushes. As always moles had been active; even the recent severe frosts did not appear to deter them. This landscape has hardly changed in the 36 years I have known it, there has been no intensive 'improvement' of the hill pasture and presumably many damp flushes are not worth draining. Down towards the narrow switchback road to Moniaive the course of a small burn is marked by more extensive rushes — this would be called a 'lane' here. These patches of undrained land are often hunted by barn owls and sometimes by hen harriers. If we had squelched our way through it all we would probably have raised a snipe, or just possibly even a jack snipe.

Up on the knowes black-faced sheep stood and peered, nervous and fierce-looking at the same time. Shepherds say that the variety of their facial markings is infinite and every animal is recognisable. There are usually one or two brown hares up here. When we first came rabbit trappers had quite a local industry. Since the first great impact of myxomatosis in the early 1950s rabbit numbers have fluctuated widely, but they have never regained their universal abundance. At the bottom of Bogue Moor a long straggle of hardwood has long been a haunt of badgers, which in recent years have locally been on the increase. Seen from a distance in this soft February light the mass of the trees look pale brown-grey reminiscent of a Cotman watercolour, except where clumps of birches stand out, as if stained with crimson dye. Scanning the uneven skyline I expected to pick up a soaring buzzard or hovering kestrel but saw neither. The silhouettes made by the hill cattle might have been cut out of the sky. There

were slivers of snow on the high slopes of Cairnsmore of Carsphairn and its satellite Beninner, the granite mountains which dominate the northern skyline of Galloway.

The Southern Upland Way turns north across the hills from the dyke we were following today. We were only out for an afternoon's stroll, so we came back by Tower farm, examining its attendant scatter of trees, oak, ash, wych-elm and hawthorns, for birds. They were strangely lifeless. This winter most of the fieldfares and redwings moved on in November; indeed I cannot remember a winter when I have seen so little of them; the haws have been very patchy with many bushes bare. I wanted to do a circuit of Moss Roddock, the little loch which is so close to the village that the trumpeting of whooper swans when they are there is easily heard from our garden. It has a round island topped by a clump of old Scots pines with an understorey of rhododendrons. The walk round revealed more tufted duck and pochard than I would have guessed from a quick glance. They all remained on the water while we watched them from close range. Pochard are rather mysterious ducks; why are there nearly always far more drakes than ducks on British waters? Here in Galloway a few of the lowland lochs — like Carlingwark, the town loch of Castle Douglas — carry quite high numbers in winter, while small groups, like those on Moss Roddock today, are widespread on hill lochs. In winter pochard and tufted duck commonly associate, but while tufted ducks have bred in Galloway since last century pochard have always been rare breeders. It was a disappointment to see no goosanders. A pair or several birds are often a conspicuous feature of Moss Roddock at this time of year. At the marshy end of the loch a heron rose and we may have overlooked a moorhen, but this is no longer quite the abundant bird it used to be before the spread of feral mink. Although much that is said about the depredations of mink is speculation, there has been increasing evidence in recent years that in Galloway they are significant predators of waterside birds, their nests and young especially.

Just as we began to walk down the hill to the village I heard the calls of pink-footed geese from the sky behind us. A loose skein of about 60 seemed to be hurrying north and were quickly out of sight. They were never near and but for their calls specific identification might not have been possible — as it was there could have been a few greylags among them, though I could not detect greylag voices. Pinkfeet are mostly hard-weather visitors to the upper part of the Ken valley and my guess is that this flock came south from central Scotland in last month's snow and are now heading back in this mild spell. If the weather stays mild the first spring flocks of lapwings and oystercatchers will very soon be up on this hill ground. Today one solitary lapwing briefly saluted the high pasture but flew off without landing.

I had been struck by the absence of small birds all afternoon, but they were apparently all in or around the village. The plump black shapes clustered on garden trees were all starlings, ready to make their roosting flight. We are on the look-out for waxwings as a flock has lately been reported in Ayr. Perched in silhouette or even more in flight they can look quite starling-like. I fear it is already too late in the winter now for much hope of seeing any — not since the 1970s have we enjoyed a good waxwing winter.

13 February Dalry — Loch Ryan

During the recent mild spell rooks have been more active and vocal at their nests. Until 1985 they had only been casual visitors to the garden, but that autumn it was plain that nesting was

Opposite: Waxwings, Dumfriesshire, 1946

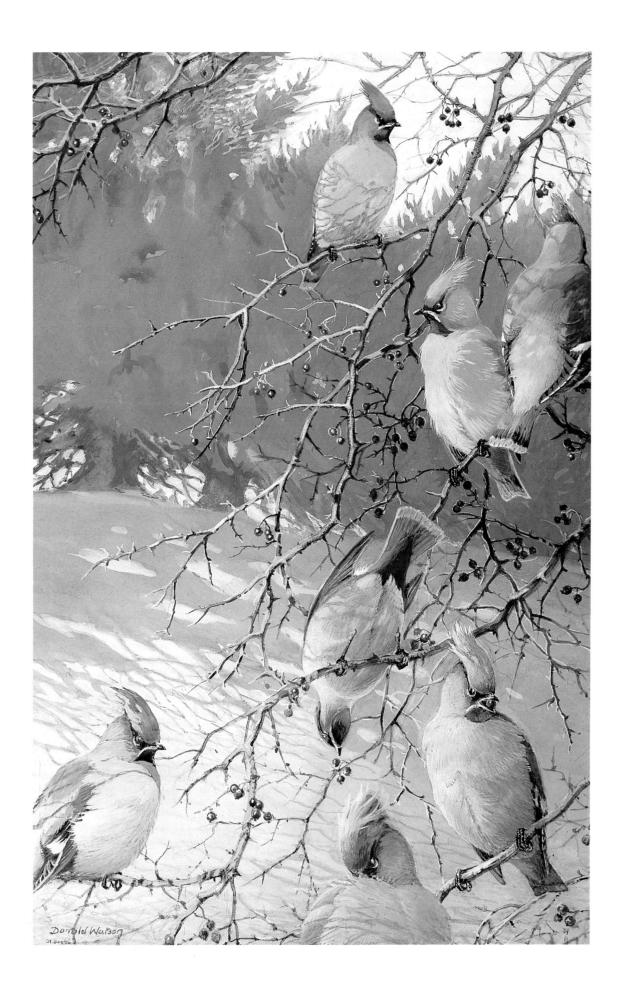

in prospect in the tallest Scots pine that stands just 10 yards from the front door and towers over the pavement of the village main street. In 1986 six nests were built, all very high so that it was impossible to say how many were completed. Apart from a few wry comments on the litter of sticks dropped on the pavement our neighbours did not complain, though most called them 'craws'. In April children were dismayed when they found one dying after it had inexplicably plummeted out of a tree and a week later I found another dead. At first I thought they had been shot but more likely they had picked up poison. Although only two nests produced young we again have six pairs this year. At this date they are still spending the nights at a winter roost and fly to the rookery very early in the morning. By about 9.30 am they have dispersed to feed in the fields. The lack of sticks on the pavement shows that little building is being done at present. Later in the day they are at their nests from time to time.

Cold weather has returned. The east wind was icy as we set out for Stranraer and Loch Ryan, Galloway's uncharacteristic sea loch. Beyond New Galloway, as always I scanned the roadside fence wire for stonechats, but as expected there were none. On the most favoured stretch, opposite Darsalloch, there were two or three pairs in 1978 but since then very few inland stonechats have survived an increased number of spells of severe winter conditions. On the south side of the road here well-grown conifer plantations — Sitka spruce with patches of larch — clothe the hill down to the Knocknairling burn. A few years ago when the trees were small and had not extinguished a rich growth of heather and bog myrtle, stonechats benefited from them. There certainly still appears to be sufficient good stonechat ground on the unplanted north side of the road with its riotous bog myrtle. That they lived here many decades before modern afforestation began I learned from a diarist of Edwardian times.

Approaching Clatteringshaws, between tall straight-edged Sitka plantations on both sides of the road we were suddenly plunged into sunless winter, every tussock along the broad verges still white with last night's frost. Summer tourists would be unaware of how even on bright days in winter the eerily silent plantations can change stretches of this road into a frost-bound tunnel. The same effect applies, even more, to the rides through the older forests. We came out into sunshine again where a big swathe of trees had been clear-felled.

We made a short stop at Clatteringshaws Loch. On a fine winter's day such as this the artificiality of this water — created for hydro-electric power — could be forgotten. Northward Millyea, well-flecked with snow, was lit by peachy sunlight, the loch almost entirely covered by leaden grey ice, with one beautiful serpentine of calm open water reflecting a little of the warm colour of the distant mountain slopes. The few duck usually to be seen had probably left for ice-free water, the goldeneye very likely feeding on the Black Water of Dee, where they are sometimes plentiful.

A car had stopped opposite the Forestry Commission's deer range, the occupants watching the small herd of enclosed red deer. In summer these are a strong tourist attraction, though a brief view further on of two wild stags standing alert before sliding into the darkness of a plantation was far more arresting. Two summers ago Frank the ranger had a week-old male calf at his house, destined for a protected life on the range. At that age deer calves are exquisite little animals with their dappled backs, neatly patterned heads and dark liquid eyes.

Along at the goat park, an even more popular tourist attraction, one of our few surviving pairs of hill-nesting ravens had built up their nest at a traditional site in the black recess beneath an overhang of rock. ('A smasher of a nest', commented an enthusiastic friend later.)

Last week when we were walking below another crag shared by ravens and peregrines both had been on view, the almost white breast of a peregrine shining in the evening sunlight. While we were watching that pair of ravens performing a close-circling nuptial flight, a third ventured near and was driven off. The circling pair made a rhythmical throbbing with their slow wing beats, very audible from far below.

As so often when the Stewartry hill country holds the snow we came down into faintly green fields, with no trace of snow, as we approached Newton Stewart. The huge spread of conifer afforestation through so much of upland Wigtownshire is to some extent belied by the limited view obtained travelling the direct route to Stranraer, along the A75 Euroroute. Along circuitous minor roads the extent of the plantations, increasing every year, is much more apparent.

There is still some truth in what Crocket implied at the beginning of the century, that the small towns of Galloway, divided by tracts of thinly populated country, make up sharply independent communities. Stranraer is almost like an island town, bustling but dominated by its status as a port for the Irish ferries. We headed for the old sea-plane base at Wig Bay, arguably the most productive bird site on Loch Ryan. It needs to be, to justify the mileage we have to cover to reach it. It is in no way a beautiful spot, sadly litter-strewn, like almost every part of our coastline in the 1980s; but the outlook across the loch to the long arm of low hills up to Glen App was particularly delightful today, distant bracken salmon-coloured, merging to pastel green on the lower grassy slopes. The wildness of the moorland country beyond would not be suspected from here. Close at hand, along the madder-black wrack of seaweed a flock of small finches rose in airy dancing flight, perhaps 50 twites. Every winter they are to be found here. Today the light was perfect and every detail could be seen as they settled to feed again. Drab they may be, but in this light they look very distinctively bright buff against the dark weed. Some are losing the yellow colour which their bills only have in winter and as they rise again, disturbed by passers-by, a flash of pink shows above the tail. Here in Galloway twites have a limited breeding distribution, mainly near western coasts, but flocks can be found on several estuaries or in fields near the shore during the winter — perhaps these birds are at least partly migrants from further north and west in the Highlands and Islands.

Loch Ryan was calm as a millpond and the engine throb from a ferry boat nosing towards Cairn Ryan was clearly audible across the water. The stretch between Wig Bay and the hard where an increasing number of yachts are drawn up is well-known to birdwatchers as a winter haunt of uncommon grebes. There have been counts of 15 or more of the small black-necked grebe in Loch Ryan. In fact, as is shown in Valerie Thom's *Birds in Scotland*, this is the only Scottish site where appreciable numbers of black-necked grebes spend the winter. Unfortunately there have been fewer recently than in earlier years. It is possible that these birds come from the very small Scottish breeding population. This, however, was not a good day for seeing grebes, perhaps in the calm conditions they were widely dispersed. Certainly, some of my best views have been on days when the wind was whipping up the waves and it was hard to hold binoculars steady. One stocky-necked, larger bird, well off shore, appeared to be a red-necked grebe, which is the rarest species here. As the tide receded to uncover a spit of pebble-dashed mud, immaculate wigeon came ashore, with shelduck and mallard among them. On the glassy water mergansers were romping about and one drake flew close past us looking taut, slim and beautifully patterned. Pairs of eiders and little groups of goldeneye were well

scattered all the way between Stranraer and Wig Bay. A black guillemot was diving off the boat marina, a stumpy, low-slung black shape with splashes of bold white on its wings, for the breeding plumage is complete even earlier than this.

While watching a mixture of the common waders along the shore I noticed quite a flock of rock pipits and was reminded how much the colours of birds vary according to their background. Against the dark reddish tide wrack the pale shapes of rock pipits have a distinctly olive-green tinge. Often they look dark, rather sooty brown, when seen on bright lichen-spattered rocks.

At dusk we were back close to the town of Stranraer, on the straight road which skirts the head of Loch Ryan. If a good spot can be found to park and the tide is neither too high nor too low, this can be one of the finest viewpoints for enjoying wading birds at close range. This evening the tide was far out, bird shapes were mostly silhouettes — a scene to be savoured rather than examined in detail. Gulls had gathered to roost in thousands, wigeon feeding in many hundreds, a long line of lapwings hunched in sleep. Among a subdued medley of bird calls, the lovely bubbling song of a curlew rose above all others. From the dark gravelly foreground the bay receded in ever lighter horizontals until mud and water merged almost imperceptibly. We drove homeward under a full yellow moon, with a threat of snow from a great cloud bank in the west.

8 March Dalry

Sometimes just an hour in the countryside makes a memorable little cameo, although nothing remarkable has been seen. So it was by the river this afternoon. Yesterday Louise had come up for the week-end on the train from London, to find Galloway deep in snow and all roads home treacherous. After resigning herself to spending a night in Castle Douglas she was finally rescued by a minibus which nearly turned back at Crossmichael.

As we trudged in wellingtons down the slippery path by the Mote to the River Ken the flat fields of Waterside Farm beyond lay under eight inches of crisp snow. Along the near riverbank the straggle of alders were almost mirror reflected, mazy and purplish in grey water. A subject here for an outdoor painting, if only its tonal subtleties were not so fleeting and there was not the hazard of a sudden head of water from the power station totally changing the aspect of the river. Across the bridge built by the Army for the Southern Upland Way we wandered over partly vegetated shingle, where an oystercatcher lay dead. Its bloody head and a small scatter of plucked feathers suggested an avian predator, possibly a peregrine which is sometimes seen right over the village. I hear there is a first-year peregrine which has found a winter roosting ledge on a church in the middle of Newton Stewart lately. There are often goldfinches on the river bank — last winter as many as 80 one day. Even in late winter they are still able to find seeds in the desiccated heads of knapweed, but at this time of year they might be feeding among the alder fruits. The oystercatcher was not long dead, its stout dagger-like beak still bright orange-vermilion. The first small flocks of oystercatchers had come inland by mid-February. On the 25th a line of 7 were on the ice of Clatteringshaw Loch, making the only hint of spring in the gloom of a wintry dusk.

Along the road to Glenlee I wondered if it was necessary for the hawthorn hedges to be cut so low, greatly reducing their attraction for birds. A mistle thrush flew into the trees by

Waterside farm buildings, its silvery underwings flashing in bounding flight. In the hedge bottoms several blackbirds and song thrushes were foraging vigorously. The song thrushes are mostly not long returned after wintering further south, or possibly on lower ground not so far away.

On a fence-wire between road and river the bodies of 34 moles were strung. It is curious that moudie-killers continue the old ritual of stringing up their victims. Not so long ago a fence beside the main Ayr road at Eriff was festooned with rotting corpses of foxes, but this ceased, probably after objections from passers-by.

The Grennan Holm, a mile or so down the valley, has in late years attracted increasing numbers of the Icelandic greylag geese which are much the most plentiful grey goose locally. They feed in most of the grass fields between Dalry and New Galloway, but this winter is the first they have taken much liking to the Waterside fields. In recent weeks there have been between 1000 and 1300 in this part of the valley. For some years a keeper periodically scared them away from the Grennan fields, but the landowner has told me that he enjoys the spectacle of this flock and as for damage to grass from their grazing he is not worried. The geese are shot sporadically but they are mostly undisturbed now and have become very confiding, often feeding close to the main road. This afternoon we heard them distantly and occasionally glimpsed part of the flock as they lifted and dropped back into a different field, or onto the river. Greylags are my least favourite of the grey geese but undeniably a big flock is a magnificent sight, especially when in flight their silver grey wings contrast against a background of dark winter woods.

At the edge of the field near the tree-lined Coomb burn flood-water had made a yellow-green patch of ice in the snow. Worth a quick sketch with snow-freckled birches as a backdrop.

Looking down from the little bridge on the outlet channel from Glenlee Power Station I was pleased to see a humpy, white-chested dipper on a black tree root at the water's edge, then its mate like a toy boat, flat-backed out in the water. It was not diving deep but actively feeding just below the surface. We were reminded of watching a pair of American dippers behaving in exactly the same way in a clear mountain stream in Yosemite Park; in comparison we thought

the white chest of our own species added so much to its attraction. This could be a pair which nest further up the glen, perhaps at Garroch Mill, where old Bob McMillan used to prop up the nest to save it from collapse. For years he kept a proprietary eye on all the birds' nests around his house.

This will be the third and last season of Juliet Vickery's study of riparian birds on three local rivers — the Fleet, Scaur and Minnoch. There are far more dippers in the Scaur glen on Wenlock Shale in Dumfriesshire than on the Galloway Fleet, much of which flows over granite. Juliet's study is concerned with the effect of acidity on food, breeding density and success of dippers, grey wagtails and common sandpipers. Of these, she finds it is the dippers feeding *in* the water which are most at risk, but we await her full results with great interest. Now that many birds formerly regarded as commonplace in Galloway are evidently declining, more exact information about numbers in the past would be valuable. We took them too much for granted until concern began to be focused on acid rain and the increased acidity found in some rivers with conifer afforestation on the slopes above.

We ended our short afternoon's walk in the dusk light of an evening promising frost. Spring seemed a long way ahead.

14 March Mackilston — Lochinvar

Mackilston Hill looks unremarkable, rising gently to less than 1000 feet, much like many others in the uplands between Dalry and Carsphairn. It must be unusual for anyone but the shepherd to walk over it. I have known it for many years for its breeding curlew, lapwing, golden plover and red grouse, and a few summers ago we discovered a colony of large heath butterflies on the wet moor which fringes its eastern slopes. This was where we started from today, hoping to find that a few golden plover would by now be on their nesting grounds. More than 30 years ago I found my first Galloway golden plovers' nest near here and for long after that it would have been unthinkable that this moorland ground should ever lack them. Now many of their old haunts have disappeared beneath plantations of spruce trees which have irrevocably changed the landscape, vegetation and animal life of so many little hills like Mackilston. Lately the pace of afforestation has so quickened here that it is obvious the future of Mackilston as a hill farm must be in doubt.

With continuing low temperatures snow still lies patchily. At close range the recurrent marvel of early spring colours and textures on moorland was heightened in contrast to the whiteness, making even the pale, papery tussocks of molinia look a richer tawny. Snow was grooved by bent trailing grass, casting shadows as if drawn by a fine brush. I always like to know where the herd of Galloway cattle are before walking out over the hill. It is not a good idea to get between a cow and her calf. Today their square-cut black shapes could be seen far out on the low moor. Most of the sheep were feeding on the drier, snow-free knowes which already carry a faint flush of green. Only the tight clumps of hair moss retained their winter-long green intensity. Climbing, we negotiated many trickling drains, some still ice-solid beneath a surface of melting snow, like a mini-arctic landscape. We saw no golden plover but perhaps the moorland was still too inhospitable for them. They can arrive in early mild weather and then return to valley fields in these conditions. Eight or more lapwings, however, were on their nesting grounds, some possibly paired, but those in high combative flight would

all be cocks. They too might return to join a flock in the valley before dark. Standing boldly erect, with curled crest outlined against the sky, the cock lapwings were extremely eye-catching on rugged, brown heathery ridges. There is no question that lapwing numbers have sadly declined in recent years. How I wish now that I had made careful counts of the colonies of 20 or 30 years ago, many of which have entirely disappeared. It must be 15 years since I saw them nesting on the river flat at the head of the glen and throughout Galloway the higher, marginal lapwing ground has been increasingly deserted. Some of the substantial groups that used to nest on rough pasture close to the village have gone or greatly diminished too, even though the habitat looks unchanged.

Last year I saw the first cock wheatear on 19 March and the weather was hardly more welcoming than now. Perish the thought that when the wheatears do arrive on these hills they will find many of their best territories furrowed by the forestry plough. They are one of the first birds banished by afforestation. Up on the snow-free little plateau, between the Green Hass and the summit, a single meadow pipit darted out of a tussock. A couple of resonant croaks from high above came from a pair of ravens, which ought to have had a clutch of eggs at this date, but their behaviour suggested they had no nesting ties. For many years a pair nested in an old Scots pine in the Craw Wood, a small shelter wood now much wind-blown, low on the southern face of the hill. Both the shepherds I came to know on this farm liked the ravens and were angry when they were sometimes shot by a gamekeeper. In Galloway, unlike many hill regions, there is generally little distrust of ravens as enemies of sheep. Now it is afforestation and improved sheep husbandry with little carrion available that seem to explain the absence of pairs from so many traditional sites. Tree sites, however, have in my time been less common than crag-sites. Two years ago crows built a nest on a roadside telegraph pole at Mackilston, but the ravens' nests on electricity pylons in 1969, a few miles north of here, were much more exceptional.

Walking downhill towards the Black Water we were led on a meandering course among dark pools of snowmelt. There are many memorable place-names in Galloway but the names of burns generally show the utmost economy of description. The Black Water, looking sharp metallic blue in low sunlight, could never be black. The artefact of a watergate set me feeling for the sketchbook in my pocket, but it was too cold for more than a few hasty inadequate lines. As we covered the final yards along the road back to the car the last sunlight was turning the stones of the roadside dyke sharp yellow-green and the untrampled snow at its back held a rosy glow.

In the dusk we drove round by Lochinvar, rabbit scuts flashing as they vanished into an unhealthy-looking spruce plantation. The loch was all smooth grey, except for a few winking ripples and the moon was up by the time I scanned the water for duck, just a small number of mallard and goldeneye. The mallard were still in pairs, though some ducks could have eggs by now. Lochinvar, our water supply, is dammed at its south end and its island with castle ruins has vanished. At the entry to Lochinvar Lodge it was interesting to see a couple of dunnocks still feeding around the sheep troughs at this late hour. They are to be found all winter at isolated habitations in upland Galloway and seem well able to withstand hard weather. At this date surely they should be close to nesting, but it was difficult to imagine what site they could find for nest building around the lodge, in the absence of any shrubs or hedge which could give concealment, unless they built untypically high in one of the tall pines.

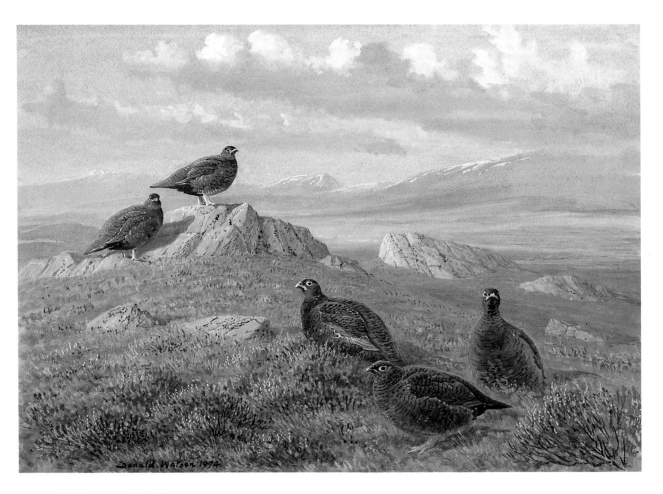

Red grouse, Mackilston, 1974

Back at home about 6.45, the rooks had all gone for the night but they had been actively nest building early in the day. There are now 6 substantial nests with 15–20 birds visiting the rookery. I decided to sweep up the litter of dropped sticks on the pavement as a small public relations exercise, though it seems to me that the human habit of throwing litter into and over our privet hedge is far more objectionable. It is amusing to see how many passers-by have taken to walking on the other side of the road, to avoid being spattered by rook droppings or hit on the head by falling sticks.

26 March *In the hills*

Derek R.'s visit, on his annual tour of raven nesting sites, prompted me to re-read T. B. Hough's diaries of his birdwatching in Galloway in the early years of this century. On 2 April 1914 Hough was shown a raven's nest with 6 eggs, in a little ravine, a regular site then, not far from Dalry. During the 1950s I saw ravens' nests in that same site. Two days ago, on his way here, D. visited it and found one there which he judged to have been used but robbed this spring. The taking of ravens' eggs is much less publicised than eagles' or peregrines', but they have always been attractive to collectors. Hough was remarkable for his time in being strongly against egg-collecting and the killing of birds like ravens and birds of prey. The gamekeeper, Tom Tait, told him that another keeper from neighbouring ground had shot one

of the pair of ravens and the nest was deserted. If Hough is to be believed Tom and his employer liked to have ravens and buzzards on the hill and were very displeased with what had happened, hardly a typical attitude in 1914. In the 1950s I only once saw a brood fledged there, sometimes stones had been hurled into the nest, one year a brood was killed in this way. In recent times the birds moved to tree sites which were less vulnerable especially one deep into a plantation, but gradually they seemed to disappear as more and more of the surrounding ground went under trees. At least they have been back at the ravine this year. (Later a brood fledged from a repeat clutch.)

Yesterday D. and I went to a raven territory where nesting has a long, virtually continuous, history. Two nests had been built up. Walking the rough boulder-strewn slope along the foot of the crag we did not see the birds till they were flying and croaking up above. D. concluded that the higher nest had eggs, but found the burnt ground at the top too treacherous to see what the nest contained. A peregrine made a brief appearance and dived magnificently at the ravens, one side-slipping it with its great beak pointed skywards.

This morning's plan to look at other raven sites in the northern sector of Galloway had to be abandoned, because of unrelenting rain. We were car-bound for most of the day, looking out at dripping forests and sodden moors.

After a chat with my friend Geoff (a forest ranger) and his wife up at Kirriereoch, we had our sandwiches looking out over Loch Moan and its islands. I remember the extraordinary spectacle made by the huge colony (3–4000 pairs) of black-headed gulls on their nests among massed bluebells (wild hyacinths) on these islands back in the 1960s. G. says the numbers are quite small now and hardly any were there at this date. A small colony of feral greylag geese has bred at Loch Moan for many years. Originally some had been introduced in the 1930s to Lochinch and Monreith and by the 1939–45 war they were moving round freely. I recall when the first 'wild' nesting was discovered there was some excitement and it was thought best to keep their whereabouts secret to protect them. They soon began to spread and inevitably farmers complained about loss of summer grass. Other people enjoyed seeing them, especially the pairs with their flotillas of downy goslings. Whether or not there was a truly native stock of nesting birds in Galloway centuries ago it is now impossible to be sure.

While we were looking at these geese on the grassy White Island we were astonished to see that one of them was not a greylag but a white-fronted goose. It appeared to be of the Greenland race which winters in Galloway and was a fully adult bird. It seemed to have paired up with a greylag. The breeding season of our migrant greylags, from Iceland, is very much later than that of the feral birds and that of the Greenland white-fronts is later still. So this does seem an unlikely pairing, even though geese are notorious for interbreeding. Hybrids between greylag and Canada goose are not uncommon locally. This white-front may perhaps have escaped from a wildfowl collection. Anyway my friend G. will be keeping a sharp look-out to see if anything transpires.

We drove north over the Nick of the Balloch and across the River Stinchar, by one of the less travelled routes in southern Scotland. Once a blackcock hurried away from the verge into deep forest, showing none of the beautiful blue sheen on its plumage in the pouring rain. At Dalmellington we decided to head for home ground but first made a detour up to the head of the Ken valley. A quick stop at claustrophobic Glenmuck revealed another raven's nest, but no sign of the birds which would have little chance of success there. A fine, reddish-chested

cock sparrowhawk perched deceptively still in a hawthorn tree. At the Lorg the sheep are in the care of a travelling shepherd and the little house stands empty. This highest farm, I have been told, was too steep and rocky for forestry. On a better day I must explore the delights of the Lorg burn again and perhaps find a ring ouzel's nest. The steep gullies up here, with their abundant mats of blaeberry, have always been good nesting places for these wild 'mountain blackbirds'.

Driving down the High Ken valley I vainly scanned the straggling willows — known as 'The Sauchs' — for the blackcock, which were so plentiful a few years ago that parties of birdwatchers came from England to enjoy them feeding on the buds in early spring. Young forestry plantations generally attract blackgame but there may be too much older, thicket forest up here for them now. They have always fluctuated mysteriously in numbers. I find it absurd that a big grouse moor owner in England can write that he does not welcome them on his ground. There is scarcely a more spectacular wild bird to be seen in Britain.

We made a final detour round by Lochinvar, D. looking hard at the vertical forestry ploughing for sediment in the water which is pouring into the burns in this weather. Soil erosion from this type of land-use is inevitable.

There was a large gathering of rooks and jackdaws at the old spruce plantation above the filter station. From the road we could not be sure if there were nests in the dense foliage, but it may be a substantial rookery which I had not noticed before. Possibly it is just a roosting place — it was dusk when we came by. Surprisingly the rooks at our home trees were absent at 6.45, presumably having flown off to a less exposed roosting site (perhaps the wood at Lochinvar

filter station) on this night of driving rain and east wind. D. pointed out this morning that we now have eight nests, two in a second pine, where there is much squabbling because the nests are contiguous. They have been carrying nest-lining during the past week; interestingly they have dropped a little sheep's wool, obviously brought from the field beyond our dyke. Wool is typical nest-lining for crows and ravens but is not usual material for rooks.

30 March Glencaple — Mackilston — Stroanfreggan

I had an illustration of barnacle geese to complete by the end of March. Happily it is almost ready for the post. I made some fresh sketches of these beautifully patterned birds the other day, watching a mixed flock of pinkfeet and barnacles on the merse south of Glencaple, down the Nith estuary. There were, of course, far more back in the winter at the Wildfowl Trust's reserve at Caerlaverock. As soon as shooting stops in February they become much more dispersed and there are usually some among the great flocks of pinkfeet which in spring are such a spectacle along Kirkconnell merse, on the Galloway bank of the Nith. On this occasion only about 1000 geese were on view, all on the Dumfriesshire side, but there were enough barnacles for my purpose.

At four o'clock this afternoon I was becoming thoroughly restless in the studio and kept looking out at cloud patterns on the hills. So I asked J. if she would like to take a run in the car up Mackilston way, surely we should find our first wheatear there. In fact there were none on this favourite stretch of roadside and we scanned the stone dyke tops for another eight miles before one nearly escaped unnoticed, while perched with only head and shoulders in view above a coping stone. In a moment it had made that typical little drop to the ground and up again. Nothing is more symbolic of spring in the hills. Today, as so often in memory, the first cock wheatear stood bold and compact against a wintry wind, quivering a little. In the dusk the Kells mountains seemed to crouch beneath wild ragged clouds building from the north-west.

Later I heard that Richard had seen his first wheatear on the Southern Upland Way on 24 March. Being the warden of 'the Way' he is up on the high ground a great deal. No matter, we are content to have seen one in March.

11 April Moss of Cree — Wigtown

I heard from Willie in Dumfries that 100 sand martins had arrived at Lochmaben, a goodly number for these days, and chiffchaffs have been heard singing. We headed for the Machars of Wigtown, meaning to look at the seabird colony at Cruggleton, but got no further than Wigtown because of car trouble.

On the way to Newton Stewart I climbed a little eminence to scan an expanse of forest which has for some years held a nesting pair of hen harriers. It was quite a chilly day but the strong wind would be conducive to high flying by the harriers if they had returned. In minutes I picked up a fine grey male, not just cruising around but in a paroxysm of 'sky dancing', the amazing display flight which is performed over the chosen nesting area. Far up the forested slope at first he intensified his dance over last year's failed nest site, approaching all the time. Although he passed quite close to me, continuing his trance-like rising and falling display, I

still found it difficult to decide whether he actually turned over on his back at the top of each climb, though it seemed that he did. I followed him for about half a mile as his rising and falling became shallower and then, to my delight, I saw he already had a mate. She rose circling on stiffly spread wings from close to where the cock had ended his display. Top-lit by the bright midday sun she looked so pale against the dark conifers that I nearly mistook her for a grey male. She flew back to last year's nest area and herself sky danced a little there, less steeply than the cock had done. This year's nest site is unlikely to be chosen yet but it won't be far away.

At one time I would have been anxious that the conspicuousness of these harriers might lead to too much attention and disturbance by passers-by, but I have learned not to worry about this. The birds nest in a virtually impenetrable jungle of Sitka, bog myrtle and heather which would intimidate most people and is excellent for getting lost in. There is, nevertheless, a slight hazard from the merely curious visitor, tempted to spend too much time trying to get close to the birds, which might then move elsewhere. A few days ago I saw a male hunting over a prime grouse-moor in Dumfriesshire where he would have little chance of long-term survival, a pair with a nest even less.

We made slow progress along the minor road by Moss of Cree to Wigtown. Long ago the Moss of Cree must have been a real wilderness, virtually inaccessible to man. Reclamation was well underway in the eighteenth-century era of agricultural improvement, when great numbers of cattle were being brought in from Ireland. The indefatigable Rev. C. H. Dick, bicycling through Galloway early in the twentieth century was disappointed to find little but 'turnip fields, bean fields, corn fields and pasture and only here and there . . . any rough moorland'. Now the central part of the Moss is part of the Forestry Commission's Kilsture Forest, most of it close to felling time. Between the forest blocks and a great expanse of flat estuarine farmland there is still some rough country with abundant birch scrub, and Carsegowan Moss retains an extent of open, heathery moor scarcely invaded by trees. It is only fair to say that the reclamation of the Moss of Cree must have greatly increased the total volume of its bird-life, for it is in the fields that geese, swans, waders, pigeons, gulls and many small birds can be found in numbers which, especially in cold winter weather, make this one of the richest bird haunts in Galloway. Predictably these concentrations of birds attract predators and on a lucky day I have seen peregrine, buzzard, hen harrier, kestrel, sparrowhawk and merlin while covering about three miles along the road. During a short February afternoon last year a big finch flock, including bramblings and twites, was raided at roughly hourly intervals by a peregrine, a harrier and a sparrowhawk. In early February 1979, when the Moss of Cree fields were a green oasis in generally snowbound country, I estimated there were over 3000 skylarks mostly on recently manured fields. When they flew low over the fields they looked like a drift of brown leaves swept along on the bitter wind.

Today there were no vast flocks of birds and the only predator on view was a cock kestrel hovering with grey head sharply angled downward. In a field of fresh green grass curlews were feeding in a flock, some much more buff-breasted than others. Were these birds which will travel late to northern breeding grounds? I made sketchbook notes of curlew attitudes until they all took flight for no obvious reason. No matter, there were many splendid pairs of shelduck to draw, one close enough to absorb every minutia of plumage, especially the velvety specula of maroon and green on the wings, difficult to memorise accurately. Their blackish-

green heads quite lack the vivid sheen of a mallard's, but in the bright sunlight their scarlet bills glistened as if coated with varnish. Out on the broad merse below Wigtown pairs of shelduck were scattered far and wide. Where, I wondered, do all these pairs nest? In Aberdeenshire, where shelduck have been well studied, most nests were in rabbit burrows, but in some districts hollow trees are favoured sites. A few nest on open ground. I have known of Galloway sites many miles inland, both deep into woodland and out on the open hill, but I am woefully ignorant about their nest sites in general. At this time of year pairs seem to spend hours idling and sleeping out on the merse-land but the experts have found that they defend special feeding territories on the mudflats. I suppose many of the pairs we have been watching on the merse may be on their feeding territories, which could include muddy pools and channels there.

The centre of the little town of Wigtown is quiet and spacious. It seems to have the heart of a Galloway village within the body of a once bustling town. Many years ago a friend living in one of its tall houses invited us to look through a telescope from an upstairs room at the great flocks of geese on the merse far below. Height and a powerful magnification enabled me to pick out a single lesser whitefront feeding among a mass of pinkfeet. It is still, so far as I know, the only example of this rare goose to have been seen in Wigtownshire. Apart from its small size and distinctive head pattern it stood out by its rapid feeding rate. Over 2000 pink-footed geese can be seen on Wigtown merse towards the end of every winter, a few staying as late as early May. Most may have been over on Creetown merse today as we saw only a few hundred and they were distant.

We walked through the churchyard to read again the inscriptions on the graves of the 'Wigtown martyrs' — Margaret Wilson and Margaret Maclachlan who on 11 May 1685, for adhering to their Covenanting beliefs, were tied to stakes in the Bladnoch tide and drowned. They are also remembered by a simple memorial on the merse below the town, said to be the traditional site. (The course of the river was diverted to the south in 1817.) It is sad that for many visitors to this pleasant little town their most lasting memory is likely to be of this story of ghoulish cruelty. In their book *Old Galloway*, Donnachie and MacLeod found one epitaph in Wigtown churchyard which they described as 'sublimely perfect'. I hope they will not mind my quoting it:

. . . John of honest fame,
Of stature small and a leg lame;
Content he was with portion small,
Keepit shop in Wigtown and that's all.

13–15 April Dalry

This is the time of departure for the big flocks of greylag geese, which have been feeding day after day on the Grennan Holm. Their numbers have thinned over the past week, only 2–300 remaining now. Looking up from the garden on the afternoon of the 12th I glimpsed a skein of 36 through the bare branches of our big ash tree, as they headed silently away northward up the glen. At midnight on the 13th I heard the flight calls of another skein passing over the village. Very soon the only greylag we shall see till October will be the local residents.

I have gazed once again with a child's wonder at the miracle of a song thrush's egg. 'Ink-spotted' John Clare called it, but the inky spots are not all black, an artist seems to have flooded the large ones with purplish-red at their edges. The sparseness of the spotting leaves an expanse of purest blue, as light and clean as the sky on a perfect April day. A nest in ivy against our top dyke had four eggs on the 15th.

Until quite recently, I could be sure of hearing the 'drumming' of snipe above the garden on spring evenings. For years nesting was taken for granted in rushy patches by the Brack burn a quarter of a mile away. There was always a pair or more of redshank there too. Now I hear neither and greatly miss them. I might think I had lost these sounds through increasing deafness, but I have recently confirmed that I can still hear the drumming of snipe well enough from quite a distance and redshank calls are no problem. Is the field no longer right for them (it is still wet), or is this just another reflection of the sad decline of both these waders over a much wider area due to drainage and improvement of so much marginal farmland? Fortunately curlews are still near enough for their songs to be heard from the garden or house, though the nearest lapwings are not as close as they were. I doubt if oystercatchers show any change, but it is a few years since a roding woodcock flew over the garden trees.

16 April Clatteringshaws

A fresh wind was blowing curling wisps of last year's molinia grass into the sky as I drove along the back road by Craigshinnie burn. It is still known as the 'gatehill road' but the gate has long been replaced by a cattle grid. Twice the massed flowers of coltsfoot, like tiny golden suns, caught my eye on the stony verges and beyond a clearfelled slope a spread of wild daffodils, long masked by the trees, made a brilliant display in contrast to the great extent of drab and dreary 'brash' left by the woodcutters. The Forestry Commission have publicly declared that their policy is to make clearfelled hillsides 'visually acceptable', but it is obvious that nothing is done. These clearfelled areas do have the merit of opening up the countryside for a few years, but (during the early years) they resemble nothing so much as a First World War battlefield, chaotically littered with brash and tree roots which the foresters presumably hope will depress the growth of natural vegetation liable to compete with second generation tree planting.

A buzzard mewed as it circled over a likely nesting site. I looked out for an early whinchat on the fence-line across the open brackeny hill, a favourite haunt for them, but only saw a pair of wheatears, already well settled here. A siskin flew in high jerky flight towards the forest; a few stay the winter in Galloway but now in April they are returning in great numbers to breed in the older conifers, making one of their most attractive features. Since the beginning of the month they have been coming to feed on peanuts in the village gardens. Local bird-ringers have found that many of the siskins they catch here in spring have already been ringed in the winter in southern England, some even within Greater London. Some move to north-west England before completing their migration back to Scotland.

I moved on to the smallholding of Craignell, some young lambs already in its pasture fields between forest plantations and Clatteringshaws Loch below. A little bay nudges close to this once lonely farmstead where Alec, a shepherd's son, grew up to acquire an expert knowledge of birds and their nests in his native hills. Sadly, like so many youngsters in this depopulated region he had to leave as a young man to find work in the city, though his job with the water board has enabled him to retain his country interests. The stony shores of Clatteringshaws Loch attract ringed plovers in spring. When the water level is low a good number stay to nest, but they are always at risk as the level is at the mercy of the electricity authorities. There might now be just about enough exposed shore to entice them to stay — 3–4 were running and dipping at the water's edge and one was feeding among lapwings up on the grassy slope. A few common sandpipers have already arrived but none showed up for me. The sparse scatter of lapwings on the fields looked too well watched by crows. Indeed I saw one crow flying to the shore which at a distance seemed to have a yellow bill; very likely the colour came from the yolk of a lapwing's egg. Nevertheless this little colony of lapwings continues and chicks are reared.

Through the afternoon, with a cool wind at my back, I sat on a little knowe far up in forestry ground with grey crags above, watching for hen harriers in a well-established nesting territory. Below me stretched ruined mats of old brown bracken, no hint of green shoots yet. The knowe was topped with heather clumps, greyish and frosted-looking, starred with pale heads of last year's flowering. By 1.15 I was quite cosily seated on a bed of dry molinia sheltered by tall heather, well-placed to survey a big expanse of 10-year-old Sitka forest. Fortunately the steepness of the hillside and its numerous rocky outcrops have made it impossible to plant regular blocks of trees. At the top limit of planting the patchwork of luxuriant heather and small conifers is visually pleasing, almost natural-looking. After an hour and a half I had seen no harriers and had begun to move downhill, when with binoculars I sighted a male drifting above the trees where a pair had twice nested in recent years. I quickly lost him again but it was enough to encourage me to prolong my watch. Last year's female had disappeared, presumed dead, in July, leaving her mate to feed the brood of 5 chicks successfully on his own and I wondered if the cock I had briefly seen was paired. Nearly an hour later I saw him again and watched him along a molinia slope at the forest edge where he pounced and rose with something in his talons. He began a long weaving flight across the hillside. At first I thought he might be carrying nesting material. I held him in the binoculars for a long time before I at last caught a flash of brown and silvery underwing, as a female rose not so much *to* him as *at* him. Obviously now he was carrying prey. The two birds flew high into the sky, the female pursuing as he dodged away

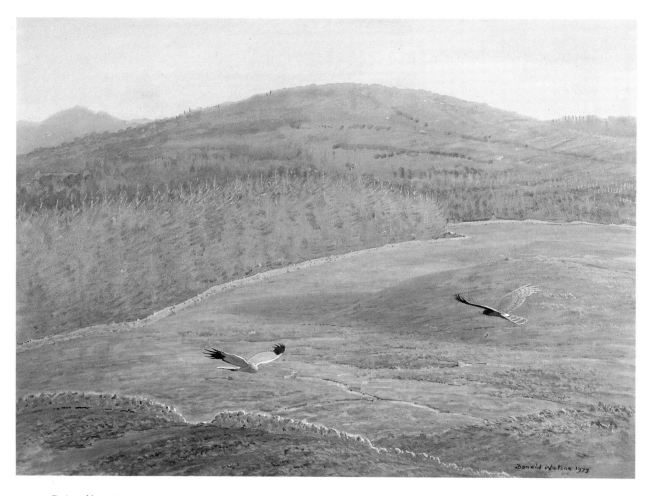

Pair of hen harriers, Galloway, 1979

from her, not yet ready to release his catch in a food pass. Almost three hours had passed between the start of my watch and confirming that both male and female were in residence.

17 April Loch Ken

Our first really warm day and 2 or 3 sand martins were over the river at the Ken Bridge. A flash of lemon yellow as a grey wagtail flew from the parapet. Oystercatchers madly piping along the riverbank; a good lambing on Kenmure lush field, many black ones. Down the west side of the loch we parked opposite the stretch of 'carr' woodland that almost obscures the open water of the bay known as Little Kenmure Loch. There is a mixture of alders, birch, hazel and willows, much of the woodland floor really waterlogged. I find that since I ceased to hear many high-pitched calls and songs it requires persistence to track down the variety of small woodland birds which are sure to be around. We soon found a willow tit — its mate could already be at a nest in one of the numerous rotten stumps — and a tree creeper. Willow warblers were appropriately singing among the yellow male flowers of sallows (or pussy willows), which have never seemed more abundant and decorative. Not long ago I flushed a woodcock as I climbed over the tumbledown dyke at the roadside — a nest is a possibility but

66

how often I have searched in vain in promising spots! This small strip of woodland might be too disturbed for them now, judging by the appalling amount of litter which has accumulated, mostly thrown over the dyke at this roadside. Watching a silent robin, obviously near a nest, I had a close but fleeting view of a stoat, with arched back and waving black-tipped tail, as it bounded through the grass. So much, perhaps, for the robin's nest but in such a place it would be much more difficult to spot (to a human eye at least) than in some garden sites.

Bevies of pike fishers were in occupation of the west bank of the loch, many huddled under large umbrellas. Probably a competition was in progress. There is still apparently some argument about precisely how the record pike of 73lbs was caught, many years ago. I hear that the pike fishers often travel up from Wigan and who could quarrel with them for seeking the peace of Loch Ken-side? Yet so many feet on this once delightfully vegetated shore have left little but bare eroded ground in many places. Years ago I found common sandpipers' nests on these banks, now they are too populous. Often in times past, I set up my easel on the shore of Loch Ken without thought of disturbance all day long in winter or early spring. I have no right to complain if more people wish to enjoy Lock Ken in varied ways but there are some activities, such as power-boating and water skiing, which are certainly incompatible with the survival of its special quality. In the local battle over the future of Loch Ken the case for development of any kind as likely to increase the tourist trade has powerful supporters, some of astonishing insensitivity, both in and outside local government.

We moved on to glance at a much smaller loch, further down the valley on its western side. Its old name of Loch Grenoch (the gravelly loch) was happier than 'Woodhall Loch' as it was re-named by a nineteenth-century landowner. S. R. Crocket spent his childhood near by, at Little Duchrae.

The ground to the west of Woodhall Loch rises quite steeply and the mixture of evergreen conifer and larch plantations, flanked by a good spread of hardwood trees, has been a pleasing prospect for as long as I have known it. Now there are swathes of clearfell through the conifer forest. This is one of only a few local lochs where great crested grebes nest and one was floating by as we stopped to look, its silky white neck and chestnut frills bright and clean against the darkly reflected woodland. More willow warblers sang from the sallows beside a layby and a frog chorus rose from a little reed bed. Frogs survive plentifully in rainy Galloway. Keen 'froggers' are always hopeful of finding the first spawn before February is out. Two hedgehogs had been killed on the road within 30 yards of each other.

Ray, the RSPB warden at Loch Ken, stopped on the roadside for a chat. He said there were still 190 Greenland white-fronted geese about — they generally stay a week or so later than the greylags. The name Loch Ken used to refer only to the water north of the old railway viaduct, now it is commonly given to all the water down to the Glenlochar barrage. Before its closure in 1966 the railway carried the expresses from London to Stranraer, for the Irish sea-crossing. Sometimes driving home late from Castle Douglas I would hear the night train — always known as 'the Paddy' — on its thunderous approach to Castle Douglas and feel a strange elation as it glided by, shooting red sparks into the night sky. There is a story of a much-loved headmaster of Parton school who liked to spend his Saturday nights in a New Galloway pub. He always took the shorter route, walking across Loch Ken viaduct. It is said that returning late one night he had to cling on to the girders to let the Paddy by. That must have been hair-raising even after a good evening's fortification. Travelling on a slow train

from Dumfries to New Galloway station on a fine winter's day could be a wonderful bird-watching experience, the sky full of ragged skeins of geese and many kinds of duck rising from the marshy lagoons alongside the track, but even the slowest trains were too quickly past them. West of New Galloway station — actually at the hamlet of Mossdale — the trains crossed miles of lonely moorland, now nearly all afforested. At Loch Skerrow Halt they took on water and sometimes fishermen left the train for a day on the loch, returning to Mossdale by another at night. It was sadly romantic when we took our children to Stranraer and back on the very last day in the life of the railway.

The marshes on Hensol estate, below the viaduct, are now part of the RSPB Reserve and Ray hopes that the new sluice will enable more birds to nest without risk of being flooded out and passing waders will be attracted to controlled feeding grounds. It is extraordinary how much suspicion these operations arouse among some farmers. A letter to the local paper the other day suggested that it was a wasted effort as most of the ducks would later be shot at flight ponds on neighbouring estates anyway. To be sure there is a grain of truth in this and I have long deplored the heavy toll on wildfowl lured by feeding to the increasing number of private ponds in the neighbourhood. I am sure that the visitors who will crowd into the RSPB's new hide to admire wigeon, pintail, shoveler and other duck would be horrified if they knew the whole story. Surely we ought to take a leaf from the American book and fix limits on daily bags of wildfowl.

The electricity board owns the water of Loch Ken and nearly all the shore-line up to the 150 foot contour. When the level of the loch was raised as a result of the hydro-electric scheme in the 1930s, a significant amount of agricultural land was lost to marsh and shallow lagoons. Interestingly, this created much more attractive habitat for wildfowl, especially at the southern end and it was then that the rather rare Greenland white-fronted geese began to come in numbers. In fact there are only two major flocks wintering on mainland Britain and both are in Galloway (the other near Stranraer). I had hoped to enjoy a last look at some today, but we failed to locate them. Perhaps they were already flying away over our house as I have often seen them do on warm days in the second half of April.

Up at the hill farm of Grobdale in Balmaghie in the still warm evening, all the hills were hazed, drained of colour. A 'couped' ewe looked dead from a distance, with splayed hind legs pointing to the sky but I managed to right her quite easily and she trotted away briskly enough. The ewes up here are still gravid, lambing yet to begin. Bennan Hill is little more than a large knowe, but a superb viewpoint into the heart of upland Galloway in clearer weather. The grass is greener than in many years at this date and I hear that the ewes are in good condition. Years ago I would meet the shepherd herding his flock from horseback, but there is no longer a resident shepherd at this or the next two hill farms and the sheep also have gone from one. At least the house is still occupied at Grobdale in Balmaghie, for a time by a solitary lady weaver, then by a young couple, the wife an artist, and now by a young man who tells me he is a mechanic (I hope he has a job) and his family. The farmers, two brothers, are good friends of mine and they have to travel some miles to do the shepherding themselves.

It was almost dark when we came down to the roadside where song thrushes and a robin were singing from the tops of spruce and larch. Many a time in past years, if I had worked through the day in the studio, I leapt in the car about teatime and drove here to race up Bennan Hill and watch for hen harriers floating over the forest below or hunting the Grobdale

moorland. Wonderful therapy after hours indoors. Now, alas, they have gone and it has become a nostalgic place. But we look forward to the butterfly season, especially the Scotch argus which swarm along this roadside verge in August.

20 April *Palnure Glen*

Easter, P. home for the week-end, welcomed by pouring rain and a wintry blast. Miraculously the sun shone this morning, heralding a fine spring day with high clouds racing from the north-west.

The Palnure burn flows through Bargaly Glen, deeply sheltered from the east by the great mountain mass of Cairnsmore of Fleet. We turned down from the Newton Stewart road west of Craigdistant, a house whose name lingers in the memory. The distant Craig must be Craignelder, all granite blocks on its upper slopes, but no longer a sure place to see a soaring pair of eagles since the forests have covered so much of their old hunting ground. At first I thought our day was heading for disaster as we scrambled futilely over barbed wire in an attempt to walk the burnside along a circuitous stretch. Then back on the little road below Bargaly House the first small tortoiseshell of the spring towered from the tarmac. There were so few in last year's sunless summer that there cannot have been many left to hibernate. We decided to take the easy route upstream past Bargaly Farmhouse. On the way red admiral butterflies twice flew past without settling, very early for Galloway.

Jane, the young farmer's wife there, happened to have been one of J.'s pupils of 10 years ago at Dalry school, so in no time at all we had all the local gossip and much useful guidance for the rest of the day. I asked about the very special calf she was tending, Belgian Blue out of

Friesian she said. Farming at its most beguiling in April sunshine, and apparently traditional, but that brilliant green field full of ewes and tiny lambs must know all about nitrogen and phosphates. Jane was pleased to tell us of the woodpeckers (doubtless great spotted) which nested down the tree-lined burn and I was able to tell her that the little birds she had seen with bright yellow on their undersides would be grey wagtails. Two swallows flashed over the steading, the first had come almost a week past. Right above the farmhouse a pair of buzzards hung in the sky and Jane said there was one lying dead beside the track up the glen. We soon found this and when I turned it over I was momentarily shocked to discover that both legs were cleanly severed and missing. I soon rejected the thought that it had been trapped as surely no-one would leave the evidence in such an obvious place. Perhaps a boy had fancied the legs as collectable trophies? Buzzards have increased in glens like Palnure with a mixture of trees and open slopes where there are plenty of rabbits and voles. They are unlikely to be entirely unmolested but they are no longer systematically destroyed by gamekeepers here. If not too far away they really have very little resemblance to eagles yet sometimes it is the closest view of a buzzard, when it can look huge, that leads to mistaken reports of eagles. I would be instantly distrustful of any report of an eagle perched on a roadside telegraph pole. Buzzards look clumsy in flight compared with peregrines or harriers, but there is great beauty in the moth-like pattern on the undersides of their spread wings and their flight is wonderfully manoeuvrable. I had a glimpse of a sharp-winged grey bird speeding away along the edge of a larch plantation. Could it have been a cock merlin? No, the tail seemed too long and the colour not blue enough, so it must have been a cuckoo though I have not yet heard one call. A pair of goosanders flew fast and direct up the burn at tree-top height. Some nests, in hollow trees or rock-fissures, may have eggs by now.

It was a pleasant discovery to find that the plantations beside the forest road round the hill above Bargaly are not yet tall enough to obscure a wide view of the Cairnsmore range. For all that is wrong about the forests, from this road I think at their present stage they make an aesthetically satisfying base to the bare slopes above. At this time of year the broad rides look from afar like roads of straw, startlingly clearcut, and there are great tracts of luxuriant, red-brown heather on Blairbuies Hill, richly contrasting with the neutral colours of the high ground. A cock kestrel landed on an outcrop in the heather and pounced deep into it, no doubt grabbing a vole. All that could be seen was a flurry of flapping wings. The plantations seemed otherwise remarkably empty of birds, except for one magpie. The Palnure Glen is one of only a few places where magpies have a long history of residence. Their scarcity is puzzling and can hardly be due entirely to gamekeepering nowadays. As we came down the hill facing a cold wind, it no longer seemed the same day we had seen the first butterflies flying in the warm midday sun.

Driving back by a circuitous route it was almost dusk when we slowed for a cock pheasant. Behind him crouched a much more brilliant bird — a cock golden pheasant, arguably the most gorgeous bird to be seen wild anywhere in this country. Galloway shares with Norfolk the distinction of having the only well established population of wild (though originally introduced) golden pheasants in Britain. Recently they have become scarcer, possibly due to cold winters, but it is shameful how little is known about the lives of these exciting birds. How can I have lived here so long without ever making the effort to witness what are described as truly spectacular displays by the cock birds?

23 April Peregrine time

On a bare earthy ledge behind a rim of bright green grass the three red eggs lay like ripe plums, sacrificial looking. This site is high up a black gash in steep grassy upland, easy to look into if you know where to climb. No-one who cares for peregrines would now dream of disclosing the exact locality of a nest. People still covet those beautiful eggs as trophies, and some would take them for the money to be made from the chicks. There are also pigeon-racers who do not welcome peregrines nesting along the flyways and still some grouse-shooters and keepers for whom the only good peregrine is a dead one. Under licence from the Nature Conservancy Council I play a small part in monitoring the breeding of some specially protected birds of prey. People, including some bird-watchers, sometimes ask me why we do this, wouldn't it be better to leave the birds completely alone? They seem not to understand that no useful conservation can be done without knowledge. If Derek Ratcliffe had not visited a great number of peregrine nests back in the 1960s he would never have been able to produce convincing evidence on how organo-chlorine pesticides were causing hatching failure, egg-breakage and deaths of peregrines and we would never have seen the amazing recovery, which has followed the banning of the offending chemicals. No one should imagine that he and his fellow-workers had an easy task in fighting the powerful interests against this. I can also cite an example of the importance of responsible monitoring from last summer in Galloway. Many more nest robberies than took place would have been suspected if careful checking had not shown that many broods had died because of the heavy June rains, either saturating young chicks or making it difficult for their parents to care for them. Obviously it is important that watchers do not visit nests in such conditions.

I have known the site we inspected today for well over 30 years. A friend once told me that he nearly broke his neck when he was photographing it in 1938. In one way it is a rather unusual site; nearly all the peregrines known to have nested there have used the same ledge. The reaction of peregrines to human presence near the nest at egg-stage varies. Some sitting birds fly off silently and are easily missed. We never saw a bird leave the nest this time, but once we were on top of the hill the pair were circling and cackling not far away. As we came quickly down we saw the falcon swinging back to the nest.

Down on the valley bottom a ewe had just given birth to the second of its twins as we passed on our way up, and we watched its first struggling efforts to stand. As we came by again it was already taking staggery steps. At the roadside we met the shepherd; his sister had been a class-mate of one of my daughters. We talked about the sad absence of lapwings on the hill and he said there was only one pair of ring ouzels where I used to know 3 or even 4 pairs. Even curlews were sparse on his ground.

24 April Killantringan — Portpatrick

I am accustomed to telephone calls, often from strangers, about rare or mysterious birds they want to report. It can be rather difficult to decide whether to drop what I am doing and go out to try to see the bird myself. A retired major of the Irish Guards I used to know assumed that I was always available to travel 15 miles to sort out his problems in identifying a strange goose. Once I had a call to say that a barn owl had got itself stuck in a rhododendron thicket and

could I come and rescue it (word had got around that I had taken some injured owls into my care). This time, after peering into the bushes, the only problem was explaining that the supposed barn owl was a big white cat. If I do make a special journey to see a rare bird I know the chances of finding it are about 50 per cent or less.

On this occasion Derek R. had just arrived to stay a couple of nights and I doubted whether a report of an ivory gull — it seemed genuine — would be enough to interest him in a trip to Portpatrick in furthest Wigtownshire. But warm sunny weather held and the prospect of a walk along that rugged coastline won the vote, with the chance of seeing one of the rarest and most beautiful gulls in the world as a possible bonus.

We started our walk at Killantringan Lighthouse, southward from there along the first stage of the Southern Upland Way, here a good path along the cliff top. In past years we had always headed north for the sandy shore of Killantringan Bay where in the 1960s an old man with a horse and cart used to gather the purple *porphyra* seaweed which was sent to South Wales to be made into laver bread. It was popular there (and may still be) when dipped in oatmeal and fried or boiled.

Killantringan Lighthouse was brilliantly white in the sunshine. A keeper emerged and I asked him if he ever saw choughs along these cliffs. No, he had only seen them in Islay, their well-known stronghold. From time to time pairs do still appear on the Galloway cliffs but it is doubtful if any have nested for many years past. This seems surprising since they flourish on the Isle of Man, which on clear days can be seen in some detail from the Mull. Jack G. Gordon wrote, but never published, a good account of choughs in Galloway, early in the present century, when a number of pairs were still nesting. In May 1907 he wrote 'My brother and I visited Portpatrick in search of Choughs. On the 22nd we went south along the cliffs, finding a nest containing five eggs (one of which is in my collection) in the roof of a cave beyond Dunskey old castle, seeing altogether six birds.' North of Portpatrick (where we were today) they saw 9 choughs but found no nests. He thought, even then, that they were much scarcer than they used to be. I have been reliably told that a few still nested into the 1930s, probably later, as an old aviculturalist in Dalry used to visit the cliffs near the Mull in search of young choughs in the 1950s, when they were sometimes still to be seen at cage-bird shows in the district. Gordon said that the farmers used to shoot them for the damage they were supposed to do to young corn, but Derek thinks that cultivation to the cliff edge deprived them of the ants which were an important food.

Right below the lighthouse the wreck of a small cargo boat lay disintegrating and partly submerged, a reminder that this coast is not always as benign as it looked on this calm sunny day. Flotillas of eider ducks rode the slight swell of the grey-green sea, the old drakes very beautiful as the sun caught the peachy bloom on their breasts, contrasting with the delicate olive pattern on their napes. Fulmars nest along the cliffs and several glided silently by, sepulchral-eyed, incomparable fliers. Herring gulls have few admirers these days but at this season the pairs, snowy-white and pale grey, standing imperiously by their still empty nests, are surely everyone's childhood seagulls. I had been told to look out for kittiwakes, as the ivory gull had been in their company, but there were none on this stretch of cliff today and of course no ivory gull. The scratchy 'key in a rusty lock' calls of sandwich terns led my eye to the first I have seen this year, ghostly white in the haze where sea merged with sky.

No one but ourselves was on this stretch of the Way. I am not sure it is as popular as the

planners hoped, perhaps the long distances between places offering a night's lodging deter some. Those who stop for bed and breakfast in Dalry, we hear, usually arrive exhausted.

We wandered away from the path over grassy slopes to the cliff edge. This western coastline of Galloway is delightfully floral, prolific with primroses and violets, the latter we hope promising many butterflies later. The first flowers of sea campion were out, even one or two early blooms of thrift, massed celandines at their peak in wet hollows, gullies and ledges sprinkled with the small white flowers of scurvy grass, rock slabs matted with reddish stonecrop.

A cormorant seen in winter on sea or loch hardly merits a second glance but here a small breeding colony made an arresting picture. Unlike many Galloway colonies this was absurdly accessible. In full breeding plumage, seen at close range, their reptilian sinuous shapes have a sculpted quality. Just now they look their best with their striking white thigh patches, blue-glossed necks and bronzed backs and wings, each feather as if edged with black lace. Many Galloway cormorants have heads white-dusted, some are almost white-headed, like southern cormorants. Two of the massive untidy nests held big white elongated eggs, one nest decorated with a piece of vermilion plastic. The cormorant nests were built on the exposed top of the cliff; lower down, recessed above an inlet of the sea, a few pairs of shags were nesting. They equally must be seen in spring to be appreciated, before they lose their curled green crests.

The path is stepped down the steep slope to the little beach at Port Mora. D. drew our attention to plants of bloody cranesbill, not yet flowering, and fronds of black and sea spleenwort on rock faces. Inland above Port Mora the extensive hardwoods of Dunskey climb to the skyline. Long ago they were home to a remarkable colony of long-eared owls, now they are notable for the most westerly of Galloway's green woodpeckers.

This cliff top approach to Portpatrick flanks Dunskey golf course. The path divides two worlds, landward a green, manicured landscape with its golfers absorbed in their game, seaward the plunging slopes dense with bramble and impenetrable tracts of stunted gorse. Here I expected a pair of stonechats but none were on view as we passed.

In the evening light the bright colour-washed houses of Portpatrick looked from afar like a model of a douce seaside town. Once the sea port for the Irish crossing, Portpatrick's harbour lost its status to Stranraer in the mid-nineteenth century with the arrival of the railway there. The ambitious harbour works were never completed — if they had been I suppose black guillemots might not have found nesting sites in the walls, as they have done for many years.

25 April *Grobdale in Balmaghie*

Warm sun and a cloudless sky, with D. to search for nesting golden plover. Last year in early May we walked the neighbouring farm of Grobdale in Girthon and found only one pair, which showed no sign of having a nest. The three hill-farms, the two Grobdales and Laghead, used to be as good as anywhere in Galloway for golden plover; even 10 years ago, when the decline had already begun, there may have been 20 pairs. We had no great expectations today, as we would be mostly on ground where heather is sparse, but I knew there should still be a pair or two at the north end around Clack Hill. There had been a pair with chicks in 1985, on a flattish area where the heather had been recently burnt. Apparently the height of the

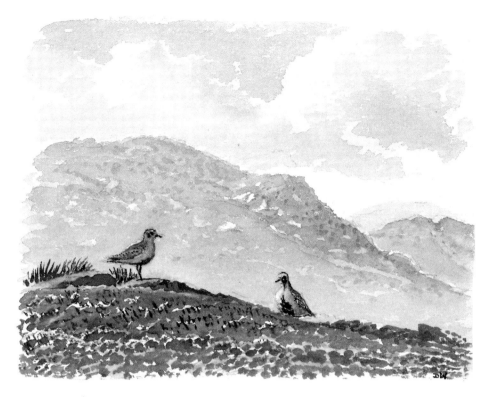

vegetation is crucial: if it is too tall the chicks are at a disadvantage in feeding. Nowadays the once familiar sight and smell of smoke from spring 'muirburning' is little more than a memory on these hills. True it was often done too late, sometimes illegally so, and many ground nests were destroyed by the fires, but golden plover and grouse particularly cannot prosper where all the heather has grown rank and old. Rotational burning of selected areas is best for both, although very hot fires can eliminate the heather altogether and in this wet climate molinia grass takes over, which even the sheep can find little sustenance in. There have been fires in this locality which have set light to neighbouring forestry plantations and farmers fear the cost of compensation such incidents can bring. In various ways the spread of the plantations is the biggest cause of the decrease in golden plover and other moorland nesting birds. It is well known that crows take many eggs and foxes kill sitting birds and destroy nests and broods. In spite of the efforts of forest rangers to control their numbers both have benefited from increased afforestation. Recent research has come up with the disturbing conclusion that birds like plovers and curlew avoid moorland close to forestry plantations for nesting, probably because of the high predation risk.

As we stood talking to Dougie the farmer and his son, on their way to the sheep, a cuckoo called. One was rarely out of earshot for the rest of the day and several times one flew by in that peculiar winnowing flight. Frank, born and bred in Dalry and now in his seventies, says that as a boy 24th April was the day he expected to hear the first cuckoo and that was the signal for discarding his winter clogs 'if they had not by then fallen off' and starting to go barefoot till the autumn. He adds that he wouldn't care to do that on modern roads. Before making our way over the hill we looked into a hollow tree-stump where a goosander brought off a brood last year. Sadly she was absent this year, probably shot in the winter said Dougie nonchalantly. Such a large duck must have had a tight squeeze sitting for weeks in that small

cavity. The ducklings would have had to be powerful jumpers or climbers to get out and face a hazardous journey to the Grobdale Lane before they could start feeding.

It is just about two miles from the farmhouse over the hill to the golden plover ground at Clack Hill. All the sheep and lambs were on the green slopes fenced off from the brown moor to the north. Wood anemones (or 'windflowers') starred the grass among the old brown bracken; a momentary sight of a hunting kestrel, a new crow's nest (D. found another later) high in an old pine where ravens used to nest, at the lonely spot known to shepherds as the Hangman's Tree, since a suicide 100 years ago. Down here the deep, snaking course of the burn through the Grobdale Lane hides another, quite recent human tragedy. Eight or so years ago the shepherd from the Girthon side went out on a misty March night to check the progress of his muirburn and never came back. He had fallen into the deep burn and could not swim.

After lunch, with an eye on the heather and rocks of Clack Hill, we began to walk separately through the most likely golden plover ground. The vegetation was still short enough, but in a few years without further burning it might be too long. This ground is part of a recent extension to an old Site of Special Scientific Interest and is unlikely to be afforested, but it is likely that the close proximity of forest plantations and increased drainage have already reduced its fauna and flora. D. came across to say that he had seen a plover fly silently away, an off-duty bird perhaps, or one that had already run some distance from a nest before flying. D. is high in the league of golden plover nest finders, with a record of 7 in a day on the Moorfoot Hills.

The birds might never have been there, no further sight nor sound of them came our way, but moorland nest-finding is akin to botanising; keep your eyes to the ground (but also watch well ahead for a plover taking wing) and never give up hope. A nest had to be there somewhere. It was D. who found it, an incomplete clutch of 2, as beautifully camouflaged as ever; one egg with a buffish ground colour, the other more olive, each heavily blotched in black with a hint of purple. It is as if the colours have been picked from the mosaic of heather, sphagnum moss and dead grasses among which the nest cup lies. We quickly moved away, with never a glimpse of the lovely spangled birds near the nest. It was almost exactly where I had seen the pair in 1985, when with chicks hatched they were vocal and conspicuous. It is not always appreciated that golden plover with eggs can keep a very low profile and remain silent. I almost stumbled onto a nest with a clutch of 4 warm eggs not long ago when, like today, I never saw the birds at all. We made a circuitous progress across other possible nesting ground around Clack Hill but found nothing more.

Standing on the narrow bank of firm ground beside the dark-flowing burn, we watched fingerling trout rising and listened to frogs croaking among green waving sedges. A blissful, lonely spot, Loch Skerrow sparkling in the soft sunlight beyond the crumbled relics of the old railway halt. D. flushed a pair of teal and 3 mallard from the burn — there will be nests of both not far away. From across the lane on the fields of Grobdale in Girthon I could hear the voices of the little lapwing colony and an occasional pipe from an oystercatcher. All day we had been in prime curlew country, but there were fewer than there used to be. The same is undoubtedly true of snipe, though in the evening light 2 or 3 were drumming in the sky. The only sign of red grouse were some fresh droppings in the Grobdale Lane; of black grouse, which used to have a lek near Clack Hill, there was no sign at all. The disappearance of the dunlin which used to nest near Loch Skerrow is probably due to afforestation.

3 May *Short-eared owls and clearfell*

After the warm spell, the blackthorn winter has come. The creamy-white blossom so often coincides with a sharp drop in temperature. Two inches of snow fell up the glen last night. I went out in late afternoon to observe a patch of clearfelled forest, not far from home. I wondered if a pair of harriers might be nesting, as they had recently been hunting there, but I have not yet found a harrier nest in clearfell and I suspect this pair were only visiting to hunt the great number of field voles it contains. I knew there were short-eared owls about too and decided to watch from the car, parked beside the monstrous red tree-extractor abandoned on the forestry roadside like a war relic. Very soon an owl flew silently above the car and swept down to perch on top of a heap of brash. It stayed for many minutes, swivelling its head as it spied for vole movement with its fierce-looking golden eyes. From experience I knew that early evening was a good time to see the maximum activity of these owls; even when young have to be fed the parents are not very active through the middle hours of the day. Hunting birds may suddenly pop up all over the place around five or six o'clock at this season. There is assuredly more than one pair on this clearfelled hillside, but I kept my attention on the bird I had seen. It took off again in wonderfully buoyant flight, seeming to float on air, hesitating and almost hovering over tawny clumps of old grass. Suddenly it plunged swiftly down into a hollow below my field of view, rising seconds later with a vole dangling from one foot. Unconcerned by a watcher in a car it flew steadily uphill with its prey. I held my breath — might it fly over the first crest, the nest site perhaps quite out of view in the dip beyond? It happened to be my lucky day. Just as it reached the crest it lost height and rose again without touching the ground, but the vole had been dropped to a nest in that quick manoeuvre.

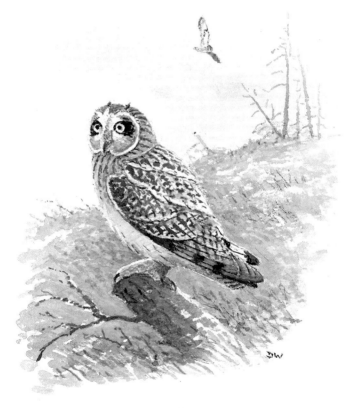

Now the only problem in finding the nest was to keep the right line walking up the slope. It looked near enough to be easy, but if the bird was sitting it could still be a problem to find the exact spot among the wreckage of cut branches, hoary old stumps and upturned roots. I decided to wait on in the car and watch for another prey delivery, which would give a more precise location of the nest — I was watching from about 400 yards. Sure enough the hunting bird, probably the male though it could have been either, returned with another vole after 35 minutes. I felt confident in going up to the site and had almost completed a rough little walk, when at 10 yards an adult owl rose, a much darker bird than the one I had watched bringing in voles. A few more steps and there was a huddle of chicks in a remarkably open site slightly sheltered by a pile of brash. I have found a number of short-eared owl nests over the years but this was the easiest. As always the chicks were well staggered in age, the eldest showing vestigial black and tan wing feathers, the younger ones entirely downy and grey, very small and helpless looking. A quick inspection made the total six, but there could have been an unhatched egg under the amorphous mass of bodies. I was reminded of an occasion years ago when I spent a long time looking for a nest which had been reported as 'a nest of young falcons on the ground'. This had proved, as I expected, to be a short-eared owl's nest with chicks. Very young owls have large, prominent hooked bills, not partly concealed by feathers as in older birds, and anyone unfamiliar with them could easily think they were falcons or hawks. The wind was cold so I quickly retreated and was glad to see a parent owl home into the nest as I got back to the car. Now I regret my complaints that foresters do nothing to make clearfelled ground 'visually acceptable'. Hideous though it is I would much rather they left it as it is to provide good nest sites for owls — and possibly for harriers too. The forest ranger tells me the voles are causing much damage to the young trees, so owls and harriers are the foresters' friends. By late summer there should be a lot of young owls hunting this hillside unless there is one of those crashes in the vole population and owl-food runs short.

A pair of pied wagtails ran all round the car but I forgot to investigate the 'red monster' which could well provide them with a nest site.

7 May *Evening forest watching*

Peter is a forest ranger who was formerly a shepherd. He looks after the Commission's enclosed herd of red deer, but is nostalgic for his shepherding days. He misses the birds of the open hills, especially the curlews, peewits and red grouse. When I met him this evening below the deer range our talk was of shared memories of this heartland of Galloway, of 20, even 40 years ago. He used to shoot rabbits on Craignell but always left a good few. Then when the sheep were taken off the hill there and trees were planted the rabbits disappeared and he has seen a great decline in hares too. The young forests sometimes harbour a good number of the blue or mountain hares, but they can be much more plentiful on open moorland in Ayrshire, Dumfries and in parts of Wigtownshire. We spoke of the scarcity of peewits (lapwings). Peter says they are almost extinct on the ground he travels. Of course the forests have covered much of the lower elevation pasture which they favoured, but why have they gone from the fields like those on Peter's smallholding?

In the book *Farming and Birds* published last year, it is said that they have generally increased in the uplands of north-west Britain and the big decrease has been on the intensive

arable farms of the south and east, but a warning is given that even in the uplands they are now threatened by agricultural changes. Looking at many fields near my home, which were good for lapwing nests only 10–15 years ago, it is all too obvious how they have changed adversely for them. Now in May they look like lush green lawns, heavily fertilised and without field flowers, well on their way towards the first early cut for silage. Research has shown that silage grass has grown too tall for lapwing chicks to feed in successfully by the usual time of hatching. Compared with the old flowery hay meadows, monoculture fields of rye grass are likely to be impoverished of the insect life which is an important part of lapwing food. Many of the lapwings breeding in Scotland travel to Ireland in the winter. This movement often enables them to avoid starvation in severe weather but whenever hard weather is prolonged and widespread many die and the numbers returning to breed are noticeably reduced. The several rather bad winters in the last decade must therefore be considered as factors in the decline observed on the breeding grounds in Galloway.

My evening sessions on my comfortable leather-seated sketching stool have been fairly uneventful. A young couple, obviously from England, came by remarking on how beautiful they thought the forested slopes looked. It was one of those matchless evenings when the low sun brings a golden glow to the greens of massed conifers. They are often described quite wrongly as black forests. Regimented they certainly are — I write of huge expanses of planted trees now well over 20 years old — but colour-wise they bring to my mind the old artist who said 'there is no black in nature'. The pines, even though they are that rather miserable species the lodgepole, are a quite different and much warmer colour than the spruce and just now the larch stands have completed their astonishingly rapid transformation from the pinkish-brown of winter to spring's transient emerald freshness. The hill I was watching seemed to lie like a sleeping giant, clothed up to the waist by a mantle of forest, naked above in the still wintry colours of old grass and sparse heather. I am not sure if a silver-grey cock harrier in full sunlight looks more beautiful when floating above a dark green forest or a madder-brown heather moor. When, as tonight, none appears, my eyes grow hungry for life and movement and scanning this peculiarly static landscape can soon seem uniquely time-wasting.

In almost any other year the blackcock would have been gathering behind me for their evening attendance at their display ground or 'lek'. Now and again I heard one making its 'roo-kooing' song from somewhere in the forest. A ranger has seen 15 at a lek further up the valley, but several of the local leks have not materialised this year, although the numbers reported recently feeding on larch buds point to less of a scarcity than I had suspected. I kept turning round to scan the old lekking slopes and became interested in a call which was strange to me. All I could spot was a fine cock pheasant which was perched upright on a tumbledown stonedyke. Eventually it was clear that he was making this call, which I noted as 'wok, wok', repeated up to twenty times, rather low and soft-toned. Surely, I thought, all the call notes of such a common bird are well known and described by the authorities, but not so, it seems. Neither in *The Handbook of British Birds* nor in *The Birds of the Western Palearctic* can I find any such call described. The only possibility was what is charmingly described by *B.W.P.* as the 'titbitting call' of the cock to encourage a hen to feed, though it did not seem right and there was no hen in the vicinity. I confess I find the dense columns of *B.W.P.* often do not give me the information I really want.

All evening the cuckoos were calling. This is a great year for them. Once one flew close by

and perched on top of a larch at the edge of the forest, so near that I could see that the bill did not open when it called. The evening songs of the countless song thrushes in the forest — they come there only for the breeding season — mingled with a solitary blackbird song. In my experience, in Galloway at least, blackbirds are sparse colonists of the conifer plantations compared with thrushes.

Coming home I stopped to look at the two swans grazing the lush grass at Waterside. One was the unfortunate whooper swan with a twisted broken wing, which has been about for several summers, the other a mute. Just companions I guess, surely not paired up! Back at the village swifts flickered in the sky and our garage-nesting swallow flew from its nest on a beam as I put the car away. After a pair had nested successfully in 1962 we had no more for nearly 20 years. Now their annual return is happily reliable and the garage is so full of old nests that new ones are rarely built from scratch. Does anyone know how long a swallow's nest can last? The 1962 nest is still basically intact.

10 May *In the Glenkens*

Ian and Diane Willis wanted to see the young short-eared owls I found last week. Another visit to see how they had progressed seemed in order. The possibility of predation by a fox was in my mind, the chicks had seemed very vulnerable in this open site. Happily all was well, the oldest chick already mobile enough to scuttle off into the herbage. Long before they are fledged young short-eared owls habitually scatter, thus I suppose reducing the chances of a whole brood being killed by a predator. It might seem that the parents could defend them better if they kept together (as young harriers usually do) but scattering must be safer for them. Today we counted 7 chicks so presumably there was an unhatched egg under the huddle I had seen before. Later, in the evening, we saw at least 3 adult owls hunting the clearfelled ground and if time allowed other nests could certainly be found there.

In cool blustery weather we drove some way up the valley of the High Water of Ken where curlews were making their strange explosive warning calls to chicks hiding in the grass. As we drove along an expanse of grassy moor we saw a female emperor moth doing what it is not supposed to do — flying in broad daylight. Experts say that females only fly at night. It alighted on the roadside verge, wings vibrating, so that J. was unable to keep it in sharp focus with her camera. It soon took off, as if blown away on the wind, which perhaps explains why it was airborne in the first place. Male emperors, which have orange-brown hindwings and are much smaller than females, may commonly be seen flying in search of a female in daylight. Sometimes on warm spring days many scores of males may be glimpsed flying at great speed over heathery ground in Galloway, but a female resting on the heather with her beautiful wings widespread is always a memorable sight. The powder-grey wings are four-eyed and near the tips of her forewings she carries discreet touches of purest crimson.

12 May *A garden in Dalry: butterflies and birds*

The first orange tip butterflies appeared in the district this year during the first week of May. Our earliest date is 1 May, in the fine warm spring of 1984. Not only have they been emerging earlier in late years but they have also been yearly expanding their range westward. As

recently as 1980 in Thomson's *The Butterflies of Scotland* the distribution map for Galloway shows the orange tip confined to the extreme south-east near the Solway Firth. Last century it was evidently fairly widespread in Scotland, but it had become quite rare by early in the present century. Such fluctuations have occurred in many butterflies, sadly too many having declined and not recovered. I have no idea why the orange tip is spreading, certainly it is very welcome, especially as in Scotland we have so few butterflies which fly in spring. I like to think that the mass of lilac-pink flowers of lady's smock (or cuckoo flower), which are just now one of the prettiest sights in our 'wild and tame' garden, are an insurance for future years of orange tip abundance. Of course this is only possible through leaving some good-sized patches of grass unmown. Lady's smock is the main food plant for the larvae of orange tips. The male butterflies, which appear in advance of the females, are eye-catching because of the bright orange wing tips. They make sustained erratic flights about the garden. When at last one alights on a flower head it is most likely to hide its orange tips between closed wings, but this habit at least provides a clear view of the beautiful chequered underwing pattern.

It was a botanist friend who christened our garden 'wild and tame'. He liked it that way. It would in any case be far beyond my minimal gardening skill to tame an acre or thereby of ground. About a third of it is woodland, including hundreds of aspens whose new leaves are shimmering coppery-gold just now. Sir Arthur Duncan, who was the best entomologist I knew, used to say that aspens were among the most interesting trees for insects. Alan Mitchell remarks on their attractiveness to green woodpeckers but here, where these birds are not numerous, they only rarely visit our aspen grove. Most keen gardeners would probably rather not have aspens for their habit of sending up a network of suckers which, if not checked, would obliterate a garden in a few years.

The lawn has been invaded by a profusion of the common field speedwell, a weed in the eyes of orderly gardeners, but I have left large patches uncut meantime to enjoy the blue carpet they make in sunshine. Goldfinches seem sparse at present but not from lack of dandelions in the garden. They are most attracted to them for a short period when the seeding heads are close-packed and have no interest in them when the 'clocks' open out. Watching the pair of chaffinches near the back door I expected their exquisite mossy nest to be well hidden in the ancient apple tree but no, it is easy to spot in pruned-back ivy on top of the old, useless brick wall below the kitchen window. I believe this wall was built about 70 years ago when the house was a small unlicensed hotel called The Gordon Arms. In summers long past tea and lemonade were served in its shade, perhaps under a canvas roof. Long ago ivy took over the wall and it has at various times provided nest sites for a great variety of birds, most of them predictable, but it was a surprise to find a garden warbler's nest one summer, seven feet from the ground in the ivy. Before I cut the ivy back to improve the view from the kitchen there was an autumn roost of more than 60 blackbirds. Each year I watch the progress of the rowan sapling growing out of the ivy — it is big enough now to have good clusters of orange berries in late summer.

The ancient apple tree will bear a heavy crop of fruit this year. Our pair of bullfinches drop in for a brief feed and disappear again, though they could surely gorge themselves on the buds all day. Greenfinches are almost always on view and I think there are more than 2 pairs nesting. Now the spotted flycatcher is the only summer migrant we still await. A garden warbler has been singing for the past week. Many people have difficulty in distinguishing the

songs of garden warbler and blackcap. Even though I can no longer hear many high-pitched sounds I still find the continuous warble of a garden warbler distinct from a blackcap's short bursts with their crescendo finish.

This is the week when years ago I would not fail to hear a whitethroat's scratchy song from raspberries or bramble down the garden, but there has not been a nesting pair since 1968, the year of the widespread crash in numbers believed to have been caused by winter mortality in the drought-stricken Sahel. In spite of a marked recovery in parts of Galloway they may not return to the garden because there are so many big trees. It is possibly now more likely that lesser whitethroats might nest, since they are no longer the very rare birds they used to be in this part of Scotland. Back in 1951 when one appeared and sang in the garden it was an exciting event. It is a much overlooked warbler and I suspect that many older people may find its rattling song beyond their hearing range.

Where have the mistle thrushes gone? They are not about the garden now. If young had been hatched nearby the parents would have made themselves conspicuous by their churring alarm calls as they flew at rooks or jackdaws. The rookery near the front door increased to 10 nests and most have well-feathered broods. I fear the noise and white splashing of the pavement are bringing criticism from some passers-by, but they will have gone well before the Clachan Fair in June.

24 May Minnigaff — Glentrool Woods

P. home from Worcester for a week, L. from London for the week-end. We planned a family walk north of Minnigaff to explore Knockman Wood, one of the lesser-known old hardwoods of Galloway. Before breakfast L. and I had spent a couple of hours in clearfelled conifer forest, even nearer home than where I had found the short-eared owl's nest. Here again were a pair or more of the owls and a buzzard hunting for voles and for some days there has been a male hen harrier displaying so persistently that it could not have spent much of its day hunting. From the brownish tinge to its grey wings and dusky back it could not be more than 2 years old and everything about its behaviour bespoke a youngster desperately trying to attract a mate it cannot find. This is not so surprising since male chicks have been much more numerous than females in Galloway nests I have seen in the last few years — in one nest last year all five chicks were males.

Hardly a minute passed without the spectacle of an aerial conflict between owls and harrier, once a pair of owls, harrier and buzzard all swirling above us at once, the ponderous buzzard merely trying to evade the others. Every roving crow was chased by owl or harrier though oddly the harrier paid no attention to a crow which landed near the heart of its territory. It was all thrilling stuff to watch, but maddeningly difficult to capture in a sketchbook. How hard it is, even with long experience, to maintain concentration on wing angles and foreshortening in twisting, turning flight actions; the temptation is always just to enjoy the spectacle. When a companion is someone I do not know well I still feel inhibited in trying to make quick field sketches. There were whinchats in this clearfell, but a blackcap singing from among the few old hardwood trees at the forest entry was more unexpected.

Early morning grey sky had become cloudless blue by the time we all set off for Minnigaff and Knockman Wood. A naturalist friend used to say that this last week of May was the best

of the year. All too often in late years it has been spoilt by cold wet weather but it could not be better this year. For once the Whitsun caravanners have seen an unbelievable Mediterranean Galloway. J. and the girls had a touching faith that my suggestion of exploring Knockman Wood was a good one. We had never been into it before and were not even sure of the best access. I knew it belonged now to the Forestry Commission having once been part of the Earl of Galloway's Cumloden estate, where white fallow deer used to roam. I expected a locked gate for which I had a key and permission to drive through, but we found it open. We left the car where the forest road petered out in the middle of a young conifer plantation. So young indeed that two pairs of curlews evidently still found it acceptable for nesting. A rough walk up a gentle slope brought us to the straggling edge of the old wood of Knockman.

Having spent some time this month in other Galloway hardwoods — good ones are few and far between — I was looking forward to comparing this one with them. On 15 May Geoff Shaw and Andy Dowell, both Forestry Commission employees, had led us through the oak and birch woodland around Caldons caravan park in Glentrool. Through the summer this is a popular and busy site with holidaymakers. This is perfectly reconcilable with the wood's richness in the small insectivorous birds characteristic of oak and birch, most notably the colony of pied flycatchers which Geoff has encouraged by putting up many nest-boxes. Last year 12 pairs of them bred in his boxes. When we were there the other day the smart black and white males were fairly conspicuous, but most seemed to be awaiting the arrival of females. No nests had been begun in the boxes looked at, but a tiny bat with reddish-brown fur was roosting in one. Bat identification can be difficult but this was certainly the very common pipistrelle.

Caldons — the name apparently means the hazelly place — is a small oasis of native woodland in the vastness of Glentrool's forestry plantations. Knockman is a much larger wood with many of the same kinds of hardwood trees, sparse in places, but with clumps of aged oaks and beeches here and there. We passed two massive beeches entwined in a serpentine embrace. We were often walking through quite open glades where newly emerged small heath butterflies were flying, the dab of orange on the upper wing very bright in the sun. There are many dead or dying trees. In wild weather it could be a melancholy place, but it seemed Arcadian in May sunshine. I was sorry to see that parts of the wood had recently been underplanted with Sitka spruce.

Walking through woods like this in spring or summer I am ever hopeful of finding a woodcock's nest or chicks. I remember the advice of an expert nest-finder that a favourite site is where the leaf litter is partly overhung by lightly trailing bramble. How many times I have searched what seemed the perfect spot and found nothing! So for me it had to be the highlight of our walk when just five feet ahead of me a fat brown bird exploded into heavy flight and a quick search revealed two light, brown-mottled eggs in a nest, quite openly sited among the young bracken which was springing up through a mat of dead oak leaves. Chance findings of ground-nesting birds, unless they are abundant species like meadow pipits, are rare in my experience. Many first clutches of woodcock should be hatched by now, and perhaps a mere two-egg clutch would be consistent with this being a repeat laying after earlier failure. When a woodcock rises at my feet during the nesting season I always look carefully just ahead before moving forward, having once as a boy trodden on a chick in my eagerness. Eggs are well camouflaged, the wonderfully rich brown, buff and black chicks even better. I have lost count

of the number of people who have told me they have seen a woodcock carrying a chick under its tail. The other day I read through the detailed account of woodcock behaviour in *The Birds of the Western Palearctic*. Here it is suggested that some observers have been deceived by a female performing a 'distraction flight', when she flies off heavily 'calling and *apparently* struggling to prop young between feet with depressed tail'. Surprisingly the only definite mention of carrying young refers to a female carrying two chicks, one by one, in her bill.

When I was younger and had excellent hearing I relied greatly on songs and call-notes for tracking down small birds in leafy woods. Familiarity with sounds is almost indispensable as so much time can be wasted in trying to follow every little movement in the foliage, the bird most often proving to be a chaffinch, rather less frequently a willow warbler or one of the commoner tits. Paul Collin, the RSPB warden at nearby Wood of Cree, reckons Knockman is a good wood for redstarts. Certainly it looks ideal for them, with many possible nesting holes in the old trees. No doubt some were singing unheard by me but, as Paul agrees, male redstarts have a unique ability to remain invisible when singing from the crown of a tree. On this day we never glimpsed one. (Yet they can be very conspicuous at times — a few days later we chanced on a pair, at the edge of some old hardwood in the Urr valley, which were perching quite openly on fence wires and low branches.) Even when seen in deepest shade a redstart always betrays its identity by the charming habit of quivering its red tail. A male with sunlight on its brilliant white forehead, jet black throat and orange-red breast is close to perfection. A classic book on the redstart was written by John Buxton who, from behind the barbed wire of his German prison camp, compiled a dossier of notes on one pair covering 850 hours in April–June 1943.

Redstart, pied flycatcher and wood warbler — these are the most special summer migrants to the Galloway oak and birch woods. The greatest numbers of pied flycatchers are found where nesting sites have been increased with nest-boxes; wood warblers are most plentiful in the Wood of Cree, where the once coppiced trees grow on a steep slope — research in Wales showed that the steeper the slope the greater the density of wood warblers. We watched one closely as it sang among golden young oak leaves in Knockman Wood. Never as quick-moving as a willow warbler or chiffchaff it is probably the easiest warbler to keep in view. Ampng bright new leaves the lemon-yellow throat and breast can look less obvious than in illustrations. An unmated male will progress ceaselessly around its chosen patch, often trilling its sibilant song in slow butterfly-like flight. Wherever there were open spaces and especially along the woodland edge tree pipits were making their parachute song-flights. We had seen our first spotted flycatcher last week and now they have flooded back.

A few years ago the Glentrool hardwoods were a certainty for green woodpeckers. It is possible that their scarcity there now is due to the loss of open grassland grazed by sheep, where these woodpeckers used to feed on ants. I have seen them disappear, probably for the same reason, as the conifer plantations engulfed a remnant hardwood in the Dee valley. Great spotted woodpeckers, however, are still plentiful, especially in the Wood of Cree where we heard one drumming, but could not find the bird in the dense canopy. They do not commonly feed on the ground. From the number of starling broods calling incessantly from holes in the dead trees of Knockman Wood, woodpeckers obviously face severe competition for nest sites. More than once I have seen a persistent pair of starlings evict great spotted woodpeckers from a nesting hole. Within the next 2–3 weeks the starlings will leave the woods, breeding over for

the year, and flocks will be found out on the upland moors. I have never understood why so many of these flocks consist entirely of young birds.

As we came down the hill a hen pheasant burst into flight in front of us. She had a brood of downy chicks some of which literally burrowed out of sight into tussocks of molinia.

25 May *Carlin's Cairn — the heart of Galloway*

As we drove home last night the sky still had no hint of cloud and it seemed as certain as it could ever be that the fine weather would hold for at least another day. L. had to be on a train for London at 5.30 pm today and Dumfries station is 26 miles from Dalry. Unless we sprang from our beds with the first notes of the dawn chorus — and no one was prepared for that — we would have to be content with covering less than half of the high ground which makes up the ridge along the Rhinns of Kells and the Carlin's Cairn range. Being favoured with a Forestry Commission permit to drive the long forestry road up the Polmaddy Glen, I opted for the short climb up on to Meaul by the Goat Craigs. I remember the first plantings up Polmaddy glen and how it swarmed with short-eared owls and kestrels in the vole-plague year of 1960. Now for six miles tall spruces march back from the roadsides in almost impenetrable blocks.

I had been warned that part of the road was extremely rough and it certainly was. Once a sparrowhawk dashed across ahead of the car, carrying its kill, possibly one of the innumerable fledgling thrushes in this forest just now. What joy to emerge into the full morning sunlight at last and see the Goat Craigs beckoning ahead. From the end of the road the summit of Carlin's Cairn looks high and far and slightly menacing. These Galloway tops, none as high as 3000 feet, may seem puny to a real mountaineer, but having been both hopelessly lost in mist and caught in a ferocious thunderstorm on them, I regard them with respect. McBain, the author of *Merrick and the Neighbouring Hills*, was an intrepid hill walker and positively revelled in thunderstorms on the tops. I particularly like his description of the October night he walked from Dalmellington to Back Hill of Bush with his little spaniel as companion. At midnight on Carlin's Cairn 'the scene was diversified by incessant flashing from the lighthouses on the Clyde striking a thin layer of cloud overhead'. He did admit to being not unmoved by thoughts of supernatural apparitions as he rested at the Witch's Cairn. We now know that when he was walking the hills soon after the First World War, eagles were nesting and he could have seen them, but sadly he hardly noticed birds at all.

As we started up a ride we at once saw a red deer hind ahead and for a minute watched it grazing, unaware of our presence. It was still in its grey-brown winter coat. It vanished into the trees in a flash when it caught our scent. Possibly it would have a calf lying up nearby. Calf-tagging by forest rangers is no longer carried out here. For a number of years they spent many days at this time of year on the high ground watching for calves below. Sometimes they were lucky enough to see some dramatic incident — Ian Watret has told me of the time he was watching a fox stalking a mountain hare and an eagle swept down and took the hare just ahead of the fox. He said the fury of the frustrated fox, as it ran in circles with tail raised, was a sight to remember.

Above the forest the climb becomes steeper. L. disturbed a meadow pipit from its nest in a mixture of blaeberry and grasses. The four, dark sepia eggs lay beautifully snug in the deep

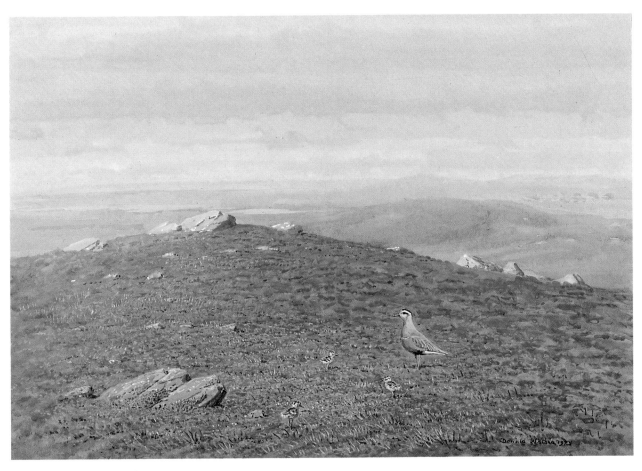

Dotterel and chicks, 1975

cup lined with fine grey and white hairs, the nest as always deeply recessed into the surrounding vegetation. What a delightful nest site with its mantle of fresh green blaeberry leaves and tiny pink flowers like fairy lanterns! We took care before moving on to see that we left it as well concealed as we had found it.

Once on the high ground, though we were still far from any summit, we were walking easily with springing steps. As one of my companions said as we worked up the first gentle grassy slope towards Carlin's Cairn, it was like treading on animal fur. Soon the ground was studded with tiny plants of fir and alpine club-moss, the former like minuscule conifer trees. The woody twiglets and darker glossy leaves of the prostrate dwarf willow were woven into the bright orange-tinted mats of blaeberry. Higher up some patches of ground were barren and stone-littered. Woolly, grey-green fringe-moss (*Rhacomitrium*) became more frequent. The muted, yet wonderfully varied, colours of the ground-hugging vegetation always make me wish I had brought painting kit with me. Rough notes with coloured pencils can supplement memory, but it is hard to capture just the right tones and colours back in the studio. Of course the weather on the mountain tops is usually against any attempt to paint there, on the ambitious scale which this severe landscape seems to demand. Even today, when in the garden it would have been sunbathing weather, the wind was chilly and cloud was building by the time we reached the great crumbling pile of stones which, for generations, has crowned Carlin's Cairn. When McBain saw it in the 1920s he thought it consisted of more than 100 tons of stones but it looks more disintegrated now. I always used to expect a pair of wheatears at the cairn and it

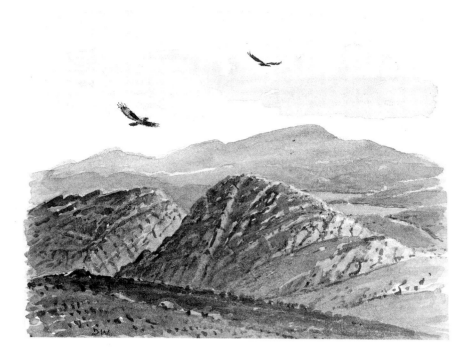

must often have held their nest. We saw none there this time and my impression is that the wheatears of these high places are fewer now. Once when a friend and I were walking over the high slopes of Carlin's Cairn a hen wheatear flew from almost under our feet. By carefully lifting a stone for a moment we could see the clutch of pale blue eggs in the nest, but what most caught my eye was the bright chestnut colour of some tiny feathers in the nest-lining. At once I suspected that these were from the underparts of a dotterel. I took one feather home and sent it to an expert on feather identification. His verdict was that it had to be either dotterel, or knot in summer plumage. Dotterel was obviously the more likely here, though both these waders have been found as kills at peregrine eyries in the Galloway hills in spring, most likely caught on the hazardous migration flight to northern breeding grounds. Little doubt, whichever it was, that the wheatear had taken feathers from a dead bird, probably a kill by a predator.

Dotterels are plovers, a little smaller and daintier than golden plovers, noticeably larger than ringed plovers. They have always been very special birds to ornithologists, being exceptionally beautiful even for a plover, often quite unafraid of man and in this country only to be found in the breeding season on the bare tops of high mountains. Happily the days are gone when great numbers were shot for sport and for their flesh or feathers, which were in demand by fly-fishermen. Clutches of their exquisitely marked eggs are still sometimes taken by collectors. The history of dotterels in the Southern Uplands is tantalisingly vague. Old accounts have the reader guessing whether the writers knew more than they were prepared to tell or had not much knowledge of them. My personal experience of them over more than 30 years, is just enough to keep alive a sense of expectation as I walk the high ground in summer. 'Trips' or parties of dotterel had been seen earlier this month, but these may have been on their way to Highland nesting grounds. I was hardly surprised when I scanned every yard of Carlin's Cairn in vain for a running bird with a neat black cap and white chevron down the back of its neck.

86

Our time was running out and we had begun to head downward when I turned for a last look at the austere heartland of Galloway, the great granite faces of Dungeon Hill and Mullwharchar, surely the sternest landscape in the Southern Uplands. Island-studded Loch Enoch lay blue and placid on its high plateau with the purplish mass of Merrick rising ever sombre beyond. How surprising that here in these miniature highlands of Galloway we have in Loch Enoch what has been called the highest loch in all Scotland! I made a quick sketch of this fleeting vista and from this later painted a picture, a retrospective impression, not very topographically accurate, of the heart of Galloway.

31 May Unknown Galloway

After taking P. to Dumfries station there were many options for a diversion on the way home. We first thought of a butterfly hunt along the old railway track by the Dalbeattie road, but gathering clouds deterred us and we headed for the mazy countryside south of Corsock village, where a cluster of small lochs can be found with the aid of an Ordnance Survey map. We turned up a 'no through road' with many hawthorns bursting into bloom and left the car at the start of a grassy track. I knew that the farmer of this land was my friend Dougie, last met at Grobdale in April, and he would not mind us doing a little exploration round the Black Loch — one of many so named in Galloway. Three cud-chewing goats eyed us disdainfully as we passed a very Hebridian-looking assortment of tumbledown sheds under the trees. A leaning chimney suggested this could be home for someone, in Africa it would have housed a large family, but there was no sign at all of human life. I would not have been surprised if some large ferocious dog had rushed out at us. I was also reminded, not for the first time, that there are corners of 'unknown Galloway' very like the pastoral foothills of the Massif Centrale.

Sun between showers gave an extraordinary brilliance to a cock yellowhammer on a grassy bank. A hen flew down beside it, her bright russet rump exposed between drooped wings. The breeding season for yellowhammers must be among the longest of any British bird, but I doubt if in Galloway eggs are ever found as early as March, as they can be in southern England. I have seen young still unfledged in September on a roadside bank above New Galloway.

While we were standing by a goat enclosure a tree creeper was collecting food from several nearby tree trunks. Watching it I was sure we would soon see it fly to feed its young, but it kept coming to trees on either side of us and retreating again. At last the penny dropped — it wanted to come to exactly where we were standing, so *we* retreated and saw it quickly fly to a panel of corrugated iron at the back of the enclosure and disappear behind it. On a close look all that could be seen were a few loose strands of nest material, the young obviously hidden in the dark recess beyond. The commonest nest site for tree creepers is behind the loose bark of a tree, but the excellent *Fieldguide to Birds' Nests* lists a variety of sites on artefacts including behind noticeboards. This one was in a very similar situation, about four feet from the ground. How safe would it be from rat or stoat? Professor Maury Meiklejohn liked to tell how his father, who had collected the eggs of almost every British breeding bird, would never take those of a tree creeper because it was such a confiding and totally inoffensive little bird.

The Black Loch twinkled invitingly beyond a scatter of birches. I would not have been too surprised if somewhere among the emergent vegetation a pair of rare grebes were lurking. It looked like one of those lochs that would not easily yield its secrets. Two young coots swam to

their parents through a great spread of white and yellow waterlilies and bogbean. A long line of white cotton-sedge fluttered beneath a thicket of willows. Trying for a better viewpoint we were soon foiled by thickening woodland, a typical little enclave of old Galloway hardwood, mostly birch, rowan and beech, some of the latter massive and spreading. In high summer bracken could be waist high in the more open patches, now the ground is carpeted with wood anemones. A pair of buzzards were nesting not far away, garden warblers and tree pipits singing. Then, as we came to some straggly rowans along the line of an old fence a cock redstart flashed into view and perched briefly in full sunlight, its white forehead gleaming above the black throat and orange-red breast. When a hen too perched on the fence wire I hoped it would lead us to a nest in one of the many cavities in the old trees, but we were not so lucky.

Canada geese have recently started colonising some of the lochs in this part of Galloway. I am not sure how welcome they are to farmers but Dougie had no complaints the other day. Certainly the pair we saw on Loch Lurkie this evening made a striking spectacle, with black and white heads held high as they eyed us warily from among the reeds. A pair of tufted ducks looked likely to nest there too.

9 June A hen harrier's nest

On 17 May Geoff Shaw had been my guide in a successful hunt for a hen harriers' nest in a vast area of young forest on heathery moorland. Sadly I could not find time to return to this remote and lovely site to watch the pair at length, but the memory of that day lingered. Under licence from the Nature Conservancy Council we had looked at this nest when it had a clutch of 6 beautiful pale blue eggs. In my early days of harrier study I had usually not visited nests at this stage, fearing desertion, but experience has taught me that the risk of this is negligible after the very beginning of laying. Disturbance of a pair when they are selecting a nest site can, however, drive them elsewhere.

I knew there was a good chance that one of my more local pairs which I wrote about in April would now have hatched young. I had seen a food pass in May, enough to give a good indication that the nest was close to a successful site of last summer. To pinpoint the nest might still be an interesting and not so simple exercise. It could be on either side of a steep valley, partially tree-covered on one side but mostly unplanted on the other. On the latter side the slope was steeper with fairly deep old heather through which bracken and lemon-scented fern was growing up. Last year the nest had been here, an unusually open site for a forest nest, though the bracken and fern provided good shade for the chicks when they were big. It had looked vulnerable to a fox if there was one about. From what we had seen of the pair this year, both Stephen, the ranger, and I were inclined to think the nest was on the other side of the valley, in heather, among quite small conifers. The best plan was to find an observation place some distance away, if possible with some concealment, and wait for the male to arrive with food. The female would probably then fly from the nest and take the food in a mid-air drop by the male. Then the problem would be to keep the binoculars on her, bearing in mind that she is more likely to fly to a different spot first and stay there, feeding or plucking, for 5–10 minutes before taking the prey back to the nest. If my observation post was too exposed or close the male might abort his approach and I would learn nothing. Worse still the chicks might be old

enough for the hen to be off the nest and she might spot me before I had taken up position, then just continue circling overhead 'whickering' until I left the area.

At 1.15 I began to walk slowly along nearly a mile of ride, deep in heather, molinia grass and bog myrtle clumps, aiming to watch from above the steeper, open side of the valley. I hoped the male was far away hunting and would not come in till I was settled. I finally found a spot where I could command a fair view of the opposite, planted slope and it seemed a good bet that the nest was over there. Cold rain began to fall, the big hills at my back disappeared into cloud and I was beginning to feel despondent, when at 3.30 I sighted the pale grey male approaching across the valley, a foot lowered grasping prey. Just as I had hoped the big brown female rose to him expertly catching the dropped prey. She seemed to rise from deep heather among the trees across the valley — it looked like an ideal site for the nest over there, but she flew straight into the steep hidden slope on *my* side and I could only guess where she landed. Still feeling elated I was confident that in a few minutes she would fly back among the trees and confirm that the nest was over there. The male had gone, 10 minutes, 20 minutes passed, my arms tiring of holding binoculars, and not a sign of the female flying back across the valley. Watching had become difficult in persistent rain — could I have missed her go back, or was the nest really on my side? If so why had she apparently risen from the opposite side in the first place? If chicks had hatched they could hardly be old enough for her to leave unbrooded in wet weather.

The rain lessened, time was running out. I would have to be clear of the forest before Stephen might be out deer stalking. I began to persuade myself that I must have missed the female flying back to that promising-looking patch among the trees across the valley, but I could make a quick search on the near side first, judging as best I could where I had lost her as she flew in. If indeed she was now on a nest down in this hidden ground, the chances of finding it were slim in the time I had.

I started down the slope, which was even steeper than I remembered, but had not covered more than a quarter of the descent when, amazingly, the female harrier rose — a startling revelation of white rump, barred, spread tail and trailing yellow legs — from the nest right ahead of me. The line I had taken was very much a guess and I doubt if I have ever been quite so favoured by luck in finding a harrier's nest. So she had indeed flown straight to the nest after the food pass and when I saw what it contained I knew why. There were 3 very newly hatched chicks in their pinkish down and 2 unhatched eggs. When I first saw her flying to the male she must surely have already been in mid-flight and I had been deceived in thinking she had risen from the trees on the other side. For obvious reasons I made only the briefest inspection of the nest before making my way back up the hill with a spring in my step. The nest was quite neatly built of heather and old bracken stems, conspicuously lined with pale, buff-coloured molinia, sited on a slight shelf among rank heather plants. Like many I have seen in recent years this female harrier was fairly mild and merely circled me calling shrilly. I can give no convincing reason why the proportion of aggressive birds which attack and even strike a man at the nest has much declined in this part of Scotland. From the ride I glanced back, well-pleased to see the female harrier planing low over the heather slopes and on the point of returning to her chicks.

It was interesting that nests in two successive years had been on open heather slopes, not far apart. The many previous nests I had seen in afforested ground had been within plantations,

often deeply hidden among the trees. The implication might be that the same female harrier had chosen the sites for the nests, but this appeared impossible since last year's female had been missing presumed dead long before her chicks flew. I thought the male, a very mature bird and obviously an excellent provider, was probably the same in both years. Did he select the site?

11 June *An eagle day*

Dick R. and I were joined at our rendezvous by young Juliet V., looking forward to her introduction to a golden eagle chick as a change from her dipper study. Dick greeted me a little ashamedly. How could he have forgotten that this was Election Day?, adding in his quiet voice 'after all we have suffered'. (His background is coal-mining in Ayrshire.) He had hoped that Ken B., a police sergeant and a bird-ringer, would be with us, but not surprisingly he was on duty. Most days, summer or winter, Dick is out on the hill somewhere in south-west Scotland. He has a unique knowledge of raptorial birds and their nesting places over four or five counties. I have never asked him his age and presume that like myself he is well past normal retirement, but he walks the roughest country with apparently untiring strides. He does not believe in wasting words, but never hides a boyish joy in telling of a successful nesting by eagle, peregrine, merlin or harrier. Philosophical about many disappointments he has tried every method to safeguard his birds from their many human enemies. His seriousness is tempered by a delightful teasing humour and his letters are minor masterpieces of instant description, which have often brought the Galloway countryside to my breakfast table.

We had hardly walked 100 yards along a sunny path between tall clumps of bog myrtle before we saw first one, then another adder coiled at the side. Moments later a butterfly rose — only my second small tortoiseshell of the summer. Whinchats alarm-called from the bracken and cross-leaved heath coming out; grassy slopes were bright with yellow tormentil and pink lousewort. Our objective was a rock-nest of a pair of golden eagles where the chick, the only one in Galloway this year, would be 40 days old if it had survived.

The history of golden eagles in south-west Scotland is better documented than for many less imposing birds. Until the end of the eighteenth century both golden and white-tailed (or sea) eagles were rather plentiful in Galloway — they were known as 'black' and 'grey' eagles respectively. In those days there were ptarmigan on our highest mountains and the eagles

preyed on them. As gamekeepering intensified through the nineteenth century both eagles became rare and the last white-tailed eagles in Galloway bred at Cairnsmore of Fleet about 1866. Golden eagles apparently ceased to breed regularly well before then, but a pair nested unsuccessfully in 1905, and there were nests in Ayrshire in most years between 1910 and 1923. Several times egg collecting prevented them rearing any chicks — golden eagles very rarely lay again after a clutch has been lost. It is doubtful whether any nested during the 1930s, but the absence of human persecutors during the war years almost certainly helped their re-establishment in the 1940s. In April 1946 the young Derek Ratcliffe was searching for peregrines and ravens on a Galloway crag when he discovered a huge mass of flattened sticks littered with bleached bones, 'nearby lay a great primary [feather], old and dirty'. He had found the nest which evidently contained a chick or chicks in 1945 — what excitement he must have felt at that moment! He concluded that they did not breed there in 1946, but many years later I discovered by chance that a local man had seen a successful nest that year, less than a mile away, on an insignificant crag. Next year two chicks fledged from this site and were photographed in the nest. From then on it became fairly widely known that golden eagles had returned to Galloway, but for many years rather few people ever saw them. I will not forget my first look down on a nest with eggs in 1956, when concern about egg-collecting led some of us to set up a watch to guard the nest — we were very upset when it was deserted, possibly because a watcher had been too close for too long. For some years now no eagles have nested in that area probably because the great spread of afforestation has made it impossible for them to find enough prey. Jeff Watson has linked a 30 per cent decline in eagles in mid-Argyll to afforestation there and expects this to continue.

To return to 1987, we were in a different eagle territory, which retains a good deal of open moorland. The eagles here have a special fascination for me as I have known them since they began nest-building in 1968–9. Since 1970, when eggs were first laid, they have failed to rear a chick in only three summers, an exceptionally good success rate. Dick and I are sure that the same pair have been there all this time and are therefore more than 20 years old. The female is the most confiding eagle we have ever seen and Dick has been directly below the nest while she remained brooding, merely peering down at him. This year the nest is in her second choice site after last year's nest collapsed at the end of the season. There may even be some advantage in this year's site as it seems an unlikely place for such huge birds to choose and so might not attract unwelcome attention.

We were about a mile from the nest when the male showed up just above the skyline. I liked Dick's comment regarding differences between male and female at long range: 'The female looks like an eagle, the male looks like a bird.' In other words the female is noticeably bigger, has a greater wing-span and could not easily be confused with a buzzard. The slighter build of the male makes him a little more buzzard-like at times but even the largest buzzard is far smaller than any golden eagle, though size can be very difficult to judge when a bird is soaring.

The chick, still mostly in snowy-white down, was obvious from some distance. The nest on a broad flat ledge had been thrown together hurriedly after an earlier start at building had been abandoned at the more usual place. Both parents were keeping a discreet distance, the male alighting for a time right on the skyline, where Juliet at first thought he looked more the size of a man than an eagle.

While Dick and Juliet went off in search of pellets cast at a favourite roosting spot, I took a

long look at the chick, sketchbook in hand. It was already as big as a small turkey, arching and spreading its wings and boldly lunging towards me. Even at this stage an eaglet has a formidable hooked bill, black except for the astonishingly bright yellow cere and gape. Huge, dark brown eyes watched me from beneath frowning brows. It was at the piebald stage, still almost white on head and underparts, but with a mass of dark feathering sprouting on back, shoulders and wings. Young eagles when fully fledged are mostly rich purplish-black, much darker than the old birds and much deeper tawny-gold on crown and nape. Far their most distinctive features, of course, are the gleaming white patches on tail and wings which contrast with the darkness of the rest of their plumage. Watching last year's young eagle flying with its parents on a sunny day in July, I thought it the most strikingly beautiful of the three. On this year's chick tiny black feathers like bristles were just beginning to poke through the white down on head and breast, the latter stained yellowish from feeding, like a child's bib. The great yellow toes were held limp and furled, the legs enclosed in down and feathers, unlike the bare yellow legs of white-tailed eagles.

Our visit to the nest had been under licence from the Nature Conservancy Council, but we had soon stayed long enough to gather the information we wanted. A last look at the well-fed chick — the only prey remains in the nest consisted of the hindquarters of 3 young rabbits — and we were on our way downhill.

21 June Barn owls in a dovecot

Ian L. is a craftsman from the city of Birmingham, but has found fulfilment in studying birds scientifically. He will shortly be writing his PhD thesis on barn owls in Dumfries and Galloway. I could give other examples of young people who have come here in recent years and contributed positively to nature conservation and knowledge of the environment. Few would deny that they are doing valuable work, but the opportunities for full-time employment in the conservation field are still far too limited.

Ian called today to take us to see a brood of young barn owls at a farm in the Glenkens. While there has been concern about declining numbers of barn owls over most of the British Isles, south-west Scotland still has a good number and 1987 is proving to be an excellent breeding year, as it is for short-eared and tawny owls. The secret of this is the abundance of field voles which I have already mentioned. This pair of barn owls catch much of their prey in the clearfelled forest near where I found the short-eared owls' nest last month. The occupants of the farmhouse are delighted to have barn owls in their outbuildings and had earlier shown me a fine series of photographs taken of last year's brood. Ian's last visit had been some weeks ago when there were 3 eggs and he had no idea what we should find. The nest is in a very old dovecot on the front of a hay loft, and the owls' comings and goings are in full view of the farmhouse. We climbed up to the loft from the back. Although it was mid-afternoon neither of the old owls was at home, both possibly out hunting. Ian said this was not unexpected, but it is surprising to me how few barn owls are seen out in daylight at this time of year, when there are known to be many nests in the district. Once the young are sizeable the adults, when not hunting, may roost separately, even a mile or more apart. So a barn owl disturbed from a building in summer may be no guide to where it is nesting.

Ian brought out one chick, then another and another — a brood of 7, no less. He laid them

in a row on the floor of the loft before ringing them. Their ages ranged from 20 to 32 days with marked differences in feather growth, size and weight, but all still mainly clad in thick white down. Clearly food provision was no problem this year — I've even heard of a brood of 8. In the light their big dark eyes were reduced to slits in their long, solemn, old man's faces. They all lay perfectly still and docile. They will not be able to fly until they are 7–8 weeks old, a good deal longer than tawny owls which fledge in 4–5 weeks. A few years ago a pair of barn owls regularly nested in the rafters of a disused church opposite our house and as fledging-time approached the snoring sounds from the chicks could be heard from several hundred yards away.

After returning the owlets safely to the nest (nothing but a smelly heap of their parents' regurgitated pellets) we climbed down just in time to see the female arrive with prey, and disappear into the dovecot.

The dovecot will continue to be a safe place under present ownership, but many local pairs of barn owls have lost their homes when old buildings have been renovated. Happily they will readily occupy boxes, many of which have been put up by owl enthusiasts. The chances of birds being killed on roads and railways are high. Motorists could certainly sometimes avoid striking an owl but trains are another matter: 30 owls found dead in one search of a few miles of mainline railway track tells the story. Unfortunately railway cuttings and embankments are very good places for owls to find small rodents.

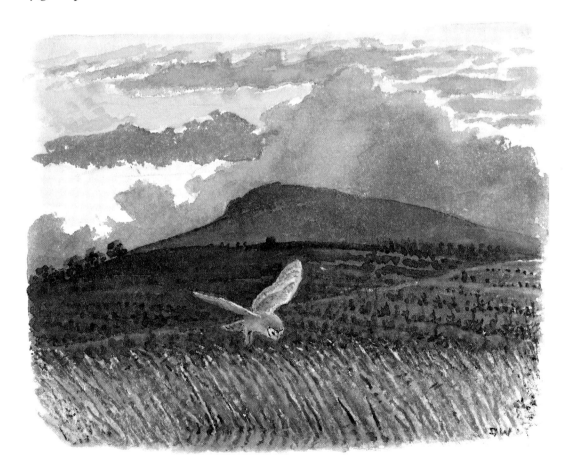

23 June *The garden in midsummer*

We are living behind the hedge now — the hedge being privet and fast making such summer growth that cutting cannot long be delayed. Perhaps it can be left a while yet, to save a second cut in late summer. There is something to be said for being screened from the general gaze.

A few nights ago, in warm muggy weather, I heard a snipe drumming as I stood on the lawn just before midnight. It was not far beyond the dyke at the bottom of the garden, so perhaps a pair have bred down in the rushes after all. The pine trees at the front door are silent now, the rookery forsaken for the summer. I saw the last fledged young being fed in the budding ash tree at the beginning of the month. Occasionally a flock flies over, calling, but they are roosting elsewhere.

Visitors are sometimes surprised by how much garden we have at the back of the house. It cannot be seen from the street and on sunny evenings now it is a special haven. Ian L. says all we lack is a pond and has generously offered to dig a hole for one. Backed by an evergreen hedge the sky-blue flowers of the Himalayan blue poppy (*Meconopsis betonicifolia*) are a delight, though too short-lived. Rashly scything long grass I exposed a garden warbler's nest only inches from the ground in a forsythia. The bird slipped off 3 eggs and I thought she would return if I built up some concealment — but no, she has deserted. There should be plenty of time for a repeat nest. I was surprised to see a fat mole bustling across the lawn this afternoon. Walking in the open the large, hand-like forefeet are splayed out in an extraordinary way, not touching the ground at their extremities; it seems to walk on its wrists. I have seen no fresh molehills in the garden recently and our velvet visitor fortunately soon lost interest after some superficial scuffling on the lawn.

The ground at the back of the house is lower than at the front and so can be ideally overlooked for birdwatching from downstairs windows. When the sun comes out after a long spell of rain birds appear miraculously out of cover. Half-a-dozen or more blackbirds and song thrushes are instantly sunning, spreadeagled in grotesque attitudes, bills open and pointing skyward. They are always interesting to draw at these times. Some years a variety of birds can be watched performing the frantic, possibly intoxicating ritual of 'anting', when they pick up ants and dab them under their wings particularly. I have not seen it this year; the ant colony under the stones by the bird bath has not been evident so far. One hen blackbird with a white nape which was usually seen in a neighbouring garden until recently, has started to occupy the prime territory in our garden, having replaced or supplanted a normally-coloured hen which had a bill almost as yellow as a cock's. Piebald blackbirds are of course common enough, not so memorable as the two pale orange-buff coloured young blackbirds which came from a nest in a neighbour's hedge three years ago. These were a really lovely colour. One which stayed with us till September we unflatteringly dubbed 'the cream bun'. Hopes that one or both would survive to breed did not materialise, unless they went elsewhere.

I have failed to spot the goldfinches' tiny nest, but suspect they have one far out on a branch of a Scots pine. Both chaffinches and greenfinches are feeding fledged young below our windows. The swallows still have young in their nest in the garage while a new pair have suddenly become possessive of the back porch, so we have left the outer door open. They make excruciating high-pitched sounds whenever we go out that way and have built a nest

foundation right over the inner door. Most likely this will come to nothing as happened last June above the front door.

It is hard to say whether swallows or spotted flycatchers are my personal favourites among our summer garden birds. Our first pair of flycatchers nested in a box on the house over 30 years ago and fed their fledged young on the children's playpen. One year a pair built in a little recess on the rough trunk of a big gean tree, but every other year the sites have been on the house itself, either in an open nest-box or among Virginia creeper, or on a roan-pipe junction, which is where the nest is this year, now containing four small young. The brooding bird does not fly off when we look down on her from the bathroom window. Last summer three nesting pairs were in view from our windows concurrently and this year there are two.

On Saturday the main street of the village was thronged with people from near and far for the biennial Clachan Fair, for once blessed by high summer weather. Now all is normal again and swifts, swallows and house martins are flying low among the rooftops. The creamy flowering of rowans is waning and soon it will be elder flower time. I have already heard the first flight calling of the curlews as they begin to pass over the village on their way to the valleys and the shore, a poignant reminder that midsummer is past.

24 June *Highland Interlude — going north*

Before we left home to drive north I spoke to the forest district manager about a problem that has arisen with the harriers' nest I found on 9 June. The Army has suddenly moved in and encamped just above the nest. When Stephen went out early yesterday in search of deer he found a detachment of infantry deployed across the hill and firing blanks — he had had no prior word of this. I was pretty furious when I spoke to Mr Michie who was very understanding and said the Army should not be there as it was a conservation area. He promised to send a forester up to 'get them moved'. As the exercise has apparently been going on for several days I could not be very hopeful that the nest would survive. There was no time to find out before we set off for the Highlands.

At the head of the Dalveen pass the uplands were summer green at last. At almost any other

season those steep-sided hills, textured like the rough hides of giant mammals, have the most wonderful variety of strong yet subtle colours. Not that they are uninteresting now; the wide expanses of open sheepwalk refresh the eye after a surfeit of Galloway's conifer plantations (although there are some here too). It is a landscape still rich in breeding birds. When we stopped for lunch, skylarks sang above and across the road in pasture bright with buttercups and sorrel, lapwings, curlews, snipe and oystercatchers all had chicks hatched. A snipe, bent-legged on a fence post, called 'trick track' and a curlew chick, lanky and straight-billed, ran through long roadside grass. We enjoyed this parting cameo of the south-west before heading out on the big road through central Scotland towards the immensity of the Highlands.

The great heather slopes of Atholl and beyond still sweep down to road and railway, but 30 years ago on my journeys along the old road in an unreliable motorcar the wilderness seemed closer. The little Highland towns are all by-passed and yearly become less familiar unless diversions are made to savour them again. Kingussie at least is still recognisable, Aviemore hardly at all. We crossed the bridge to the Black Isle, roadside embankments ablaze with broom. Last year we had come this way earlier, at the peak flowering of gorse, nowhere finer than on the Black Isle. Three weeks later this year, the fields of oil-seed rape no longer made so many brilliant yellow enclaves among green fields. Oil-rigs still stood sentinel in the Cromarty Firth, Ben Wyvis snow-flecked to the north, as we drove the last few miles to Jeff and Vanessa's cottage beside buzzard-haunted woodland a couple of miles from the tiny village of Jemimaville.

26 June A dotterel day

This morning Jeff and I were on our way for a day on high ground. In Galloway the approaches to some of the best hill walks can be complicated or simplified, according to whether you have permission to drive your car on Forestry roads. Here in Highland deer-stalking country I could happily rely on my son's access arrangements as an assistant regional officer of the Nature Conservancy Council. Even so he had to check that a formidable gate would not be locked on our return — a five-mile road walk to get the key at the end of a long hard day did not bear contemplation.

We left the car at the foot of a steep slope thick with old heather. A deer stalkers' path was at first a boon, zig-zagging conveniently. We passed clusters of birches in a cleugh that looks as if it should be home to a pair of merlins but we saw none. In this huge landscape birds like merlins would appear to have countless options for nest sites, but plentiful prey may not be so easy to find. We saw very few meadow pipits all day, but the expected buzzard sailed up from the birches and cuckoos were still in good voice. Jeff said the nearest eagle eyrie was quite distant. Once we had negotiated a deer fence we soon had easier walking on the high ground, making a detour to look at the plants on a rock face where Jeff had previously noted several species which only grow in a base-rich environment, the rarest we saw being the inconspicuous Arctic saxifrage (*Saxifraga nivalis*). The beautiful flowers of purple saxifrage were almost over. The common starry saxifrage was there too and clumps of yellow saxifrage beneath a dripping rock face. On the slopes of this Highland mountain the heathy mat underfoot was more varied than on comparable ground at home, including three species of *Vaccinium* as well as crowberry, black and Alpine bearberry and the tiny pink-flowering

trailing azalea. As we climbed higher the ground became a yielding carpet of grey and gold fringe-moss (*Rhacomitrium*) flecked with white *Cladonia* lichen, like fragments of frost-coated twigs. These are a favourite nest-lining material for the dotterel, the bird we particularly sought on this expedition. Jeff had already found nests and we hoped to find downy chicks not far from where they should have hatched. Most likely there would only be one old bird with a brood, the male, as dotterels belong to the exceptional group of birds in which incubation and care of chicks is left largely to the males.

By the time we ate our sandwiches, on the first mini-summit, the weather had worsened a little, ragged banks of heavy cloud threatening from the east. From the start it was obvious we were not in for a warm summer's day and the wind when the sun went behind cloud was chilling. Fickle weather brings the most exciting visual effects to mountain scenery, provided visibility is not altogether lost in low cloud. All day long it seemed that this might happen and every now and then cloud enveloped us, but never for very long. Often the cloudbanks swept north of us across the dark wild landscape of Sutherland, while south and east the sky was blue and the sun shone on a bright patchwork of fields and woods.

Our first dotterel ran tall-necked down a gentle slope ahead of us. It was clear at once that it was a male and somewhere a chick must be hiding. It was only going to be possible to find it by retreating and watching from a distance and at this point low cloud and rain suddenly arrived again. Rather a wary bird, this cock dotterel was not giving much away, but eventually Jeff's keen eyesight caught a movement of the chick. After he had ringed it, the rain having passed, I made a quick sketch using black and coloured pencils to record the intricate markings.

Dotterel chick, 1987

It was perhaps a fortnight old, the first feathers sprouting among down and already showed a clear russet tinge on its flanks. Through the afternoon and evening we found four families, two with two chicks and two with one. From the usual three-egg clutch better numbers might have been hoped for but Desmond, the authority on dotterel, says that chicks 'die like flies' in their first weeks of life.

We were engrossed in dotterel-watching when we heard a quiet croak, almost a mutter.

Suddenly, from nowhere, a pair of ptarmigan with necks craned nervously, were eyeing us just ahead, white wings partly opened for impending flight. For a few minutes they stood still, the greyer male more alert-looking than his mate. Clearly they had no chicks and were quickly gone, planing away down a steep slope. Nowadays ptarmigan are regrettably absent from my home hills, none having been seen in Galloway since before 1840. Once they were plentiful there and nobody knows for sure why they died out, but there has for long been a withdrawal from western and southern parts of their old range in Scotland. Was their food, mainly montane plants, impoverished by the great invasion of sheep on the tops? Attempts to re-introduce them to Lanarkshire a few years ago seem to have failed, though occasional sightings are still reported. Perhaps the pendulum might still swing back as there has been a recent natural return to the island of Arran.

We sat in the sun on a broad mossy slope, looking down on dark chocolate peat haggs and watery runnels. There had been a dotterel nest on the high ground beyond and we soon spotted a male with 2 widely separated chicks feeding in this wet area. Interestingly they had not been taken to the dry summit ground as commonly happens. It was fascinating to watch the tiny long-legged chicks successfully negotiating thick mats of grass so rapidly that they were difficult to keep in continuous view. When they were later caught and ringed the male parent went through the whole gamut of distraction display, running all round us in a crouched posture, waving one wing high, the other trailing, tail fanned and showing all the eye-catching white tips. Sometimes he almost burrowed into the ground with his tail raised. The air was full of his sweet wild notes. Just as we were about to release the chicks together there was a burst of dotterel music as two birds swept past, another male pursuing a brightly-coloured female. It looked like a thoroughly hostile chase. The male with chicks leapt into flight and chased her too, but moments later when he had gathered the chicks to brood them, the female alighted nearby and was accepted in his domain without animosity. Might she be the mate of both males?

Our last dotterel brood had also been brought downhill. They were almost at the limit of our walking range for one day. Jeff showed me the empty nest, a perfectly circular little depression looking quite conspicuous now that the white lining of lichen chips lay uncovered. By now I could only stand back and admire how Jeff took his search for the brood to exactly the right area.

What an unforgettable day! It seemed to me as we came back across a great expanse of high mossland, now golden in evening light, with the lower slopes in deepest shadow, that this had to be the most wonderful country in all the world. We had been twelve hours on the hill.

27 June A west coast day

From Conon Bridge at the head of the Cromarty Firth in the east, to the head of Loch Broom in the west, this neck of Scotland is less than 30 miles across as the crow flies. From our base on the Black Isle we could range daily into landscapes of extraordinary variety. Weather too could be entirely different; while the Black Isle was bathed in sunshine the rain could be teeming down half-way to the west and beyond. This time we were lucky. Over at Gruinard Bay young Ronan played in the warm sand beside a shimmering sea. On such a day the beaches of the north-west Highlands are rivalled only by those of the Hebrides. From where

we picnicked in the dunes the tip of Gruinard Island, now said to be cleared of anthrax residues, looked as inviting as any other offshore western isle, but its sinister wartime role will surely never be forgotten.

This was a family day, enjoyed by three generations. Not more than half a dozen other people had found this lovely beach today, though no doubt there would be quite a few more when the holiday season was in full swing. Ringed plovers evidently had chicks on the shingle at the top of the beach. On many coasts nowadays they have lost the struggle with human disturbance at nesting time, especially where there are large caravan sites. I had not thought to see great northern divers here at the end of June, but at least two were offshore, just close enough for positive identification. In winter they are seen in large numbers in Gruinard Bay and elsewhere along this coast. Perhaps the oddest bird spectacle of the day was a rock dove making diving attacks on a pair of buzzards, circling over the birch woods above the shore. Earlier in the day we had scanned an inland cliff for an eagle's eyrie. It had been uncertain at long range which of two nests was in use, but in the evening, around six o'clock, the answer was provided. One of the eagles was at home, feeding two dappled chicks in an immense nest extending for 8–10 feet along a formidable ledge. This and the eyrie I visited in Galloway recently could hardly have been more different.

Somewhere not far from the western seaboard we had passed a pair of stonechats in the heather. No bird is more indicative of the contrast between the east and west coasts of Scotland. Its virtual disappearance from the east has followed severe winters, while in the milder west it is still a common bird.

28 June *An east coast day*

Orange cliffs, blue sea, yellow gorse and the trim white houses of Cromarty in sharp summer sunlight. We strolled out to the headland called the Sutors where a century and a half ago the young Hugh Miller began his lifelong obsession with rocks and fossils. Taking down my aged copy of *My Schools and Schoolmasters* one evening I became engrossed in reading his marvellous evocation of boyhood in Cromarty. Because my paternal grandfather had been the master of a clipper sailing out of Aberdeen, and Hugh Miller's father the master of a Cromarty coasting sloop, I felt a small sense of belonging to his east coast seafaring community. The account of the night when his father and all hands were lost at sea in a great storm has a poignancy still all too familiar in this corner of Scotland. 'All flesh is fish in Cromarty' joked one of Hugh Miller's wise old uncles, from whom he absorbed most of his early knowledge of sea creatures. Now, perhaps, his writings are most interesting as social history of a time when many young Scots were drifting from the country to seek work in the cities. The story of his 15 years as a stonemason is as compelling when he is writing of harsh bothy life in Ross-shire, as of Edinburgh during the booming years of New Town building. How many Edinburgh folk today have read and pondered over the passage in which Hugh Miller wrote that few stonecutters in the city lived beyond the age of 40, killed by the dust in their lungs or alcohol-related disease? When he joined some of his mates in a dram shop in the Canongate the devout and sensitive youngster from Cromarty was horrified to find that badger-baiting, in a sort of dungeon below the drinking shop, was the usual entertainment.

How astonished Hugh Miller would have been today to look out from the Sutors on oil-rigs

and construction yards across the water. He would probably have been fascinated by the whole saga of oil from the North Sea. Yet the Black Isle, though not quite an island, has remained inviolate from such developments.

At Udale Bay, a nature reserve, waders including the first southward-bound whimbrel were gathering and common terns flew by with slow emphatic strokes of their slender wings. Through binoculars I could make out the tiny torpedo shapes of auks, guillemots or razorbills, plunging seaward from the North Sutor. Buzzards were mewing above the hanging woods round by Blue Head and hunting rabbits within sight of the houses of Cromarty.

We looked across the calm sunlit Moray Firth to Nairn on the far shore and all the little towns scattered eastward along that far-flung coast. To the south, above rising sweeps of heather moor, the Cairngorms were still well patched with snow. At this long distance they looked quite diminutive.

1–5 July Highland rarities

When I told a friend at home that I had seen Temminck's stints at a breeding site 'somewhere in the Highlands', his response was, 'Oh yes, a birdwatcher I met in Norfolk gave me a map reference of where to find them'. Some readers will ask what is the harm in doing this? Most birdwatchers, they will say, are careful to avoid doing anything that might lessen the chances of a rare bird nesting successfully. But too many feet trampling lush summer vegetation, tracks left which may encourage ground predators or somebody's friend happening to be a covert egg collector — there are many ways in which the risks to the birds can be increased. Temminck's stints have nested at up to five localities in Britain in one recent year, but they are still one of the rarest British breeding waders. I never expected to see them myself and must admit that my chances of finding a pair unaided would have been minimal. Most experienced birdwatchers are familiar with little stints as passage migrants on British coasts and both species are often seen by those who travel abroad. Long ago I saw them in winter quarters in India and more recently in Mediterranean islands and in Africa, but I had never before seen Temminck's stints in their nesting haunts. In their summer dress they are very much like small common sandpipers, rather brown little waders, but even at a considerable distance, when size is difficult to judge, it is obvious that they do not have the common sandpiper's habit of continually pulsating their tails. Our friends Desmond and Maimie Nethersole-Thompson, in their book *Waders*, say that at first glance one might be watching a common sandpiper chick. Of course all stints have very short, thin straight bills and in flight the white, outer tail feathers of Temminck's are specifically distinctive.

It was a cold rainy day when we watched more than one pair moving between estuarine mud and a very ordinary looking rushy field where they clearly had chicks. In this weather we resisted the temptation to search them out.

When I was very young my eldest brother was fond of teasing me about rare birds. He would point to a gloomy looking wood on a distant mountain and say 'I bet that is full of barred warblers' (or some other rarity that we would love to see). There was absolutely no chance that we would find out, but we younger boys were totally sceptical. The Highlands might have crossbills, crested tits, dotterel and greenshank, but we were confident we knew the limits of what could be expected. Not so today. Every young birdwatcher knows that the

list of unlikely species proved to have nested in the Highlands grows longer almost annually. It is thought that climatic change, particularly springs with prolonged cold north and easterly winds, has induced some of the migrant bluethroats, wrynecks and others to stay and nest in Scotland instead of travelling on to Scandinavia. A recent note in the journal *Scottish Birds* is very intriguing in this respect. It details the finding of bluethroats as prey of merlins at two places in the Highlands. No doubt the numbers which have nested are far greater than the two proven instances (in 1968 and 1985). The same probably applies to a whole range of birds, but how many of them are really new? The huge increase in young sharp-eyed birdwatchers, many with great expertise, has so much advanced the chances of detection. Yet it is striking that successful colonisation of the Highlands has varied sharply between closely-related species. In 1984, while there were possibly nearly 80 pairs of redwings nesting in the Highlands only one pair of fieldfares was found. I learned with interest from the report of rare breeding birds in *British Birds* that many of the redwings were nesting in Sitka spruce plantations! It need hardly be said how difficult it could be to find such nests.

One day of smurring rain Jeff and I watched a wood sandpiper flickering above a great watery strath. Again it was no day to look for the chicks, which were undoubtedly hiding in the long vegetation. Not far away greenshanks were fussing over chicks too. This was rich bird country, with a chain of lochs, and the car-borne watcher could easily see red and blackthroated divers, wigeon, common scoter and much more. Looking down on a pair of

blackthroats, sadly without chicks, I as always found myself marvelling that their domino backs could be mere feathers. The fine lines which set off their purple-black throats seem to have been drawn by a single hair of an artist's brush. A recent survey concluded that there were not more than 150 pairs of black-throated divers in Scotland, but this number is fairly stable.

We spent a very different afternoon exploring a remnant of what was probably once a vast forest marsh. Its existence would hardly be suspected from any distance, as it is difficult to overlook from nearby and well-screened by modern plantations of Scots pines. Somewhere in a pine tree out on the flat boggy ground we knew there was an ospreys' nest. It was the sort of country where it would have been easy to lose all sense of direction, much of it treacherously spongy, with a thick mat of sphagnum merging into impassable marsh. The colour scheme of lemon, green and pink sphagnum, mingled with the grey and madder of ancient heather was very lovely. In places there had been peat-cutting in the not distant past and the bare patches ranged from almost black to fiery orange in colour. The ground was quite floral between the

pine trunks; butterwort with its pale rosette of sticky leaves, round-leaved sundew and the starry white flowers of chickweed wintergreen catching the eye particularly. At the side of a forest track we saw good patches of the pink-flowered common wintergreen (*Pyrola minor*). A band of tits searching the pine needles were mostly coal tits, many of them yellowish-faced young, but Jeff heard the call of a crested tit momentarily. This and the capercaillie, which has been found here, stayed elusive. We wondered if it had been capers which had scratched up the moss under a clump of pines, but found no tell-tale droppings or feathers.

It seemed that it might be difficult to pinpoint the ospreys' nest, though we were quickly aware that one of the pair was overhead, a fish in its talons and anxious at our presence from its persistent whistling calls. Suddenly a little vista opened between the near pines and the nest was obvious, though quite distant, with the second osprey perched upright beside it. Evidently it contained chicks, but they were not big enough to be visible from the ground. We lingered a while, enjoying the spectacle of these dramatic birds in their very private forest marsh.

On our last evening in the north I spent an hour with Jeff on a little competition. We added up the numbers of bird species which have bred in Ross-shire and Dumfries and Galloway respectively, roughly comparable areas for size, in the last 10 years. The result was rather astonishing — a tie at 141 each including 15 peculiar to one or other region.

Temminck's
stint, 1987

6 July *Some reflections on nature conservation and landscape in the Highlands*

The latest in the long line of Highland controversies is billed as 'Nature Conservation versus Jobs'. Or so it seems to the Highlands and Islands Development Board and a lot of people in the Highland Region. Of course it need not be like that. It might be a good idea if the members of the HIDB and Highland Regional Councillors went to look at Yosemite and other great national parks in North America. There they would see how nature conservation allied to a magnificent landscape can create many jobs and attract many thousands of tourists. Scotland has some of the same ingredients. When Robert Cowan, the Chairman of the HIDB, responded dismissively (and with some inaccuracy) to a report which showed that nature conservation has already provided a similar amount of employment to ski-ing and fish-farming he contrived to imply that conservation-related work somehow has a lower rating. He would not have dared to say this in the Yosemite — perhaps, by the way, it is worth

remembering that the father figure there was a Scotsman, John Muir, whose ideas on conservation in the broadest sense were far ahead of his time.

No major study has yet been made of the extent to which interest in nature contributes to tourism, often cited as the Highlands' biggest industry, but the numbers of visitors to the RSPB's osprey hide at Loch Garten are assuredly some indication. The report I have mentioned, compiled by Vanessa Halhead for the Nature Conservancy Council, reveals however, that 54 per cent of visitors to West Sutherland gave natural history interests as a reason for coming. Regional authorities, landowners and politicians might learn from this not to be contemptuous of conservation. (This point was made recently by a fair-minded leading article in *The Scotsman*.) I wonder what Frank Frazer Darling would have thought about his name being dragged in on the anti-conservation side by Mrs Winifred Ewing, the Euro-MP for the Highlands. In this particular instance Mrs Ewing was performing a favourite political trick of turning a complex case into a simple jobs versus conservation issue. I am told that a proposed development could as well have provided jobs on an alternative site of no environmental sensitivity. The argument that development on the preferred site would do no harm because it was already a bombing range might seem convincing to many people, but those of us with some specialised knowledge know that it is not sustainable. Unlikely though it may appear, bombing ranges apart from the actual target areas frequently provide oases for natural vegetation and wildlife. Birds like hen or Montagu's harriers can nest or roost there much more safely than on grouse moors where they are in danger of being shot, trapped or poisoned. Readers may think this sounds inconsistent with my complaint about soldiers disturbing a harrier nest site (24 June), but there is a difference. The sudden invasion of a hitherto quiet area by a body of men firing blank ammunition is much more disturbing than shells or bombs exploding regularly somewhere in the vicinity.

The future of the flow country in Caithness and Sutherland will probably have been decided before this is read. It is especially ironic that here nature conservation should be accused of moving towards sterilising 'whole counties', when it is the developers, draining and planting the flows with conifers who come closest to doing just this. With its unique flora and fauna the flow country merits preservation on any account and there is surely a case that, in the long-term, nature conservation could bring more jobs and prosperity than badly conceived afforestation ever will. Recently Magnus Magnusson gave the reasons for saving the flow country in an eloquent statement on BBC Television. Nevertheless the argument continues as fiercely as ever.

Landowners in the Highlands, steeped in sporting tradition, have always resisted the concept of national parks: Frank Frazer Darling wanted them years ago. Might they not still offer the best compromise for enjoyment, conservation and employment in the incomparable Highland countryside?

On our way south to Galloway we diverted at Dunkeld to see old friends, Joe and Jessie Eggeling. Joe, a former Scottish Director of the NCC, has lately written a fascinating little book about the Perthshire landscape paintings of Sir John Millais, who has been called the renegade Pre-Raphaelite. He painted a series of Perthshire landscapes late in life and they are very unlike his early Pre-Raphaelite work. Few are well known today and some have disappeared without trace. Joe's researches were responsible for the rediscovery of one, *St Martin's Summer, Halcyon Days*, which the Montreal Art Gallery had lost sight of for 54

years. When it was found that the picture had been away on a long-forgotten loan and the gallery sent a photograph to the Eggelings, they discovered that it had been painted on a channel of the River Braan at the bottom of their garden. For some reason Millais had kept the locality a secret. Joe led us down to the spot where the artist had set up his easel day after day, in the bitter weather of November 1878. As the photograph taken by Joe in 1981 and the print of the painting show, the rocks, river and trees have scarcely altered.

Years ago I admired Millais' more famous *Still October* in the Perth Museum and Art Gallery where it still hangs. In this picture, as in others, his treatment of vegetation is quite impressionistic, but at the same time marvellously realistic. You can hear the autumn breeze rustling the yellow reeds and willow leaves. No doubt it seems photographic to some eyes, but I think it is really a very personal painting, unpretentious and immensely truthful of aspects of the Highland scene as permanent as anything we are likely to know.

9 July Hen harrier fledging time in Galloway

It was a relief to find that the harrier nest had survived the Army invasion after all. I knew that the chicks should be starting to fly before we returned from the north. Fortunately Geoff Shaw had found time to visit the nest and ring the chicks on 3 July. They were by then fully feathered, very vigorous and only just manageable by a ringer on his own. I always think they are beautiful at this stage, with a purplish bloom on their dark brown backs, fierce owlish faces ringed by freckled ruffs and still-growing tail feathers banded and tipped in bright cinnamon. At least here on Forestry Commission land no one will wilfully destroy them. It was no surprise, however, to hear that the only brood found on one Border grouse moor had vanished, presumably killed and buried by a gamekeeper. That was just a few days ago.

As I walked down the familiar ride towards the nest site, through the lush mixture of molinia and bog myrtle, I saw movement ahead. Twin roe deer calves had been out feeding in the broad ride. They made for the trees as I approached, pausing a second to look back. They were just tall enough for their heads and the tops of their still-dappled backs to show above the vegetation. Framed in green their chestnut-red coats glowed with colour, especially on the outsize ears. Half-way along I heard the female harrier's 'whickering' and glimpsed her circling not much above the forest trees. Soon I heard the deeper, nasal-sounding chatter of the male and it was he who came nearer as I went down the steep heather slope. I reckoned that two chicks must already be out and away. The third rose a little unsteadily from the flattened remains of the nest and floated across the little valley, while the male watched and chattered from a larch, using his long tail to maintain balance.

I came back along the ride, in a cloud of midges which seemed undeterred by oncoming rain. The roe calves were out feeding in the ride again. I felt that end-of-season nostalgia for all the past times I had seen young harriers at this fledging time and wished them well in their dangerous life ahead.

11 July Laurieston — Grobdale — butterflies

Westward from Laurieston village the hill road curls and climbs a little between conifer plantations, mostly now over 20 years old. Even at this age there are patches where wind has

flattened or torn up trees at the forest edge. Near Lochenbreck where long ago there was a spa and hotel, the road is shaded by a double avenue of beeches. They have quite an aged look, but have never grown to any great size. I imagine that they were planted in the days of the spa, when they would have stood out on the open moor.

For some years we have known the wide verges between the road and the forest plantations as good for butterflies. Now we wonder if the numbers of some species will ever again be as good as they were in the warm summers of 1983 and '84, or in the mid-1970s. Often the sudden changes in abundance or distribution of butterflies defy explanation. Peacocks, for instance, were so rare in Galloway early this century that the sighting of a single specimen was an event. Yet from the mid-1930s they became quite plentiful and, beautiful though they are, in late years I have taken their presence for granted. Now after two sunless wet summers they are close to being rarities again. Looking back over the past decade I have come to realise that years of great peacock abundance, like 1977, may be exceptional. Butterflies like peacocks, which hibernate as adult insects, may die quickly in spells of extreme cold in spring and there may be some truth in the theory that the widespread use of anti-woodworm prescriptions (based on dieldrin) has killed great numbers of butterflies which hibernate in buildings.

Twenty years ago I only noticed the conspicuous butterflies, but have since learned that it is not difficult to identify almost any species likely to be seen in this country. J.'s enthusiasm for butterfly photography and recording has been a great stimulus. Although 1987 seems unlikely to be an outstanding butterfly year in Galloway there was certainly an abundance of ringlets and small pearl-bordered fritillaries along the roadside verges today. In spite of their dusky brown colour ringlets are quite eye-catching, as they fly just above the tall grasses in wayward fluttery flight. They alight frequently. The chain of rings across the undersides of the wings is conspicuous but much less so on the upper sides, especially on the darker and smaller males. This is one of the commonest July butterflies in Galloway, though it is very unevenly distributed throughout Scotland and very scarce in the north.

Small pearl-bordered fritillaries, though fast and wide-ranging in flight, often oblige by protracted feeding on the tall marsh thistles along this road. Then their upper sides, tawny-red finely reticulated with black, look much like miniature versions of the dark green fritillary (this name refers to the underside of the hindwing). The latter is the only other fritillary at all common in Galloway. There is only one reliable way of distinguishing between the small pearl-bordered and the pearl-bordered and this requires a good view of the underside of the hindwing, when the central silvery segment on the latter is seen to be clearly surrounded by yellow: there is a larger silvery area in the small pearl-bordered. Of the two the latter is much the more numerous in Galloway. The pearl-bordered emerges earlier by two or three weeks and when in Morven in the second half of May, we have found it common there on the slopes among birch and oakwood.

17 July *An old railway cutting*

While all day long golfers and spectators were enveloped in the east coast haar, the skies cleared over Dumfries by lunch time. It was sunny enough along the old railway track by the Dalbeattie road for butterflies to fly. Ringlets and meadow browns rose ahead as we scrambled down to the deep cutting near Goldielea. Along the partly overgrown cutting itself

there were dark green and small pearl-bordered fritillaries as well as common blues, but all in small numbers. The deep crimson flowers of the northern marsh orchid (*Orchis purpurea*) were in profusion. Soon, it was saddening to find the track deteriorating into a rubbish dump with a line of rusting vehicles and a stretch apparently bulldozed bare of vegetation. There is a lot of scope for nature conservation along Galloway's many miles of old railway network. Much has disappeared, reclaimed into fields by farmers, some has been kept open as private or forestry access roads, but a great amount is florally interesting and attractive to butterflies, birds and adders. There must be a good case for a general survey of what remains. Here at Goldielea for instance trees like birch and hawthorn are fast growing up and without management will soon become thickets too dense and shady for butterflies.

20 July A swallow in the house

What do you do when a swallow flies into the house at midnight? One of the pair which started but soon abandoned their nest-building in the back porch continued to roost there. Forgetting this I opened the back door to look at the sky last night and the swallow flew in. It was soon obvious that as long as any lights were on it would simply fly round them in endless circles like a moth. Quite impossible to catch. At first I could only stand spellbound by its angelic beauty in the bright light as it sped from bulb to bulb always just out of reach. I thought of leaving it to find a roosting place in the house and letting it out in the morning, as it was already past my own bed time. Then I went upstairs to ask J., who was in the bath, where she had put her long-handled butterfly net. I should have realised at once that the best solution was to put out all the lights and open doors and windows. When I did this of course it flew out into the darkness, but it took some time after turning the lights on again to check that it had really gone. I should have known enough about the reactions of birds, from experience of bird-ringing, not to be surprised when tonight it was roosting again in the back porch, undeterred by what might seem a traumatic experience.

21 July Kingfishers, red squirrels and nightjars

After working most of the day on a large painting begun in the spring I went down the west side of Loch Ken with J. this fine warm evening. We stood for half an hour at the bridge over the burn at Kenmure fish farm, long enough as it happened for a brief view of the kingfishers which have bred nearby. There was just enough light to pinpoint their electric blue top sides as two sped under the bridge before disappearing upstream among shadowy tree reflections. Last year one which had been ringed as a nestling near Carstairs, Strathclyde, was picked up dead here. It is apparently not unusual for some kingfishers, perhaps mostly young like this one, to travel such distances from their natal rivers.

The last few years have seen the forest on the slopes of Cairn Edward and Bennan on the western side of Loch Ken largely clearfelled. In the dusk we watched a ghostly barn owl hunting there and saw it fly with a vole to feed its brood in the ranger's byre across the road. After Mrs Fergusson had taken me to see the four chicks, one already well-feathered, she talked about the red squirrels which had once given her so much pleasure. One came to the window to take biscuits. Now, she said, they had gone. No doubt tree-felling has made the

immediate surroundings unsuitable for them, but too many are killed by traffic on this road. In the hardwoods further up the Glenkens they seem to have increased in late years. There are no grey squirrels in the district.

As it grew dark we listened hopefully for the sound of a churring nightjar from the Bennan slopes, but none came. Nightjars have been there this summer as they have always been since I first found them some 35 years ago. Indeed, I have been told they were nesting there before the conifers were even planted and I have spoken to old people who remember when the nightjar was familiar over brackeny hillsides on summer nights throughout the district. Now there is little chance of finding any in south-west Scotland except in a few very traditional sites, near or within conifer forest. It seems remarkable that they have for so long remained faithful to this western side of Loch Ken, through such changes in habitat. In the present stage of clearfell backed by remaining forest it looks more suited to nightjars than for many years, but they have not increased and may be decreasing. From past experience I expect them to be quite evident at this date and on through August, but I suspect that our summer temperatures have not been high enough to suit them these last three years. Certtainly there appeared to be no great abundance of night-flying moths for them tonight.

We drove home with the sky above the Rhinns of Kells glowing red long past sunset and found a tawny owl poised, alert and still, on the electricity wire outside our bedroom window, probably watching for the sparrows roosting in the creeper.

22 July Landscape and birds

Many years ago Ian MacNicol, the Glasgow art dealer and part-time painter, told me how he used to accompany D. Y. Cameron on painting expeditions. 'D.Y.', he said, 'always went to paint by the sea in July to get away from the summer greens.' I used to try to follow his

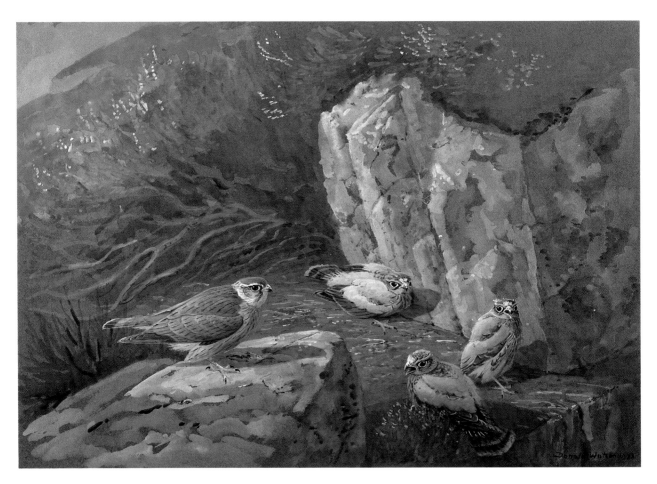

Cock merlin with chicks, Galloway, 1973

example whenever possible and at this time of year I think longingly of days spent painting on the flowery Hebridean machair, rimmed by translucent sea. Years went by and I became reluctant to leave the moors in July when favourite birds like harriers and merlins were still feeding their broods. Landscape painting and ornithology increasingly became a tug of war. Perhaps the temptation to see landscape as a setting for birds could become too much of a straitjacket. I am still trying to learn, as a wildlife artist, how best to resolve this problem.

This afternoon, under a bright racy sky, it was the large heath butterfly that most drew us to the damp moorland at the foot of Mackilston Hill. Its season would soon be past and J. wanted a photograph. We have already lost too much time to the vagaries of Galloway weather, which since May has never settled into a spell of prolonged warm sunshine. The other night dipping into Abel Chapman's monumental book *The Borders and Beyond* I chanced on his vivid account of finding colonies of large heaths on and near Cheviot. He was very surprised as they were thought to be rare. Why he called them 'mountain ringlets *or* large heaths' is a puzzle as the former, a much rarer butterfly, is quite a different species, more like a miniature Scotch argus. The large heath is a little bigger than the widespread small heath and is only found on wetter moors. Those we have seen in Galloway all have the distinct white rings, the larger ones dark-centred, on the undersides of the hindwings, a feature lacking in the more northern form. On this breezy day the two we saw were maddeningly restless, never once settling long enough for photography. It is already late in the season for the northern

brown argus, a neat little butterfly which we have found in a floral meadow not far from here.

An end-of-season atmosphere was heightened by what Juliet Vickery announced as her 'going down' party at Blowplain Open Farm, to mark the end of her last field season of dipper study. A memorable evening was enjoyed, with supper and some enthusiastic dancing to Jo Miller's fiddle in the byre, the dusk sky above cloudless and starry.

23 July Corserine

The fine weather held, perhaps for only one more day. It proved to be ideal for the walk up Corserine I had planned with Ian W., my fellow bird painter. Not a blazing summer's day, but friendly weather, making the slow climb to the broad plateau easy and relaxed, no more than a stroll. At the turn on to the Gararries road we had stopped to admire the first two Scotch argus butterflies of the year, fresh looking males looking almost black in flight; one settled among the molinia on the verge, showing the neat red-brown wing panels with their rows of tiny black rings, silver-centred. An osprey had been seen fishing in Clatteringshaws Loch last week, probably the same bird that visits Loch Ken quite often. I had phoned the forest ranger to check that it would be alright to use my permit to drive up the long forest road by Back Hill o' the Bush and start walking up a ride from the end of the road. It is two or three years since I climbed Corserine by this route and the trees had grown so much that at first I did not recognise the ride I was looking for.

Soon the forest was shed behind us like discarded clothing and we were out on the boundless hill. Corserine had assumed its grey-green summer look, but on closer inspection the ground was quite multi-coloured, yellow tormentil and white starry heath bedstraw everywhere, yellow again in the bright rays of the dwarf mountain golden rod. From above the source of the Hawse burn we looked down on the indigo waters of Loch Dungeon, calm beneath the plunging rock slopes of Milldown and Millfire. At any season this is one of the most memorable prospects in the Galloway hills, almost benign-looking in this sunny summer weather. I recalled walking to it long ago from the head of the Forrest Glen across wild moorland, when many bleached tree roots of an ancient forest lay exposed among the peat haggs. Now the modern plantations have thrown a dark cloak all over this ground. One day over 30 years ago, I was stopped in my tracks on the top of Milldown by the eerie wailing of red-throated divers from the loch far below. Over the following weeks I returned several times, once carrying a load of painting kit across the boggy moor and working for many hours at a landscape of the frowning cliffs and dark reflecting loch. The presence of the divers, so rare on Galloway lochs, brought the perfect focus to this sombre setting. Although I saw them often and searched every yard of the shore and the islet I could find no nest, but I was sure they must have tried. On the islet I found an otters' holt, with midden and a much-used slide into the water, while only a few yards away a goosander had nested.

Ian was making his first visit to the summit of Corserine and was surprised and delighted by the extent of the almost level plateau, not rugged at all. Here you can walk for 1000 yards without losing any noticeable height and all the way on short even turf or bare stony ground. We had separated a little when Ian caught the movement of a running bird and called me over. It was a dotterel, clearly a male, but we had to conclude it had no chicks as it showed no anxiety and soon flew out of sight. It was the least colourful dotterel I have seen this year, but

the beautiful head pattern with bold white chevron was as fine as ever. Jeff tells me that late in the summer there is much wandering between different tops and this bird may have been a failed breeder, perhaps from another summit. It had only just gone when we had another moment of excitement — an eagle glided low over the high plateau in almost level flight. It flew on northwards without a wingbeat, making the slightest shimmy of its great wings as it turned and vanished behind the projecting scree of Carlin's Cairn. If there had been the usual pair of golden plover earlier there were none still about. Hunted by peregrines, foxes and perhaps eagles the young of waders on the high tops face many risks.

We exchanged waves with two young walkers as they moved over to Carlin's Cairn. In very little time they looked lilliputian figures beside the great pile of stones. They had probably started up over Millyea and would complete the ridge walk to the old lead mines. We were still on the high ground when a large moth, probably an oak eggar, flew swiftly by. Up here I am always on the look-out for the mountain ringlet butterfly, but it seems certain that the claim that it was once found here arose from a deliberate deception by a mischievous lepidopterist who wanted to confuse a rival collector. It is described in the *Atlas of Butterflies in Britain and Ireland* as the only true montane species in the British Isles and is found quite plentifully on some mountains in the Highlands and the Lake District. The Galloway tops certainly have plenty of mat grass, its only known food plant.

We completed a circuit of the high ground and headed slowly down to the forest as distant rain-clouds began to obscure the Lowther Hills on the eastern horizon. We looked down on the sunlit back of a young kestrel drifting on the wind up the Hawse burn and a pair of ravens played around the summit of Millfire. A dozen swifts, perhaps up from Dalry, gave a marvellous exhibition of aerobatics, skimming the high grassland for flying insects. Meadow pipits and wheatears seemed scarce, larks and ring ouzels neither seen nor heard. We saw two or three small heaths and a big *Cordulegaster* dragonfly above 2000 feet.

Down in the ride, the midges were at their peak of evening ferocity, a tiny frog seen on the way up was still in the same spot and the blaeberries were darkening. A roebuck looked vivid red among sharp green molinia.

A detour across the bridge to Loch Dee was notable for the numbers of redpolls and siskins, one big party of the latter very approachable on thistle heads beside the forest road at Craigencallie. From down here the summit of Corserine looked withdrawn and remote, no mean hill so close to home.

5 August *The Mull of Galloway*

This chameleon summer threw up a perfect day for our belated visit to the Mull, the south-western promontory of Galloway — daylong sunshine and exceptional visibility. On the way we stopped at the Piltanton Estuary, beyond Glenluce, where for some years there has been a sand quarry with a good colony of sand martins. I had forgotten how short the life of these quarries can be. The site had been levelled since our last visit and was now a grass field. Some new workings had been started nearby and the birds had made a few nesting burrows, but it was scarcely a colony this year.

We had high hopes of a good variety of butterflies on the slopes leading down to East and West Tarbet just short of the Mull, but in spite of the favourable weather there were neither graylings nor wall browns on view. One August day in 1983 there were 13 species in these bays, but today we could only muster meadow browns and one or two red admirals, apart from whites. Surprisingly we saw no red admirals on the buddleias in Drummore, but in and around the lighthouse garden there were over 20. All appeared in mint condition — had they just flown in over the sea? Twenty-five miles to the south the mountains of the Isle of Man were as clear as I have ever seen them. One day I might go and climb one of them. Would the reality live up to the enchanted prospect they present from the Mull on a fine summer's day? Perhaps it is better not to know, though the knowledge that there are choughs and hen harriers there often tempts me. The news that a pair of choughs had been seen this spring walking about the lighthouse car park at the Mull has raised the possibility that these long-lost Galloway birds are returning. So when I was in conversation with a lighthouse keeper I asked him if he had seen any. My guess that he would know a chough seemed justified when he answered that two had been sitting on the wall a few days ago. A week later a letter came from a birdwatcher on holiday that he had seen two and possibly three at the lighthouse. For us sadly only jackdaws appeared.

The seabird colony below the lighthouse was depleted of its auks, but many kittiwake nests still held young and at least 7 fat fulmar chicks were visible at a quick glance. In sunshine these massive sandstone cliffs glow with warm colour, beautifully offsetting the grey and white of seabird plumages. Out from Lagvag Point at the tip of the Mull the sea is always turbulent. A file of gannets, dazzling white against the mid-blue water, checked in their westward flight and began plunge-diving. Their home on the Big Scaur in Luce Bay stood out sharp as a hewn artefact, at this distance its teeming birds just a blur of white through binoculars.

Lighthouse keepers have exceptional opportunities to become ornithologists, but few go beyond a general acquaintance with the seabirds and the commoner birds of passage that come to the lantern. The young keeper I spoke to said he saw great numbers of goldcrests and

firecrests in September and October, but his firecrests would probably be male goldcrests, showing the brilliant orange central crown feathers. After a 'lantern night' many crippled migrants fall prey to the cats, which no doubt accounted for the remains of two young wheatears mouldering in a corner of the courtyard. The big walled garden has lately been intensively cultivated for vegetables and flowers and must now be an attractive feeding ground for tired migrants. Looking over the wall I could see a family of the resident stonechats and two whitethroats, which may also have been local birds. There could easily have been other warblers skulking out of sight and I thought of returning a little later in the season and asking permission to search the garden.

West Tarbet Bay in the late afternoon sunshine was idyllic. There are lime-rich pockets here which account for the profusion of flowers like bloody cranesbill and marjoram. The steep tangled slopes were so bright with flowers that feeding red admirals were almost incon-

Red admiral
and small white,
Dalry, 1959

spicuous. The silky white cups of grass of Parnassus shone in damp grassy corners. Many of the birds revelling in the evening sun were whitethroats which breed abundantly along this heavily vegetated coast. At this date they may already be moving south. A third stonechat family confirmed that survival has been so much better on coastal sites than inland. The two drab little finches in a gorse clump showed themselves just long enough to be identified as twites, belonging no doubt to the population which breeds along the western fringe of Galloway.

18 August Wood of Cree — Borgan

Three summers ago we could have seen purple hairstreaks easily at Wood of Cree on a sunny August day like this. In 1983 they were there in profusion and we found them in several other oakwoods, elsewhere in Galloway, that year and in 1984. We hope there are a few this year somewhere among the Wood of Cree's extensive oaks, but we looked in vain today, not surprisingly in view of the scarcity of so many kinds of butterfly. It was many years ago that Nigel Champion first told me that this was the place to find them. Once the trick is learned of how to look for them it is easy, especially for a birdwatcher, as they are best spotted by watching the oak canopy through binoculars. They are most likely to be first seen as they rise in dancing flight above the canopy. Then, their drab underwings look pale and silvery against a clear blue sky. Like all hairstreaks they are tiny butterflies but distinctly larger than green hairstreaks, which are early summer fliers and much scarcer in Galloway. J.'s earliest purple hairstreaks were on 24 July 1984 and we have seen them just into September. In strong sunlight the uppersides of the male's wings are a beautiful iridescent blue-purple, but females look brown, with a maroon cast and a panel of intense blue rather than purple on the forewing.

At this time of year, in these big hardwoods, small birds are mainly in roving flocks which travel through the trees at a remarkable speed. The majority are tits, including willow and long-tailed tits, while treecreepers, goldcrests and warblers add to the variety. The pied flycatchers which bred very successfully in the wood are unlikely to be seen any more, but redstarts can be more noticeable in August than earlier. Four years ago when up in the wood I was puzzled by a cacophony of screeches which did not sound quite right for the ubiquitous jays, but I could never see what birds were making them. Afterwards the warden told us there had been a male golden oriole about in July. Could it have been a family of golden orioles we heard? A pair raised a brood elsewhere in south Scotland last year! They do make screeching sounds and are notoriously hard to see.

Towards evening I used my key to drive up a forest road above Borgan. Siskins rose from the marsh thistles at the roadside. Higher up we stopped at the bridge over a tumbling burn, splendidly named Ballocharush burn. Someone had beehives for heather honey on the flank of Larg Fell. In years to come the enchanting prospect back to Wood of Cree and beyond will disappear as the conifers grow. Few people will know that it ever existed as it can only be discovered by a long exploration up a forest road. I have rarely seen such magnificent flowering of the heather as this year on the unplanted knowes along this roadside. What a landscape this must have been before it was overwhelmed by the Sitka plantations! I have just

discovered from June Chatfield's book that F. W. Frowhawk, the famous lepidopterist and illustrator, lived at Borgan in his old age, during 1940–1. He found the Scotch argus plentiful, but did not mention purple hairstreaks. At that time, he said, bracken was fast replacing heather on the hills.

21 *August* *Bengairn and Balcary*

A day of intense clarity, the landscape washed clean by two days of ceaseless rain. The twin hills of Bengairn and Screel are landmarks on the southern horizon of Galloway. They look much higher than they are — a little over 1000 feet. A gated road, which grows rougher by the year, skirts Ben Tudor, a satellite of Bengairn, where in past years we had found a good variety of butterflies. It was not our lucky day as the farm at Nether Linkins turned out to be the scene of sheep gathering, with lambs being segregated from ewes, and after half an hour's wait it was obvious that driving through the gate would not be welcome. Anyway we were told that the road was too hazardous for driving after all the rain. So we headed back for Gelston and south, below the steep eastern side of Screel towards Auchencairn, a village which, like Dalry, retains much of the atmosphere of old Galloway. The path to the cliffs at Balcary emerges from woodland depths to give magnificent views of the indented coastline eastward to the upper Solway. The green top of Hestan Island was still white-spotted with big gulls at their nest sites, but a far greater number now occupy Almorness Point on the mainland nearby. This is a notable colony for the high proportion of lesser black-backs.

Back in the 1950s expeditions to Hestan Island were memorable for its fine tern colony. In 1956 I counted common terns at nearly 300 pairs, sandwich at 75 and saw a single roseate tern. In a few years all the terns had gone, whether because of the big gulls or because the vegetation grew too tall for their nests I do not know. It is sad that there are no longer any good colonies of sandwich terns in Galloway although they can be seen almost anywhere around the coast and are sometimes numerous at this time of the year. This afternoon there was a steady stream of common and sandwich terns passing westward off Balcary Point.

The highlight of our cliff-top walk has to be the brilliant small copper butterfly on a gorse bush, but J. was equally delighted with the grayling she saw and photographed on a patch of heather while I was ahead watching kittiwakes and fulmars. We should have been here in June for the best of the thrift and sea campion and the nesting seabirds, but it would have been hard to find a day to compare with this for colour and sunshine. A cock yellowhammer as bright as an oriole against a backdrop of blue sea made a cameo picture to be remembered.

1 *September* *Dalry*

The pond which Ian dug now occupies one side of our lawn. Beneath the top soil the ground was very stony and we used a lot of sand, old newspapers and sundry bits of old carpet to protect the lining from puncture. On the third day of work the great moment arrived and for

two hours we watched it fill with a hosepipe from the kitchen tap. Then came the ceremonial planting, or casting into the pond, of the water lilies, pondweed etc., which Ian had kindly brought with him. Seven-year-old Andrew added a bucket of late tadpoles and the pond was in business. True the water is not yet crystal clear, but a vision of tree and sky reflections has been born where there had been grass. No water lily flower was ever more cherished than the one which opened during the first days. Then we discovered (but could not explain) the fickleness of water lily flowers, perfectly opened one day, tightly closed the next, regardless of bright sunshine. No doubt a little acclimatisation is needed and it *is* rather late in the year to expect much flowering.

Ian says we shall at once attract new birds to the garden. I already imagine a snipe or a sandpiper dropping out of the sky; perhaps when winter comes a woodcock will be enticed by the semi-aquatic corner. On 30 August, the first full day in the life of the pond, the mixture of regular garden birds already bathing in it was enriched by a cock blackcap. To be honest I cannot claim that it came to the garden because of the pond, but it certainly found it good for bathing after feeding on the honeysuckle berries.

13 September *A sparrowhawk by the pond*

Sparrowhawks, of course, are predators on garden birds. Many people who would never fault their cats for the same behaviour, find it unacceptable when a sparrowhawk takes to killing the birds they feed. I suppose none of us can be wholly consistent about birds of prey. I would be sorry if the cock sparrowhawk which today was 'still hunting' from the pond edge had flown off with the only grey wagtail which has come there. I remember once discussing the problem of harriers and grouse with a gamekeeper and I was rather taken aback by his suggestion that my concern for the harrier was just as much flawed by financial interest as his for the grouse. I could not deny that I painted and sold a great many pictures of harriers!

With its blue-grey back and vinous-red barred breast the cock sparrowhawk at the pond looked quite superb. From a window all the minutiae of its soft plumage were perfectly clear, but one feature alone stood out — the brilliant orange-yellow eyes which seemed to radiate ferocity as it swivelled and tilted its small head towards the bushes above. The small dark-eyed falcons, kestrel or merlin, are no less fierce, but yellow eyes seem more frighteningly alien.

The sparrowhawk stayed for several minutes, long enough for a quick pencil sketch. Colours would stay for a while in the memory. It was in bright sunlight and the yellow legs were almost lost in body shadow. Then it flew off at seemingly reckless speed, weaving away among the aspen boles. No wonder so many hunting flights end up with a fatal crash against the big windows of the school.

27 September *Equinoctial colours*

The young house martins found on the pavement when the nest collapsed were today peering out of the box which Jo has put up under the eave for them. They have survived well and will

fly very soon. Few swallows are left in the village — the last of the garage family, one of the parents, deserted its roosting beam more than a week ago. I only saw the second brood of young roosting for a couple of nights after fledging, when they were all piled on to the nest. Do they join one of the big communal roosts in reedbeds down the valley?

Horse chestnuts are now beacons of orange and yellow in the generally sombre woods. Sitting in the RSPB's excellent hide at their Loch Ken reserve on Hensol estate this afternoon, we were surrounded by a rich variety of low-toned September colours in the tangle of bushes and small trees which partly screen the hide. Crimson clusters of guelder rosehips mingled with glossy black sloes in front of a great, spreading crab apple, laden with yellowing fruit. Yet this ancient and beautiful habitat of the woodland fringe is evidently less attractive to blackbirds and thrushes than our man-made garden in the village. Having a mature beech, bristling with mast this year, the garden seems to have gathered in all the blue tits for miles around, too. Surely it will bring bramblings later.

Beyond the close bushes the view from the RSPB hide takes in a marsh and a backdrop of old hardwoods. By building a bund, the warden has created an area of controlled water level, something much needed at Loch Ken where nesting birds have suffered from the fluctuating levels dictated by the hydro-electric scheme. We spent a peaceful weather-proof hour in this very secluded place, enjoying just the common birds of the loch — mallard, moorhens, coots, snipe and lapwings, a flock of redpolls and a reed bunting. In early summer, Ray tells me, it is a marvellous place, warblers and redstarts coming almost within touching distance and the marsh has attracted water rails and even a spotted crake. (I should add that access must be arranged with the warden.)

On a recent visit to the flow where harriers roost, my nephew Roger spotted an otter swimming almost under the riverbank on which we were standing. A momentary view of head and wake and then we had no idea where it had gone. Two brown harriers drifted in and dropped for the night long before sunset on that murky evening. They chose the reedbed to settle in. At this time of year the phalanx of reeds stands out like green lances in a great expanse of brown and buff-coloured grasses and sedges, straggling clumps of bog myrtle, dark purplish-red. Alas, on this occasion no late shafts of sun penetrated the gloom. On brighter evenings September colours in this rain-swept upland landscape are the richest in all the year, most brilliant where mats of deer-sedge turn the ground fiery orange. Some bracken slopes are already yellow and russet after early frosts, others still green. 'Smouldering' may seem a strange word for the colours of autumnal moors in wet Galloway but I cannot think of a better. Distant mountains, blue and indigo, appear and vanish behind ragged banners of cloud. Even half an hour or more past sunset, when the eye can no longer see any detail in the landscape, a barn owl hunting the riverbank still retains a luminosity which never fails to astonish me.

10 *October* *Autumn at the rookery*

The garden rooks started to take an interest in their nests early in August. Over the last few weeks they have spent more and more time at the rookery, almost as much as if it were spring.

Cock sparrowhawk,
1987

Watching them I notice that they are refurbishing nests and I'm sure they have also dismantled one or two small, unguarded ones which were built late in the spring, perhaps by yearlings, and not used. There is little if any carrying in of sticks from afar but some are added from close by. A remarkable amount of effort goes into poking into the nest lining, possibly a sort of autumn spring-cleaning. Authorities say the birds are there to claim and hold their nesting territories against others. They spend a great deal of time just sitting by their nests, cawing and making mysterious-sounding noises, especially a peculiar sharp clicking call. Much has been written about 'territorial chases', but they often seem to fly up and drift about the sky amicably, in threes and fours. At night they leave for a communal roost down the valley, but this evening after they had all gone they re-appeared for a final brief inspection of the rookery at 7pm, close to darkness. Clearly it exerts a very strong pull and feeding requirements must be very easily met to allow so much time at the nests. Why do they not stay overnight? Dusk is a time of great activity in the garden, a noisy rush of blackbirds diving into their shrubbery roosts while a tawny owl calls from above.

Now we have a big female sparrowhawk at the pond. This time its heavy flight as it took off meant that it was carrying off a small bird, tucked under its tail.

Last week-end, with an anticyclone over Norway and the east coast of Scotland swept by rain on a south-east wind there must have been 'a fall' of Scandinavian migrants. The

goldcrest I watched on a pine from the studio window was very likely one of these — it was the first I had seen in the garden for a long time.

11 October *The geese of Loch Ken*

The first big flocks of geese have arrived in the valley for the winter, some 600 greylags and over 100 Greenland white-fronts so far. Most were feeding this afternoon among sodden barley stubble on the farm of Finniness, a couple of Canada geese and two pinkfeet among them. Goose flocks in the Ken valley typically contain a mixture of species, with greylags nowadays always in greatest quantity. Thirty years or more ago it was the white-fronts which epitomised Loch Ken in winter and whenever I was painting outdoors I delighted in the sounds they made, like children's laughter, as the flocks moved to and fro. In those days 500 white-fronts commonly roosted on the water at the upper end of Loch Ken and they made a great chorus as they flighted in at dusk. One dark night, about 1956, I was driving down the west side of the loch when the car lights suddenly went out. Then the sound of the white-fronts at their roost seemed to have a mocking ring.

The long spell of severe weather in early 1963 was a disaster for them. Apparently they scattered far and wide, as did the Tregaron flock in Wales. Many of the latter starved or were easily shot away from their accustomed haunt and the same must have happened to the Loch Ken flock. Next winter the Welsh birds were down from 500 to 100 and the Loch Ken flock from 500 to under 300. While in Wales numbers continued to decline there has been some recovery at Loch Ken, though not to the former strength. There has, however, also been the flock near Stranraer for as long as I have lived here and a recent increase there means that there are probably as many Greenland white-fronts wintering in Galloway now as there were 40 years ago.

At Loch Ken the most striking change in my own experience of that period has been the virtual replacement of white-fronts by greylags at the top end of the valley. Modern silage grass is evidently much less attractive to white-fronts, but there is probably more than one reason for the change. Years ago, when I watched and painted the white-fronts more than almost any other birds, I liked to think of them making direct flights to and from their breeding grounds in west Greenland. Some, it seems, may do so but it is now known that the majority break their journeys and refuel in Iceland.

24 October *The Machars*

Scotland escaped the mid-October hurricane which swept the south-east of England. We have had some gloomy days, when heavy rain flooded the valley fields, with brilliant intervals when the drenched moors and woods have flared with seasonal colour. Today, at last, the clouds were high, their shadows seeming to move lazily across the big hills. We took Marc, our young Swiss friend, to the Cree valley and the Machars of Wigtownshire. Marc's favourite bird is the peregrine which he watches with great joy and dedication in Switzerland. He arrived in Galloway after walking the length of the Pennine Way, mostly in mist and rain, still eager for more peregrine watching in Galloway.

On our way to Wigtownshire we stopped beneath a rugged crag where I expected a peregrine might be. The scene was very familiar to me and I guessed that if the bird was there it would be on one of its usual perches, yet scanning them with binoculars my elderly eyes had failed to pick it out before Marc said that he had spotted it. Far up on the crag, it was really perfectly distinct against a jumbled background of rocks and withered grasses. It stood upright and still as a statuette, sunlight catching its silvery front and yellow feet, a picture-book peregrine. Moments later it was a silhouette in the sky, passing directly overhead, on course for the hills across the valley. Then it had the look of a falcon from its barrel chest and chunky, blunt-tipped wings, rather than a tiercel.

Down by the Moss of Cree how different it was from the spring day when the merse was crowded with shelduck pairs (11 April). Some have stayed all summer in charge of crèches of ducklings, but most flew away in June or July to moult, probably on islands off the coast of Germany where many thousands gather for this purpose. Return is gradual through autumn and winter. The merse was a duller place today in their absence, nor were there yet any big flocks of geese. On a grass field 10 whooper swans were the first I had seen this winter, two pairs with families of four and two young. Across the Cree towards Palnure the sky was suddenly busy with flickering flocks of lapwings and a tighter bunch of golden plover in swifter weaving flight. We thought we glimpsed a peregrine in pursuit; much nearer, a female sparrowhawk, a kestrel and two buzzards were up.

The flat fields of Baldoon, south of the river Bladnoch, still carry the scars of their wartime role as an airfield. Baldoon is important in Galloway agrarian history as the place where, in the late seventeenth century, Sir David Dunbar revolutionised the cattle trade. In their book, *Old Galloway*, Donnachie and Macleod tell how he made a large enclosed park for 1000 head of cattle, improved the stock by selective breeding and dealt in the then illicit importation of Irish cattle. The park was fertilised with lime made from cockleshells, cast up on the Baldoon shore and burnt between layers of peat. Dunbar also took a leading role in the building of the drove road from New Galloway to Dumfries. The story of how great herds of cattle from Scotland were driven to be fattened in the lush pastures of Norfolk, is told in Haldane's *The Drove Roads of Scotland*. One route involved a hazardous Solway crossing. Baldoon's old airfield has long been a favourite feeding ground for flocks of golden plover which, a decade ago, could be counted in several thousands in early winter. We saw some 500 and a smaller number of lapwings. A juvenile peregrine, golden-brown in the bright sunlight, shadowed the closely-knit flocks of plovers as they criss-crossed the sky. Marc commented that such a chance encounter with a peregrine was even more pleasing to him than seeing one at a typical nesting cliff.

Swallows still lingered at Garlieston, all we saw being short-tailed birds of the year. The two brent geese which had been in the bay for several days were not on view when we arrived, but for our visitor from land-locked Switzerland waders like redshanks, turnstones and ringed plovers were far from commonplace. Later on an evening tour of the Machars he was enthusiastic about the surprising pockets of 'moss' which have still escaped the improvers' hand. In the last sunlight of an autumn day they enliven a pastoral landscape with rich and varied enclaves of colour. This year straggly hedgerows are crimson with haws, which are attracting down flocks of fieldfares and redwings in quantities not seen last winter. The farms of the Machars generally have too much good animal pasture to succumb to the advance of

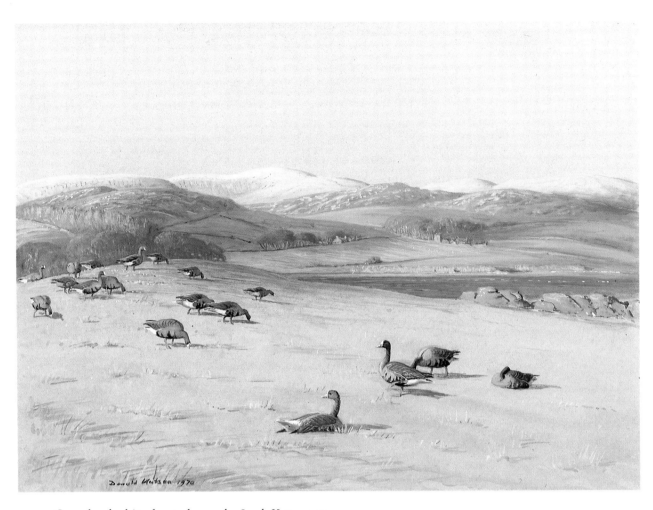

Greenland white-fronted geese by Loch Ken, 1970

forest plantations, but how safe are the remaining patches of marsh and 'carr' which account for most of the wildlife interest? In this respect the preservation of the Scottish Wildlife Trust's reserve at Dowalton is of prime importance. Many farmers are suspicious of conservation when the argument touches their own farms, but are more ready to recognise that areas of 'wild' land are necessary for their shooting value.

26 October *A visit to the picture framer*

It is a cross country journey to the framer's near New Abbey. Sometimes I vary my route to enjoy different aspects of the Galloway countryside. As Marc was with me I chose to drive down Loch Ken to Castle Douglas, then to Dalbeattie and over the moorland to the Solway coast. I expected to be able to show him the Greenland white-fronts beside Loch Ken but it happened that all the geese on view were greylags. Wigeon looking very rich-coloured in the lagoons made a new spectacle for him.

As we drove down the hill towards Caulkerbush, under a dripping canopy of broad-leaved trees, a big fox crossed the road lethargically and was in no hurry to move out of sight. My companion said that had he been at home he would have suspected it was rabid from its slow

movements and apparent fearlessness, but added that Switzerland was now virtually free of rabies, since the policy of laying out chicken heads injected with serum had been adopted at regular intervals.

A detour to the shore at Carsethorn was unrewarding as the rain was by then heavy and the tide too high for many waders to feed. Part of the big flock of scaup which gather here were on view, but in the murky light they did not hold our interest for long. Several young swallows flew about the village roofs, perhaps even now not the last we shall see this year.

Dale Cooper and his son Ian have been framing my pictures for more years than I can say. We found Ian working at his bench in the old smoke house where long ago hams were cured. If he was not such a good and genial craftsman I suppose I might at some time have felt obliged to look for a framer nearer home, but I am sure that everyone who knows West Shambellie would agree that it is worth coming here just to enjoy the magnificent surroundings. There is no finer woodland in Galloway. Long before business is done our talk usually strays to the birds, butterflies or squirrels that Ian has been seeing around the Coopers' fairy-tale hide-out. Today it was chiefly the squirrels (red, of course); Ian says at least four are coming for nuts and carrying them away along the dyke to bury under the big larch trees. Each has a differently patterned tail. We saw one while we stood for a few minutes at the edge of the wood.

The sky had cleared before we started for home, cumulus cloud-tops flushed with orange against deepening blue, later purest rose-red above the distant Kells mountains. I became absorbed in describing the features of the countryside to Marc and missed a turning on our tortuous route to Crocketford. I had done the journey countless times but it seems that some of Galloway will always be unknown.

31 October *Loch Urr and Craigenputtock*

Presumably Craigenputtock is the kite's crag. In his *Scottish Gallovidian Encyclopedia* McTaggart (1824) wrote of kites' nests being common in moorland glens; 'they build there on what the shepherds call *scurrie thorns*, low dwarfish thorns'. Were red kites still part of the scene when Thomas Carlyle was feverishly writing and Jane Welsh suffered, at Craigenputtock in 1828–34? There could hardly be more *scurrie thorns* than we saw this afternoon, along the little road that wanders down from Loch Urr just over the hill from Craigenputtock. So far the advance of the Sitka plantations is piecemeal here and rolling expanses of sheepwalk still extend from Craigenputtock Moor to Loch Urr, making great sweeps of orange-tawny colour. Hundreds of fieldfares and redwings crowded on to the green hummocky fields by the loch; the air was full of the sweet wheezing and chuckling of fieldfares as they rose and alighted again in clusters on the thorn trees and began feeding on the haws. The other day I read in a national newspaper of rowans in the Peak District being brilliantly red with berries at this time of year. This would be unbelievable here — thrushes, blackbirds and starlings finish them long before now. I suppose magpies around Nether Craigenputtock nest safely in the plantation trees. They have a strangely disconnected range in Dumfries and Galloway which cannot be entirely due to killing by gamekeepers, who no longer function in many districts.

Dick Roxburgh told me he had recently seen two different male hen harriers hunting the moors near where we were today. As evening approached we decided to stop and scan a stretch of low-lying moor in the hope of finding a new harrier roost-site. I know how slim the

chances of success are! We had seen many kestrels and several buzzards through the afternoon, but never a glimpse of a harrier. At 4.25 I was looking through binoculars trying to pick up a big brown bird which J. had seen apparently drop into some rushes (I never saw it), when to my delight a grey cock harrier came into my field of view flapping and gliding at speed, heading west from the Loch Urr area. Greatly excited I began to wait almost confidently for it to drop into a roost-site among the rushes where J. had seen her bird go, but it passed on without a flicker of hesitation. In moments it had cleared a ridge and was out of sight to the west. Looking at the map I decided that it *might* have been heading for the traditional known roost, but it would have had another 13 kilometres to go. Possible indeed, at the speed these birds can fly and in the past I have seen one heading on the right line from 16 kilometres. We never could make sense of J.'s glimpse of a brown bird (it just might have been a short-eared owl). I risked disturbing it by walking over to the rushy patch but there was nothing but a meadow pipit there. Perhaps the brown 'harrier or owl' had been making a dive after prey and slipped away in the gathering gloom towards the old roost too.

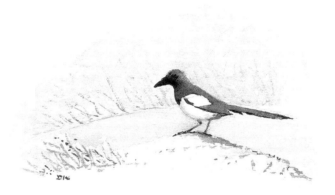

9 November *Painting on the moors*

I was told by the son of a well-known Scottish landscape painter that his father was still doing most of his work out in the country in his 80th year. Recently I have been in the habit of making only minimal sketches and notes outdoors and using these as a basis for larger studio pictures, but I used to have no doubt that in my kind of landscape painting it was better to do as much as possible with the subject in front of me. This can be exciting, infuriating and demanding. As I generally prefer winter landscapes it is rarely calm, warm or comfortable.

For the past few days an anticyclone has given a spell of quiet fine weather. It was obviously weakening this morning but I had a notion to go up on the moors somewhere and paint for a few hours. I'd put on my 'long johns' first thing as an encouragement not to waver. I very nearly did, after all the hassle of preparation, when the east wind had freshened and the early sunshine seemed to have gone for the day. It was mid-morning before I was ready to set out, but as long as I had three or four hours of daylight I might be able to do enough to make the effort worthwhile. I could paint in the car at a pinch, but not on the scale I wanted and anyway I cannot paint freely when cramped for space. Wilson Steer, a great outdoor landscape artist, listed his priorities — they included freedom from children and proximity to a public lavatory.

Neither of these would matter where I was going. Steer put 'subject' last on his list. Weather and light change so quickly that most likely the subject that is interesting when you start will look so different after an hour or two that doubts creep in. Generally I think it is better to stick at it and some chance magic may come. Hills at least will not change their shape unless they disappear behind cloud. Skies of course are quite transitory and the colours and tones of the landscape depend on them. From the look of the sky when I started, rain was quite likely and that can be a disaster for watercolours, although a moderate amount of rain-spotting can make interesting effects.

My equipment on these outings is simple; a strong but light easel, a marvellous leather-seated stool with three legs that will stand firm almost anywhere, a board with stretched paper, brushes, paints (in tubes), two large water jars and palettes. I take the three palettes I bought in India in 1945 — one is broken but it does not matter. They fit perfectly into those flat tin boxes which once held 50 cigarettes. My only purpose-built container is for brushes — I remember thinking it was expensive at £1, second-hand, about 40 years ago. Anorak pockets can take other items — pencils, black drawing pens and strongly bound sketchbook. Sometimes I take two or more boards, of different sizes, maybe with different sorts of paper stretched on them. Today I had just one, 24in × 18in. How easy it is to leave some essential item behind; once I drove 30 miles to paint on the coast and had forgotten to take my brushes. I did the best I could using marram grass and fingers and kept the result — looking at it now I am puzzled how I managed passable sky and water effects.

Driving up the road towards Lochinvar I was thinking about a possible subject for the jacket design of this book. I wanted some of the big hills of Galloway in the background, perhaps the undulating panorama of the Rhinns of Kells or Cairnsmore of Carsphairn and Beninner. If I achieved anything out on the hill the result would probably only be used as a reference for the actual jacket painting. I wanted something not too complex that could, at a glance, convey some authentic mood of the Galloway I know. I first walked a little way over the moor at Barlaes and looked back at the Rhinns. The prospect seemed too strung-out, too much scattered interest in the middle ground of the Ken valley. A simpler subject might be better. So I went on to another pitch, looking north towards Cairnsmore of Carsphairn from the roadside which skirts Mackilston Hill, where in July we pursued large heath butterflies. Now in November the boggy moor is at its peak of warm low-toned colour, flecked with grey-green where cross-leaved heath grows. Cairnsmore was patched with momentary sunlight which would probably disappear quite soon, but hints might return to play over its sombre mass. The middle ground, mainly pallid ochreous grassland, lifted the eye without fuss to the mountains. I thought there was enough to risk a start and decided to put up my easel on the verge of the quiet road, sheltered by the car from the east wind. No advantage in plodding further out over the hill where inquisitive Galloway cattle might come crowding round. At a distance they could make dark accents among moorland colours. Once started I become totally absorbed and will not think about the threat of further ploughing for forestry which has already come close and any year now may destroy my chosen foreground for ever. I must be thankful that German buyers have been paying good prices for Galloway cattle at the November sale — they should help to stem the tide.

I have described (in Chapter 3) how I often use opaque watercolour (properly called gouache). An art critic called it a beguiling technique, perhaps another way of saying that it

can flatter the artist. It enables me to work rapidly, essential in the short daylight I have left today. I paint mostly with big brushes and slosh in a sky very wet, returning to it later. In gouache the distant mountains can be blocked in against the sky before it is dry, but I chose to leave them unpainted until I had done a basic foreground. This was rich and varied in colour but the general tone needed to be kept low. My paper was a Canson grey, its tone close to what I wanted for the foreground before I began to paint. I love the textures of the moorland vegetation but I must not look for detail which could allow botanical description to weaken overall unity of tone and colour. All the time I try to see the whole subject and not become obsessed by its parts.

Years ago an old artist approved the way I left areas of the toned paper unpainted. Now I am not so sure this is wise as these may change colour after long exposure to light. A patch of pale grey paper left in a sky can become intrusive if it becomes slightly browner and darker.

The first hour or so of painting is crucial. At this stage it is easy to feel overwhelmed by problems and I drive myself on with muttered advice which would surely sound gibberish to a listener. Until I have begun to believe in what I am doing any distraction is unwelcome and I'm afraid a friendly visitor has occasionally felt that he has been given a flea in his ear. At times, as a picture develops, it can become hugely exhilarating and I may start to sing to myself. I have been at work for two hours and it is time to assess, consider and be critical of what has been done. I stand the picture up against my stool, walk around drinking warming coffee, eat a sandwich and briefly scan the horizon for flying birds. While painting I probably miss a lot though I am alert to sounds. There was a good moment today when I caught a faint gabble of greylag geese from high in the sky, then the lovely sight of an almost ethereal skein of about 100 slowly moving south, one arm of the V formation much longer than the other. I would not have been aware of them but for those brief call-notes.

I take a long look at my painting, standing back. Then to work again, now a struggle with lessening light. In four hours the appearance of my subject has inevitably somewhat altered, but it has retained an atmospheric quality unique to this time of year. The shapely masses of

Cairnsmore and Beninner have held their clarity and dominance. Late in the day I touch in some dark shapes of distant Galloway cattle.

It is very cold packing up but the car is close by. I remember once when I was packing up after painting in a field some way from a road, I was later told that young John Mackenzie in a passing car was astonished to see 'that scarecrow moving'.

It will certainly rain tomorrow and I shall not return to this pitch. There will be work to do on the painting at home, how much will be a difficult question. It might lead to another picture in the different discipline of transparent watercolour.

15 November *A goose count at Loch Ken*

This is the week-end when the numbers of greylag and pink-footed geese are counted all over the country for the Wildfowl Trust. For many years I have done the counting at Loch Ken. The sight and sound of goose flocks in the sky or on the fields are a familiar feature of the winter scene here and the casual observer seeing a field covered with geese is very inclined to overestimate their number. Many a time I have heard someone say 'there were thousands in the Grennan Holm', when a careful count, which is quite difficult, would make the figure about 600. Not that this would seem a big flock to those who live on the arable farms of Perthshire and Kinross, where the total count in November 1986 was nearly 50,000, almost equally divided between greylag and pinkfoot. Valerie Thom has given a full account of the Scottish distribution and numbers of these two kinds of grey geese in her book *Birds in Scotland*. In the autumn the biggest flocks are feeding on barley stubble or fields which have remained unharvested in very wet autumns.

Here in the Ken valley most of the fields are grass and I may not find any pinkfeet on the November census. After New Year there will be some thousands feeding on the big grass fields near the coast and later still, when the shooting season is over, on the merse or saltmarsh in the estuaries. Greylags are a different matter. Grass fields attract them even at this time of year and being less wary than pinkfeet they will come down to feed in the rather small fields characteristic of much of Galloway. If they are not shot they become almost absurdly confiding. One kind of disturbance that they will not tolerate is that caused by low-flying aircraft. It happens that the goose census has coincided with 'Purple Warrior', the biggest military exercise that Galloway has ever known. It was therefore no surprise to find that all the greylags from the Grennan Holm (about 600) had been put up by a helicopter flying low over the riverbank. They were all over the sky, forming and reforming their skeins and heading in all directions. They wove varying patterns against the grey ragged clouds and their obvious unease added a kind of excitement to the spectacle.

When we moved on down the valley we found the geese there also in a restless state. Just as we arrived they rose from their favourite promontory for no obvious reason — we were too distant to disturb them. There were only about 200 greylags and 100 white-fronts. Although they mingle when feeding they separate quickly in flight — then the smaller, dark-winged white-fronts are very distinct from the silver-winged greylags. We should try for a count of the flocks as they settle on the water at dusk to roost, but we cannot be in two places at once and roost sites frequently change in this valley. Last night I could hear greylags from the house at midnight and I'm sure the 600 at the Grennan are roosting on the River Ken, beside which

they have been feeding. It will probably be a similar pattern at the south end, just a few moments' flight to the water, but there could be flocks which have gone out of the valley to feed through the day and it might be dark before they come to roost.

By four o'clock, when we were on the west side overlooking Finniness marsh, it was becoming a very wet evening. Out over the island crows were baiting a merlin. The rain drumming on the car windows was making it difficult to hear a goose chorus from inside. I stood out in the rain to listen and watch in the murky dusk. There was no influx of greylags but then at 4.30 I caught the unmistakable, high-pitched chatter of white-fronts from far down the valley. How that sound lifts the spirits! They came into view well above tree-top height, about 120 birds, certainly a different flock from those which had been feeding near the loch in the afternoon. Usually they would come down for the night in Finniness marsh, but they never wavered and flew past as if in a great hurry to reach some other roost site up the valley. Probably they made a right-angled turn at the entry of the River Dee and then flew west for Loch Stroan, as that was where Ray the warden found the flock roosting some evenings later. It was dark by the time we were back at the north end of Loch Ken and if there were geese roosting on the river there, the sound of their conversation was completely drowned by the moaning wind and hissing rain.

It will be a rough night for any Purple Warriors out on the hill.

21 November *The garden in late autumn*

We have taken the strawberry net off the pond. It was there to catch the prodigious leaf fall from beech and ash. I have left the rich carpet of beech leaves under the tree, but the big ash leaves make drab litter. The beech has been a resplendent colour centre to the garden for weeks past: now it is almost naked after sharp frosts. Our first brambling, a pale-headed hen, has been with the chaffinches poking among fallen leaves for the mast. A cock blackcap, dense black crown contrasting with the soft greys of its body-plumage, has made transitory appearances at the apple feast among blackbirds and two magnificent fieldfares. Most years we see one or two winter blackcaps which may have made a westerly migration from central Europe. This one could easily survive for weeks on the remains of apples, but inexplicably only stays for moments at a time. What is the advantage of such waywardness? News that a bird-ringer has caught a yellow-browed warbler at Gatehouse of Fleet keeps me all the more on the look-out for unlikely garden birds.

The blackbirds are endlessly watchable. No doubt if they were all individually recognisable it would be astonishing to discover how many there are. By now migrants from northern Scandinavia must have swelled the numbers. 'White collar' is dominant in her territory when she is out on the grass, but not aggressive to other blackbirds in the apple tree. There are many first-year cocks, mostly still with blackish bills and lacking the staring yellow eye-rim of the old cocks. They are continually fidgety, as they retreat from advancing old birds. Forced to be especially alert and quick moving they may thus improve their survival chances against dangerous predators like sparrowhawks. David Snow's book, *A Study of Blackbirds*, is wonderfully informative and readable. The posturings which have been so evident on fine mild mornings this month are territorial disputes, but Snow found that the final breeding territories were not established until February at the earliest. Yet the garden blackbirds *look*

as if they are sorting themselves out for next year's breeding season now. By then, of course, many of the first year birds will have been squeezed out of the small, temporary territories they may have gained in the winter. In contrast to the blackbird activity, the rooks have lost interest in their nests and are hardly seen at all about the garden. Lately I have seen and heard carrion crows more often.

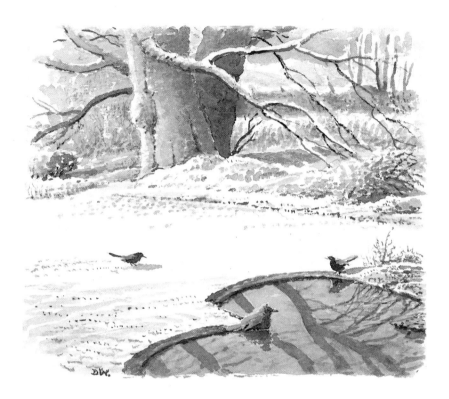

25 November *A vanishing little auk*

Local birdwatchers have been to Lochrutton, near Dumfries, to see the little auk which was discovered there 10 days ago. It has been suggested that it is the most numerous seabird in the world but it is only found around British coasts when storm-driven. It is then not very unusual for individuals to reach inland waters, but most are dead or dying when found. The Lochrutton bird is surprisingly sprightly and diving frequently for food.

Last night Ray telephoned to report his sighting of four more on Loch Ken. One was in a sheltered inlet called Cadger's Loup, beside the road which skirts the Loch on the west side and three were flying strongly. Our old friend Louis joined us this morning, confident that at least one would still be on view at Loch Ken. I had only once seen a live one before, more than 50 years ago in Granton Harbour, Edinburgh. At Cadger's Loup, a brisk and icy north east wind was whipping up wavelets. We gazed hopefully at dark tree-reflecting water, much flecked with foam, which might make a black and white bird smaller than a starling quite difficult to spot. J. saw it first. It dived and surfaced again, now very close. I called to Louis who had walked a few yards up the road. For a moment I had the binoculars on the bird,

swimming flat-backed low in the water. Then it flicked open its wings as it dived under again. Louis came back seconds too late in answer to my call. Three pairs of eyes waited for its re-appearance. An hour later it was time to go home. The little auk had vanished without trace, never to re-appear. It had to be somewhere unless, perish the thought, it had become entangled in weed or net and drowned. Perhaps it swam an underwater marathon and popped up far out on the loch where it would have been almost impossible to spot on the rough water. It was nowhere to be found in the afternoon and one of us has still to see his first little auk, while I had not seen enough of it to justify a field sketch.

After the little auk episode J. and I went to the traditional harrier roost site on the flow. It was bitterly cold, but the sun was still dazzlingly bright and casting a golden glow over the furthest hills. J. stayed in the car doing her crossword puzzle, while I went out to watch from the riverbank, not very optimistic as there was only a single male earlier this month. Forty-five minutes later I had been rewarded by seeing four or five male harriers, wonderfully ghostly and elegant as they swung about low over the withered expanse of the flow. Timber felling was so noisy nearby that I feared they might be scared away. The first arrival flew on out of sight but probably returned later. At last, at 4.15, the power saws stopped and I was left to enjoy the silent calm of an evening turning to frost with all the harriers safely settled, but not one female (ringtail) among them. Years ago at this date there would have been far more birds, including many ringtails, but tonight's 'four or five males' was the same as this time last year and by no means bad for recent years. We waited on in the car until darkness was complete, hoping for the thrill of flighting geese but none came.

3 December *A fishing record*

Our friend and neighbour, Louis Urquhart, began visiting Dalry with his wife on holidays from Glasgow soon after the war. They settled here when he retired. Now a widower, Louis has lost none of his enthusiasm for trout fishing or ornithology. He is perhaps an exceptional fisherman since goosanders are, I think, his favourite birds. It saddens him to find so many of their nests illegally destroyed by those fishermen or keepers who still regard them as unacceptable rivals. This year he took part in the national goosander survey, but found the local breeding numbers disappointingly low though the Ken–Dee river system still has more pairs than any other in Galloway.

A fortnight ago the local paper published a letter from Louis, which put the record straight about a fish caught on a spinner at Loch Ken in August. At that time it was described as an 11lb 5½oz salmon. The same angler was credited with a grilse from the loch in June. When a water bailiff, Jock McCubbin, saw the smaller fish he pronounced it unquestionably a brown trout. Doubts were then raised about the identity of the bigger fish. Although it had already been boiled, Ian McAdam of Kenmure Fisheries was able to read the scales. He, and subsequently the Freshwater Fish Laboratory at Pitlochry, found that this too was a brown trout. Louis pointed out in his letter that while a salmon of 11lb 5½oz taken from Loch Ken would be of passing interest only, a brown trout of that weight is probably the rod-caught record for Loch Ken and the Glenkens. It was reckoned to be about 12 years old and had spawned four times. Happily Mrs Struthers, who caught the two fish, has now written to the paper expressing appreciation for Louis' letter and delight at having caught a record trout!

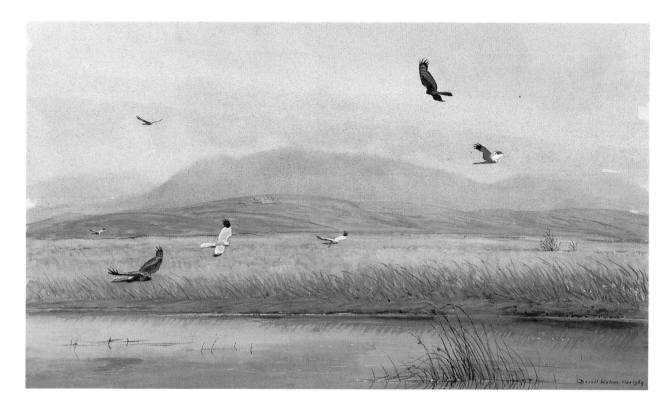

Hen harriers over a winter roost, Galloway, 1969

Our friend is writing another letter about the rudd and the ruffe, two kinds of fish which have recently been found in local lochs for the first time. It seems to be unknown how the rudd arrived (in Barscobe Loch) but the ruffe came as live bait brought by anglers visiting Loch Ken. L. comments that the ecological balance might be seriously affected by such casual introductions.

12 December Heart Moss and Dundrennan

Dundrennan, begun about 1140, is the oldest of three ruinous abbeys in Galloway. Compared with the smiling rose-coloured pile of Sweetheart Abbey, Dundrennan is sombre, even awesome to contemplate. Its beautiful remains lurk among old trees in the little valley of the Abbey burn below the line of village houses. It is easy to imagine a shadowy presence watching through those gaunt arches. It was at the peak of springtime — May 15, 1568 — that Mary Queen of Scots spent her last sad night in Scotland here, before crossing the Solway next day to England, imprisonment and eventual execution. Accounts of how she rode south after defeat at the battle of Langside are confusing. I would like to believe that she came by 'the unfrequented passes of the Glenkens and along the west bank of the River Ken' as tradition has it, but this is hard to reconcile with the story that she spent a night at Sanquhar on her way to the Maxwell castle at Terregles, beside Dumfries.

We would not have been at Dundrennan on this day had we not first been to Castle Douglas to see an exhibition of fine Galloway landscapes. Charles Oppenheimer, though a Yorkshireman, became one of the most admired artists of the Kirkcudbright group. He had an extraordinary skill in capturing the quality of Galloway country and no artist, in my view, has

excelled him in painting fast-flowing water. For many the surprise of this exhibition must have been the sparkling freshness of William Hanna Clarke's watercolours of Kirkcudbright and its environs. Clarke, from Glasgow, died quite young in 1924 and his work has never been widely seen.

We decided to drive on into the country south of Castle Douglas, where the heartland is hilly and quite rugged, and big fields with herds of Friesian dairy cattle sweep down to sea cliffs. On the way I scanned the fields and marshy 'lane' at Gelston. Twenty or more years ago this was where the only large flock of bean geese in Scotland could often be found in midwinter. Unlike other grey geese they frequently fed deep into the marsh and it is likely that partial reclamation of this has made it less attractive to them. I knew it was a forlorn hope that any would be there today. They would in any case be unlikely to come in such mild weather. Last winter I was dismayed by the sight of shooters using decoys here, even though if they bagged any geese it would almost certainly be greylags. The other day I had an interesting letter from Leo van den Bergh, the Dutch authority on bean geese, putting the decline in Scotland in an international perspective. There is little doubt that the great decrease in the Scandinavian breeding stock in the 1950s and '60s was at least partly responsible for the virtual disappearance of the flock which used to come to Galloway.

We headed west for Heart Moss, one of the most exciting looking pockets of ancient undrained mossland which survive in hollows among the broad acres of green pasture. Fortunately its future looks secure as a designated 'Site of Special Scientific Interest'. With the sun low in the southwest it made a brilliant enclave of colour, madder-red birches, thickets of almost olive willow, and an expanse of marsh grasses, sedges and reeds ranging from palest buff to orange. The lights in the big milking shed at the farm shone like lemon beacons from far beyond and further still the hill land rose to a grey fretted skyline above Felcroft Loch.

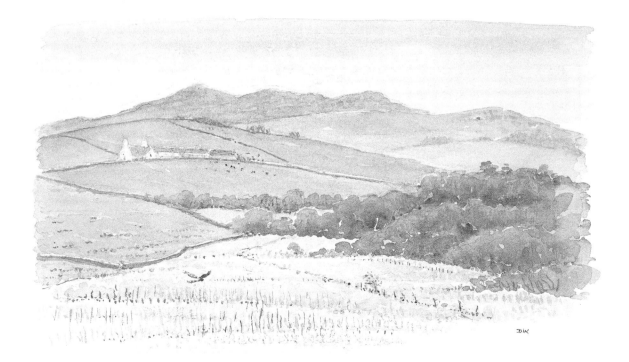

It was my specialist interest in hen harriers which had drawn me to Heart Moss on this winter afternoon. It looks the ideal site for a communal roost and I had seen a female arrive there late on a January afternoon last winter. We watched from the car this evening and I had an experience which I found fascinating and frustrating at the same time. I did not rate expectations highly, but when once again a female harrier appeared about sunset time hopes rose. It gave a marvellous exhibition of low, coursing flight, catching and eating small prey, probably a vole. Surely then, long past sunset, it had done enough for the day, but no, quite suddenly it set out in purposeful flight over the fields in the direction of Dundrennan. So there was certainly no roost at Heart Moss, not even a solitary one. Later I pored over the map and enjoyed speculating on where it might be going, but I may never find the answer.

In the dusk the abbey ruin stood shadowy and a little menacing.

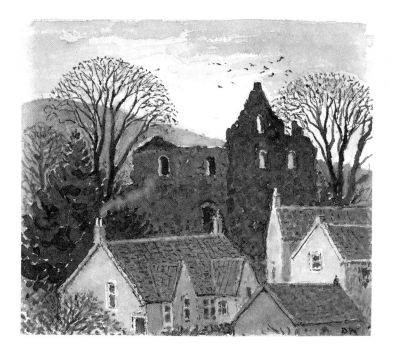

29 December *The High Ken in winter*

An early cold spell — ice was thick on the pond for a fortnight in November — has given way to mild rainy weather. At least the family had no travelling problems coming home for Christmas from north and south.

I have been visiting the upper reaches of the Ken valley. On these dark December days, with only a light snow cover on the highest hills, browns and ochre are the pervading colours of the landscape except where it is covered by great blocks of conifer forest. Some find this wintry hill landscape depressing, lacking the sparkle of snow and frost effects, but as a painter I do not find it so. 'The Sauchs' — a long straggle of willow carr beside the High Water of Ken — are peppered here and there with the white seed-heads of one kind of willow, at first sight looking like the buds of spring flowers. Sadly the black grouse, which used to have a big lek

close to the road, have not been present. There are still sheep and Galloway cattle here but for how long, I wonder? The plantations are burgeoning, mostly private forestry, usually with no obvious human presence. The one-time shepherds' dwellings are variously tenanted. Robin Ade, the fisherman/author, lives with his wife and family in one, happy to be a little less isolated than at Knockendorroch deep in the hills above Carsphairn. On the roadside we talked about the exceptional abundance of field voles which has persisted into the winter. No wonder the most obvious birds are nearly all vole-hunters. One visitor claimed to have counted 30 kestrels in the glen and there had been 7 or 8 short-eared owls in company high on Benbrack.

This afternoon, when the rain at last ceased, we drove up and had a brisk cold walk up the glen road. Snatches of a dipper's pleasant rambling song came from the burn below the bridge by Strahanna farmstead. A big brown shape swept over the willow clumps and away — a female hen harrier, white rump gleaming, which had been hunting the rushy hollows, probably the same that I had seen in precisely the same spot a month ago. Undoubtedly it was yet another vole-hunter, like the buzzards we saw here last visit. The present mixture of afforestation and sheepwalk in this glen suits both these big predators and they should be safe enough from persecution here. It would be a great loss to the landscape if the open slopes of Dodd Hill disappeared under conifers.

3 January 1988 *Winter finch flocks*

I am now receiving birdwatchers' notes for 1987, as recorder and editor of the local bird report. This is when I learn how much I have missed during the past year! Why did we never make that trip to Corsewall Point in September? No less than five Sabine's gulls, rare Arctic breeders, were seen there in mid-month and almost certainly an even rarer Wilson's petrel. But I am happy enough for others to make such discoveries — Corsewall Point is a long journey from Dalry and unless you are there early in the day and the wind is blowing from the north west you may see nothing remarkable. Occasionally, of course, a very rare bird turns up almost on one's doorstep. A bizarre example of this came my way in July 1986. Marc Kéry, our young friend from Switzerland, had cycled up to the head of the Ken valley to see some hill birds. When he returned in the early evening his lead story was of a woodchat shrike beside the empty cottage at Lorg. He was willing to return and let his supper wait. We need not have rushed — it stayed for almost a month, the only woodchat shrike ever seen in Galloway. A most beautiful adult bird, but what on earth had drawn it to this remote, almost treeless spot deep in the Galloway hills? From the number of castings of beetle elytra it had deposited on the rhubarb leaves in the shepherd's abandoned garden, food was no problem in this unlikely northern setting, for a bird which normally summers in the Mediterranean regions. I have had no experience like this in 1987, but it is always satisfactory to follow the fortunes of the birds which truly belong here. When assessing changes in bird-life of familiar country over several decades it is worth keeping in mind the old countryman's remark that the larks don't sing any more. Older people, like myself, may be led into false impressions of declining numbers of birds as hearing and sight deteriorate. So it is always worth paying great attention to what reliable youngsters report. One such observation which has just been sent in is of a huge flock of mixed finches in a turnip field in the Cree valley. Estimates of 3500 chaffinches, 1500

Barn owl hunting, near New Galloway, 1981

linnets and 500 greenfinches are high by any standards and seem to belie a general impression that agricultural changes have caused a decrease in such winter flocks. At another turnip field in the Ken valley, reports from different experienced observers suggest the numbers of linnets there in mid-winter have fluctuated between 200 and 1000. Many of these birds may be nomadic over a wide area. Since turnip fields have become less common in recent years finch flocks presumably have to roam much more widely in search of them. Weedy rape fields have lately been favoured feeding sites.

Thirty years ago, in bitter cold mid-winter weather, I spent several days studying and sketching a big finch flock at corn stacks on Bogue Brae, close to Dalry. I had no idea that unthreshed stacks would soon be just a memory and what I was seeing would become ornithological history. Bird gatherings at these corn stacks included a wonderful variety, typically chaffinches, greenfinches, bramblings, yellowhammers, reed buntings, blue and great tits, a few skylarks, dunnocks, the odd pied wagtail and meadow pipit, usually a covey of partridges, some woodpigeons, mallard and pheasants. Predators like kestrel, merlin and sparrowhawk made frequent attempts to capture prey. These and a weasel caused some of the 'scares', when all the birds flew up into a big hawthorn, but often there was no obvious explanation for these frequent and remarkably synchronised flights. I noted how the blue tits disappeared right into a stack, like mice, bringing out whole ears of oats. They would then hold them down in their feet expending a lot of energy to split them open with their small bills.

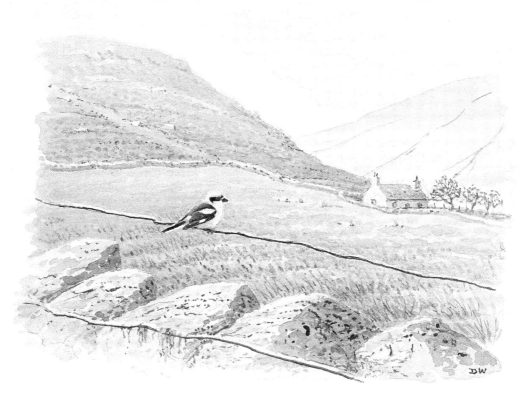

Woodchat shrike, Galloway, July 1986

There had been a heavy snowfall on Christmas night, 1957, followed by brilliant frosty weather when the colours of the birds shone jewel-like in the sun. Blue tits cast azure shadows on yellow corn. Crouched against a stone dyke I was almost within touching distance of some birds. Colours of landscape were noted too, like the gleaming purple-bronze of the empty road blown free of snow, yellow-grey stones of the dyke and grassy verges blazing ochre in low sunlight.

Few or none of the birds roosted at the stacks, the first to depart being some of the finches in early afternoon. From then on there was a drift away to the woods still powdered with snow, several fields away, but large-eyed birds like robins and kestrels continued to hunt for food until it was almost dark.

The previous winter Robert Ruttledge had taught me to look out for the varied shades of pink on cock chaffinches' breasts — 'pale pink', 'plum pink' and 'brick', which he reckoned indicated geographical origins, the first two being Continental and the last local residents. Nowadays bird ringers catch them and separate them by wing-length. A Dutch-ringed bird was found in Galloway not long ago, but Geoff Shaw has found locally-bred birds in the Cree valley flock.

The loss of the corn stacks, then so common, must have dealt a severe blow to many birds in winter. Barn and short-eared owls hunted around them for rodents too. Yet in those days there was far less food put out for birds in village gardens. These now provide the mainstay of winter feeding for more and more small birds. The other day when my friend Tony Hopkins

134

came over from Northumbria his young son, Andrew, exclaimed at seeing our garden chaffinches expertly clinging to a peanut basket and feeding from it. At Hexham, they said, chaffinches have not learned to do this yet and I believe this is true for much of England. Some learned the skill here more than 10 years ago.

By the time I came to live in Galloway, in 1951, it was already rare to find flocks of snow buntings coming to the stackyards as they commonly did at least up till the 1930s. Possibly they did so only after heavy snowfalls on the hills, where they are still regular winter visitors. A flock has been seen at Mackilston during the last few days.

18 January *Beyond the Cree*

A high greying sky and a steely wind. There were hundreds rather than thousands of finches in the big turnip field at Challoch, much of it now eaten bare by the sheep. We voted it too cold to spend time there.

On such a day the road to Barrhill was bleak and might be awkward if the snow came. Billowy white clouds like a range of snowy mountains nudged above the western horizon. The map is full of exciting names like Ink Moss and Tannylaggie Flow, but many have lost all descriptive meaning with the advance of the conifer plantations. On the brae above lonely Kirkcalla a flock of about 50 chaffinches and a cock reed bunting were at cattle feed spilled on the road. I was interested to note that at least 80 per cent of the chaffinches were males, agreeing closely with Geoff Shaw's experience of flocks at the smallholding of Kirriereoch, above Glentrool, which is only about 7 miles from here as the crow flies.

It is some years since I last saw the big lochs, Dornal and Maberry, one on each side of the road near Drumlanford House. Four whooper swans with heavily peat-stained necks were fast asleep at the edge of Loch Dornal. The only other wildfowl on either loch were a few goldeneye, one drake displaying. We lunched beside Loch Maberry, the cluster of islands crowned with bare trees reflected in still grey water, making an almost Highland cameo.

It was during the last war that greylag geese began to nest on these lochs. For a while this was regarded as confidential news and I recall how privileged I felt when Sir Geoffrey Hughes-Onslow arranged a day to show them to me, early in the 1950s. In a few years they were taken for granted, not without some protests from farmers, and were breeding on many lochs in south-west Scotland.

We spent the last of the daylight walking a stretch of the New Luce road, west of Three Lochs. The highspot was the peregrine which powered across the sky unexpectedly. It must have already fed well as it never deviated towards the big flock of fieldfares and redwings feeding late on the open grassland. Cattle feed at a lay-by had attracted a greyhen as well as a pheasant.

In the bitter cold dusk a mass of lemon gorse buds struck the brightest colour-note of what my old friend Maury Meiklejohn might have dubbed 'a dull old day'.

24 January *Southerness*

By leaving home in early afternoon there would be time to catch the high tide at Southerness at 3.22 and perhaps see a good show of waders before they dispersed over the mudbanks to feed.

Little remained of the recent snowfall and by the time we approached Dalbeattie, Barskeoch Hill was bathed in spring-like sunshine. At East Preston, as we drove down to Southerness, some 2000 dapper barnacle geese with a smattering of pinkfeet were feeding in grass fields in a long, straggling flock. We also admired a grey wagtail which dipped into the roadside ditch. Fine mild weather after a couple of snowy days had drawn quite a crowd of people to the shore this Sunday afternoon and on a fairly big tide the wader flocks were having difficulty in finding undisturbed resting places. This stretch of shore is one of the best on the Scottish side for quantity and variety of birds. Although the big gathering of bar-tailed godwits were missing and there were very few grey plover about, we saw enough to make the last two hours of daylight quite exciting. Birdwatchers from far and wide know that rocky Southerness Point is the winter home of the only sizeable flock of purple sandpipers for miles around. Waves were breaking over their favourite feeding ground below the old lighthouse, but we soon found them huddled, mostly asleep, on one of the small scars along the shelly

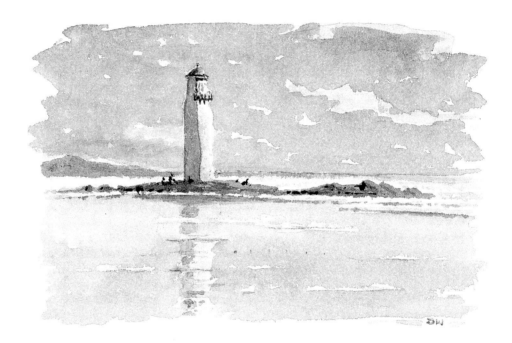

beach. While most of the turnstones flew off as children and dogs came near, the purple sandpipers held their ground, as if aware that they blended closely into the black and charcoal reef. Counting them several times I got 43, 48 and finally, quite certainly, at least 50, the most I have ever seen at Southerness. Just at that moment a friend, John Skilling, came striding along the beach. He is one of the dedicated band who brave all weathers to make regular counts of shorebirds, as part of a national survey especially valuable for conservation.

The waders hurrying by just offshore were mostly segregated into flocks made up of one or sometimes two species. There were largely discrete packs of oystercatchers and redshank, a few dunlin in company with a dense pack of perhaps 2000 knots. While the oystercatchers flew low and direct, close to the waves, the knots wove tortuous patterns up and down the sky

as if uncertain where to find a peaceful roost. J. spotted 25 ringed plovers with a group of turnstones and in the dusk 40 golden plover came down from the fields, or perhaps the golf course, to alight on the rocks. A party of mergansers flew by as if motor-powered, making the lumbering cormorants look lethargic. Twenty small finches rising from the edge of the dunes I took to be twites, but they were quickly out of sight.

Walking back in the fading light I had to stop and scribble a sketch of the crooked old lighthouse reflected in the wet sand. Silhouetted against the sky it looked from a distance a bit like a figure balancing on one leg. Out in the firth a wild sea was running, a hint of palest green in the further waves.

27 January *From the studio window*

My year has almost turned full circle. Once again the wild song of a mistle thrush greets me as I go into the garden. Snowdrops in full bloom and carpets of celandine leaves. Great tits were see-sawing earlier in the month and the collared doves are now courting and flying into the cypress tree, where I think they have the first garden nest of the year. In memory the turtle doves of my southern childhood are preferable, especially because the persistent voice of the collared dove has none of the magic of the turtle's crooning. Yet the pair perched on the beech this morning in brilliant winter sunlight were a reminder that their soft, almost indefinable colours have the discreet charm of understatement. For an artist the hope must always be that his subject will strike him as if he had never looked at it before. So it was that the apparently commonplace collared doves had me watching them intently through binoculars from my studio for an hour or more and filling a few sketchbook pages. The courage to draw the most difficult postures that birds can assume too often will not come. Artists like Eric Ennion, John Busby and Lars Jonsson have shown what can be done.

Within a space of minutes the two collared doves had gone through a range of postures that would take all day to draw as they preened exhaustively (the male sometimes turning to his mate to nibble her nape), then suddenly changed from looking fat, loose-feathered and contented, to thin and alert with plumage tight as skin. Perhaps they could see a predator in the sky. All doves have what seems a gentle, trusting charm in their behaviour, yet they are great survivors and can be aggressive to their own kind. The awful screaming 'waar, waar' of the collared dove is usually to scare off a territory invader.

A close look at this pair reveals that their colours are distinctly different, he much greyer and paler on the head, she a browner bird with less lilac-pink suffusion. When he rears up, playing the dominant partner, his head looks large and bulbous.

Travelling abroad in four continents, I have been struck everywhere by the great success of the dove and pigeon tribe. Many are wonderfully pretty birds like the mourning dove of North America, the laughing dove of southern Africa and the splendid green pigeons of Asia. All the sadder that one of humanity's lesser crimes was to exterminate the passenger pigeon, which must have been one of the finest American species. More than 40 years ago, when I first saw the collared dove (or Indian ring dove) in India it would have seemed incredible that it could ever become a familiar bird in Scottish gardens. Yet a very few years after its arrival in Cromer, in 1955, it had spread all over Britain. To say that it exploited 'a vacant niche' for a small dove is not much of an explanation.

February — one year on

A year ago I wrote of Moss Roddock, the little loch above the village. This February it has attracted up to 14 whooper swans and a male hen harrier has been hunting its shores, putting the ducks to flight. There is clearly an exceptionally rich growth of weed in the water for such a large number of whoopers to remain, day after day spending long periods with necks submerged and often 'standing on their heads', with only their sterns and paddling legs visible.

Late this afternoon we were driving home after a walk beside Clatteringshaws. Back from snow-powdered roadside verges the conifer forests looked black and mysterious. Sun slanting

through dark cloud masses lit the untrodden snowfields on the high hills. A silent world but full of a sense of stored life. I left J. at the house and drove up to Moss-Roddock to make some quick sketches of the whoopers in the gloaming. How luminously white they looked. The huge birds, usually so tranquil, were in disarray, being harried by the cob of the pair of mute swans. It was an oddly ridiculous spectacle, as he pursued them in full sail. His aim was to drive them all ashore and whenever he approached one threateningly it swam for the bank. By the time I left 4 were waiting for a chance to return to the water, but this they could only do if confrontation with the cob mute swan could be avoided.

A few days later the weather pattern changed again. For a week Galloway basked in mild spring sunshine. Lapwings and curlews made an unusually early return to upland fields though they will probably have to retreat again. Most extraordinary was a report of a wheatear at Dundrennan on the 19th — I have never known of a February wheatear before. Alas, more and more of these favourite moorland birds will find their upland nesting grounds destroyed for ever by the forestry plough. I am reminded of John Clare's lines: 'Far spread the moory ground . . . that never felt the rage of blundering plough'.

As I complete this diary of one year in my home countryside, I am aware how selective and perhaps idiosyncratic my choice of entries has been. I am told that everyone wants information nowadays. I hope that readers will have found some in what I have written (see also the bird list which follows), but my intention has been rather to describe through words and pictures what I have enjoyed, mostly in one small and perhaps undervalued corner of Scotland. The future of the Galloway countryside and its wildlife does not carry much weight with politicians and bureaucrats. Some of us, and not only those who live here, think it is very precious.

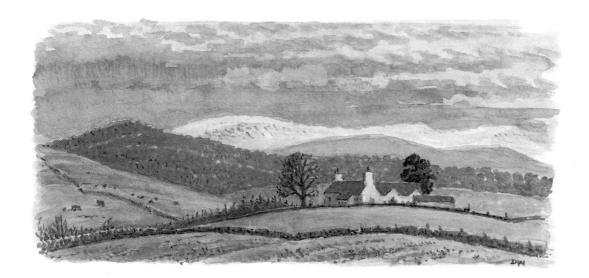

The Birds of Galloway 1900–88

R = resident, B = breeds, S = summer visitor (or present in summer), P = passage migrant,
W = winter visitor, V = vagrant, O = occasional, A = autumn, Sp = spring

Red-throated Diver OS W P has bred. The commonest diver.

Black-throated Diver OS W P has bred.

Great Northern Diver OS W ?P up to 50 Luce Bay W.

Pied-billed Grebe V one, Carlingwark Loch, 1–8 Oct. 1975.

Little Grebe R B widespread, mainly freshwater.

Great Crested Grebe R W B Several lochs, widespread coasts W, most L.Ryan.

Red-necked Grebe W scarce, mainly L.Ryan.

Slavonian Grebe W not plentiful. Most L.Ryan. Once S (L.Ken).

Black-necked Grebe W OS not plentiful. Most L.Ryan (up to 22).

Fulmar B numerous seacliffs. Seen most of year.

Great Shearwater V one, Black Head, 16 Sep. 1978.

Sooty Shearwater AP few, mainly west coasts.

Manx Shearwater AP numerous, mainly west coasts, some Sp/S.

Little Shearwater V one, Corsewall 14 Sep. 1985.

Storm Petrel AP small nos, west coasts, O inland.

Leach's Petrel AP small nos, west coasts, most Corsewall.

Wilson's Petrel V one, Corsewall 15 Sep. 1987.

Gannet B Big Scare (Luce Bay), 770 nests 1984 (increasing). Widely seen off coasts, esp. west. O inland.

Cormorant R B several coastal colonies, one inland — Mochrum (415 nests 1986).

Shag R B small colonies coasts.

Bittern W scarce, irregular, freshwater marshes.

American Bittern V one, L.Ken, Oct.–Nov. 1977.

Little Bittern V two, probably three records, none recent.

Cattle Egret V one, Stranraer, Oct.–Nov. 1986. Same or another L.Milton Dec.

Grey Heron R B widespread (only 8 small heronries found 1985).

White Stork V three records.

Little Egret V two records.

Spoonbill V one, Kippford Oct. 1976.

Greater and Chilean Flamingo V several records.

Mute Swan R B widespread.

Black Swan V (escaped) one, L.Ryan June–Sep. 1971.

Bewick's Swan W much fewer than Whooper, most Nith estuary.

Whooper Swan W widespread. Flocks up to 300.

Bean Goose W scarce (much decreased). Mainly near Castle Douglas.

Pink-footed Goose OS W flocks (thousands) mostly near coasts, few in West A.

Greenland White-fronted Goose W two main flocks, c. 300 Ken–Dee, up to 700 West Freugh.

European White-fronted Goose OW scarce.

Lesser White-fronted Goose OW up to 3, 1954–9 Castle Douglas, one Wigtown merse 27 Mar. 1960.

Greylag Goose R W widespread large flocks W. Feral breeders many lochs.

Greater and Lesser Snow Goose W small nos, sometimes S. Most probably escaped.

Ross's Snow Goose V two, Dunragit Jan. 1962. Same Ken–Dee Feb.

Canada Goose R B W small nos widespread. B increasing, interbreeds with Greylags.

Barnacle Goose W large flocks (thousands), mostly near Nith estuary. OS.

Brent Goose P W scarce, most Light-bellied. Regular small flocks L.Ryan, Oct.–Nov.

Bar-headed Goose V (escaped). One Feb.–March 1985.

Shelduck R B numerous, mainly estuaries, some breeding well inland. Large emigration for moult June onward.

Mandarin V two, Earlstoun L. Nov.–Dec. 1984.

Wigeon OS P W has bred. Numerous estuaries, some lochs.

American Wigeon V two; L.Milton Mar. 1975, L.Ryan Nov. 1983–Mar. 84 (both drakes).

Gadwall P W scarce.

Teal R B P W numerous, widespread P W, quite plentiful B.

Mallard R B P W abundant, widespread.

Pintail B P W locally plentiful P or W, larger estuaries, 100+ at times Ken–Dee. May no longer B, was scarce, 2–3 sites.

Garganey OP most May, one Sep.

Shoveler B P W not widely plentiful P or W, 1000+ at times Carsethorn and 100+ Ken–Dee. Decreased B, now scarce.

Pochard S OB W widespread small nos W, at times 200+ Carlingwark L.

Red-crested Pochard V one, L.Auchenreoch 28 Nov.–11 Dec. 1982.

Ring-necked Duck OW five records (L.Ryan, L.Ken, L.Milton) 1980–1988.

Tufted Duck R B W numerous widespread, mainly lochs. Moderate nos B.

Scaup OS W main flocks Carsethorn (much increased to over 3000 1988) and L.Ryan.

Eider R B B fair nos north-west coast, large nos moult L.Ryan.

King Eider OW Imm. drake L.Ryan 30 Mar. 1970. Ad. drake there each winter Mar. 1976–Nov. 1981.

Long-tailed Duck W small nos, mainly L.Ryan, also visits freshwater lochs.

Common Scoter S W has bred once (Monreith area 1970). Rare on freshwater. Flocks (up to several thousand July in past) off coasts widely.

Velvet Scoter W very small nos coasts. Once inland, drake L.Ken 3 Oct. 1970.

Surf Scoter OW several records Southerness area, one L.Ryan, one Carrick.

Goldeneye OS P W numerous W peak nos Feb .–Mar., lochs, rivers, sea.

Smew W small nos, more plentiful 1950s. Mostly on lochs.

Red-breasted Merganser R B ?P common off coasts, max. L.Ryan — Luce Bay 480 Aug.–Sep. (moult flock). Moderate nos B, mostly in west.

Goosander R B ?S W widespread, fairly plentiful on lochs W–Sp. B mostly upland glens, few in west. Probably decreasing.

Ruddy Duck V one drake, Mochrum L. Sep. 1985, another there Feb. 1987.

Honey Buzzard OP OS one W, shot Troqueer 17 Jan. 1901.

Black Kite V one Lochfoot 28 Aug. 1987.

Red Kite O formerly bred, three recent records, singles (one shot).

White-tailed Eagle V formerly bred, one Monreith 2 May 1986.

Marsh Harrier P OW may have bred formerly, becoming more frequent.

Montagu's Harrier O has bred — female trapped at nest, Corriedoo 28 June 1953.

Hen Harrier R B P W probably extinct as B by 1860 (persecution). Re-established 1950s. B rather sparse, more widespread W.

Goshawk R rare, B not proved.

Sparrowhawk R B numerous, widespread.

Buzzard R B recent increase lower ground follows long-term decline on higher.

Rough-legged Buzzard OW very few recent records — one 24 May 1975, Goat Craigs.

Golden Eagle R B scarce. Formerly fairly common; B occasional 1860–1945, regular since. O scattered localities W.

Osprey S P formerly bred, extinct as B by 1870. Increased sightings since mid 1960s.

Kestrel R B ?P numerous, widespread.

Merlin R B W decreased since mid 1970s, now scarce B. Widespread A W.

Hobby O four since 1973 (May, July, Sep.).

Peregrine R B ?P much decreased 1960s (pesticides), well recovered since. Widespread A W.

Red Grouse R B much decreased; loss of heather moor and lack of management.

Black Grouse R B numbers fluctuate, recently decreased. Mainly young conifer plantations, formerly more widespread.

Capercaillie V female seen Galloway/Ayrshire border, 29 Sep. 1977 and Nov. 1982.

Red-legged Partridge R B widespread introductions incl. Chukors or hybrids.

Grey Partridge R B much decreased, still widespread small nos lowlands.

Quail OS ?B formerly bred commonly in west. Scarce.

Pheasant R B numerous, widespread; many released for shooting some estates.

Golden Pheasant R B first introduced near Newton Stewart c. 1895. Became locally plentiful mainly pine/larch forests, recently decreased.

Lady Amherst's, Siver and Reeve's Pheasant O escaped or released, original introduction was hybrid Golden × Lady Amherst's.

Water Rail R B W scarce B, more plentiful W, marshes.

Spotted Crake OS OW formerly bred and probably still does, irregularly, marshes.

Corncrake S formerly widespread B, small nos still B 1970s, still few S, probably ceased B.

Moorhen R B numerous, widespread, decreased 1970s; some recovery.

Coot R B W locally numerous lochs W, moderate nos B.

Crane V one June 1920; one 6–12 April 1984 (Twynholm).

Little Bustard V one Luce Bay 29 Apr. 1964.

Oystercatcher R B S W numerous B inland and coasts. Very large flocks W some estuaries. First bred inland c. 1903.

Black-winged Stilt V one L.Ryan 17 Oct. 1920.

Ringed Plover R B P widespread coasts, up to 300 Southerness Aug., some B inland.

Dotterel OS P has bred. Scarce. P mountains and OP coastal grassland.

Golden Plover R B P W B much decreased (moorland loss). Formerly PW flocks coasts very large, now less.

Grey Plover P W widespread estuaries, small nos, but up to 250 Carsethorn–Southerness.

Lapwing R B S P W widespread, numerous, B decreased.

Knot P W numerous larger estuaries, esp. Nith–Southerness, small nos widespread coasts. OP inland.

Sanderling P W mainly small nos sandy shores. (Note many thousands at times P Dumfriesshire shore, late May).

Little Stint P fluctuates, usually scarce, estuaries. OP inland.

Temminck's Stint V one shot Islesteps 16 Nov. 1965.

Pectoral Sandpiper V one, Finniness, L.Ken 20 Aug. 1982.

Curlew Sandpiper P nearly all AP, small nos, rarely up to 10, estuaries. OP inland.

Purple Sandpiper W (S — usually absent only June–July). Scattered small flocks rocky shores, most (up to 50) Southerness.

Dunlin S B P W widespread flocks muddy shores, into thousands large estuaries. Formerly bred several upland bogs/moors, now very scarce B. Has bred on coast.

Broad-billed Sandpiper V one L.Ryan 18–20 May 1983.

Ruff P W mostly small nos coasts/coastal fields. (70+ Stoneykirk Sep. 1980). OP inland.

Jack Snipe W scattered small nos, marshy places, inland.

Snipe R B P W B decreased uplands. Widespread parties/flocks coasts and inland, A–W, max. over 100.

Great Snipe OW several old records, most Sep.–Oct.

Woodcock ?R B S W widespread, plentiful B woodland, OB moors. More in W, most immigrants.

Black-tailed Godwit P (Sp and A) OW estuaries OP inland pair bred 1972. Over 100 P Nith estuary.

Avocet V one Corsewall 12 June 1988

Bar-tailed Godwit P W estuaries. Up to 4000 Southerness Jan. 1982. Few in west.

Whimbrel P small nos estuaries, widespread, and over inland areas.

Curlew R B P W numerous B but decreased (moorland loss). Widespread numerous on/near estuaries W present all year.

Spotted Redshank P OW small nos, mainly estuaries.

Redshank R B P W B decreased. Mainly in river valleys/wetlands, not in granitic upland. Widespread, locally numerous coasts, esp. estuaries.

Greenshank P W widespread small nos estuaries, most A. Annually a few in W. O inland.

Green Sandpiper P W small nos inland and coasts. Most Aug.–Sep.

Wood Sandpiper AP scarce, irregular, most coastal.

Common Sandpiper B S P OW numerous B lochs and riversides, a few on coast. One Feb. 1988, Kirkcudbright.

Turnstone W ?P widespread moderate nos coasts. A few most of year.

Wilson's Phalarope V one, Kirkgunzeon, 25 Aug.–3 Sep. 1972.

Red-necked Phalarope V very scarce. One Loch Ken 23 June 1988. Pair said to have bred once in west c. 30 years ago.

Grey Phalarope AP irregular, scarce, mostly west coast.

Pomarine Skua P less than annual A, very few, mostly Corsewall. One, Port William 27 May.

Arctic Skua P small nos regular most A; flock 28 flew up Solway 3 May 1983.

Long-tailed Skua OP several records west coast Sep. One, inland, Carsphairn 27 Sep. 1978.

Great Skua P small nos off west coasts most A. OSp.

Mediterranean Gull V one Carlingwark L. 25 Oct. 1978, one Wigtown Bay 11 Feb. 1986.

Laughing Gull V one, L.Ken 22 Sep.–7 Oct. 1978.

Little Gull O scattered records, all seasons.

Sabine's Gull OPA several records Corsewall, Sep., since 1978.

Black-headed Gull R B W numerous coasts and inland. Widespread nesting colonies.

Ring-billed Gull V one, Wigtown Bay 11 Feb. 1986.

Common Gull R B W B, mostly small colonies upland lochs, some coastal. Largest (100+ pairs) Isles of Fleet. Very large estuarine roosts W, when big flocks field feeding far inland.

Lesser black-backed Gull S B P few W large colony 1500 pairs Almorness (1987), scattered elsewhere coasts, few inland. Scandinavian race OW.

Herring Gull R B numerous. Most B coastal — cliffs and islands.

Iceland Gull OW–Sp rare, five birds 1974–1987, 3 coastal, 2 inland.

Glaucous Gull W–Sp regular small nos, most at harbours, O at lochs.

Great black-backed Gull R B W fairly numerous, ranging inland. Most B scattered pairs seacliffs, larger colony Murray Isle, Fleet. A few B inland (Mochrum).

Kittiwake B P some W B several sites seacliffs incl. Scare Rocks. 360 nests Mull of Galloway 1986. Numerous AP west coasts. O inland.

Caspian Tern V one L.Ken 8–10 July 1982.

Sandwich Tern S B P scarce B, decreased. Common coasts Sp–A. O inland.

Roseate Tern S P rare, B not proved.

Common Tern S B P scattered small colonies coasts, few pairs lochs. Numerous P.

Arctic Tern S B P as Common Tern, much fewer.

Little Tern S B P very small nos B coasts in west, formerly one site in east.

Black Tern P scarce, fairly frequent mostly AP lochs; O on coasts.

Guillemot B P a few small/moderate colonies seacliffs, best Scare Rocks, Mull of Galloway. Large P west coasts, esp. Corsewall A.

Razorbill B P as Guillemot but much fewer. O inland.

Black Guillemot R B scattered small colonies seacliffs, e.g. Mull of Galloway, Cruggleton, Portpatrick Harbour, Meikle Ross. Small nos west coasts W, esp. L.Ryan.

Little Auk OW most west coasts; O inland (storm-driven).

Puffin S B ?P scarce, has bred Mull of Galloway, seen Meikle Ross, Balcary.

Rock/feral Dove R B widespread mixed stock B, most seacliffs.

Stock Dove R B ?S widespread small nos farmland, hardwoods. Decreased. Formerly bred commonly uplands (rabbit-holes, ravines).

Woodpigeon R B W numerous, widespread. At times W flocks 2–3000.

Collared Dove R B first seen 1961, bred from 1962. Rapid spread, mainly towns, villages. No longer increasing.

Turtle Dove OS OP has probably bred.

Cuckoo S B plentiful uplands, less so elsewhere. Fluctuates.

Barn Owl R B widespread, quite numerous. Fluctuates.

Snowy Owl V a few records, 1920s and earlier only.

Eagle Owl V has bred (believed escaped). Pair attempted breeding near Loch of the Lowes, Talnotry, April 1941.

Little Owl O ?R occasional scattered sightings 1966–86, probably breeds.

Scops Owl V one captured Kirkbean, April 1944. One almost certainly heard New Galloway, 28–30 May 1985.

Tawny Owl R B widespread, numerous.

Long-eared Owl R P B ?W Scarce, formerly widespread. Decreased since 1940s.

Short-eared Owl R B ?S fluctuates, depending on vole abundance. Widespread, often plentiful young conifer plantations.

Nightjar S B OP scarce, formerly widespread B brackeny hillsides. Since 1950s, mainly in conifer plantations.

Swift S B P fairly plentiful, B mainly towns/ villages.

Kingfisher R B small nos several rivers, few in west.

Roller V one, New Galloway, 10–14 Aug. 1969.

Hoopoe OP several records, most Apr.–May, also Sep.–Oct.

Wryneck OPA two records since 1971.

Green Woodpecker R B spread to Galloway c. 1957. Rapid establishment, recent spread to west (Dunskey). Decreased some areas, nowhere plentiful.

Great Spotted Woodpecker R B First nested c. 1905. Now widespread B, no recent change.

Skylark R B S P numerous, widespread. B decreased uplands.

Shorelark OW–Sp rare; small flock Sandyhills, Apr. 1970, singles Mull of Galloway, 20 Nov. 1971, Carsphairn 14 Nov. 1976.

Sand Martin S B P scattered colonies, decreased, but some recovery.

Swallow S B P numerous, widespread.

House Martin S B P fairly numerous, fluctuates. Several seacliff colonies.

Tree Pipit S B fairly numerous esp. hardwood edges, forest clearfells.

Meadow Pipit R B S P numerous esp. uplands B. Some decrease.

Red-throated Pipit V one, Whithorn 19 Apr. 1983.

Rock Pipit R B ?W coastal, fairly numerous, esp. rocky shores.

Yellow Wagtail S P formerly bred small nos lowlands (west). Scarce, mainly P near coasts.

Grey Wagtail R B S P fairly numerous, widespread. Mostly S, uplands.

Pied/White Wagtail Pied R B S P, numerous; mostly S uplands. Small nos White P.

Waxwing W scarce, occasionally fairly plentiful. Visits gardens for berries etc.

Dipper R B fairly numerous, fewer on streams over granite.

Wren R B numerous, widespread. Fluctuates.

Dunnock R B numerous, widespread.

Robin R B P ?W numerous, widespread. Fluctuates.

Nightingale VSp two records Stranraer area May 1980, 1984. Both in song.

Black Redstart P W scarce, coastal usually, esp. Oct.–Nov.

Redstart S B P fairly numerous, B hardwoods.

Whinchat S B P locally numerous, esp. young conifer plantations.

Stonechat R B P fluctuates, heavy mortality uplands in hard winters. Now commonest western coasts.

Wheatear S B P fairly numerous, mainly uplands decreased. Frequent P coasts. A few late A (Oct.–Nov.), often Greenland race.

Ring Ouzel S B P B uplands, decreased, not plentiful. Parties late A, feeding on berries uplands, rarely coasts.

Blackbird R B P W numerous, very widespread. Immigrants late A.

Fieldfare W P numerous, fluctuates. Pair probably bred once.

Song Thrush R B S P numerous, less than Blackbird generally but much more plentiful S thicket spruce forests. Few remain uplands W.

Redwing W P numerous, fluctuates, majority P. One, Aug., O singing birds late Sp.

Mistle Thrush R B P fairly numerous, widespread. Good nos B thicket conifer forests near open hill. Flocks uplands by late summer.

American Robin V one, Slogarie, 12 May 1966.

Grasshopper Warbler S B P fairly numerous, many, young conifer forests.

Sedge Warbler S B P fairly numerous, widespread, esp. marshes, reedbeds in lowlands.

Marsh Warbler V one singing Logan Gardens 22 May, one Mull of Galloway 16 Sep. (both 1982).

Icterine Warbler V one (possibly Melodious W) Mull of Galloway, 25 Aug. 1969.

Lesser Whitethroat S B P formerly rare, now quite widespread small nos, lowlands.

Whitethroat S B P widespread. Decline post-1968 but good recovery.

Garden Warbler S B P widespread, quite numerous, esp. mixed woods.

Blackcap S B P W widespread, fewer than Garden Warbler. Annual small nos A–W.

Wood Warbler S B P plentiful, widespread, oak/ birch woods.

Chiffchaff S B P a few R or W, fairly plentiful, widespread, esp. mixed woods.

Willow Warbler S B P widespread, very numerous. Colonises upland conifer plantations, a few years old.

Yellow-browed Warbler OPA four records, all Oct., 1913, 1951, 1982, 1987.

Goldcrest R B P numerous, widespread, mainly conifers. Migrants A often coasts.

Spotted Flycatcher S B P numerous, widespread, woods, gardens.

Red-breasted Flycatcher VA one 24 Sep. 1922, one 4 Oct. 1969, both Mull of Galloway.

Pied Flycatcher S B P fairly plentiful oak/ birchwoods.

Bearded Tit V two Auchenreoch L., 31 Dec. 1972–4 Jan. 1973.

Long-tailed Tit R B widespread, quite numerous, hard and mixed woods.

Willow Tit R B fairly widespread, quite numerous, esp. carr woods. Decreased uplands.

Marsh Tit V one Bennan Hill (Ken valley) 9 Apr.

1974, one Auchencairn, 4 Feb. 1984.

Coal Tit R B widespread, numerous, esp. older conifer woods.

Blue Tit R B widespread, numerous, esp. hard and mixed woods; gardens esp. W.

Great Tit R B much as Blue Tit.

Nuthatch O Irregular visitor, hardwoods, may have bred.

Tree Creeper R B widespread, numerous, mainly hard and mixed woods.

Red-backed Shrike V male Kirkbean 5 June 1981.

Great Grey Shrike W P widespread, regular very small nos, decreased since 1984. Most in younger conifer plantations or thorn scrub.

Golden Oriole V female Gatehouse (dead) 6 May 1925, male Wood of Cree 11 June 1983.

Woodchat Shrike V female, Lorg, 23 July–17 Aug. 1986.

Jay R B immigrations A some years — one such (1897–8) preceded first B in Galloway. Much increased; esp. larch and oak woods.

Magpie R B not generally plentiful, small nos widespread, often in mature conifers near open pasture, commoner west.

Chough O formerly bred seacliffs, from Colvend westward; in west, until c. 1930. Pairs or singles irregularly visit coasts. Pair B 1988.

Jackdaw R B decreased inland, still numerous, biggest colonies coastal. Scarce uplands.

Rook R B numerous, widespread mainly agricultural lowlands. Flocks feed uplands S 274 rookeries, 22880 nests, 1975.

Carrion/Hooded Crow R B Carrion Crow widespread, numerous, increased. Pure Hooded very rare, hybrids fairly common.

Raven R B hardly plentiful, decreased, but inland nos now stable, or even increasing.

Starling R B P W numerous, widespread.

Rose-coloured Starling V one Kippford Sep. 1935, one Palnackie 13–18 Sep. 1982.

House Sparrow R B numerous, locally decreased. Now absent large areas uplands.

Tree Sparrow R B not plentiful, scattered small B colonies lowlands.

Chaffinch R B W widespread, numerous B. Abundant B thicket conifer plantations. Flocks esp. farmland winter.

Brambling W not generally plentiful, usually a few

in large finch flocks, at times into 100s, esp. at beech mast.

Greenfinch R B ?W widespread moderate nos B esp. shrubby evergreens, large gardens. Some large winter flocks weedy fields, esp. near coasts.

Goldfinch R B S moderate nos, widespread lower ground. B mixed woods, gardens. Majority summer migrants.

Siskin R B S numerous, conifers, summer. Much increased. Some all year, taking garden peanuts mostly early spring. Many migrate England for winter.

Linnet R B locally numerous lowlands, some B hill ground. Most common near coasts, some large winter flocks.

Twite R B W small nos breed mostly near coasts in west. W flocks several estuaries, coastal fields/merse.

Redpoll R B widespread, locally numerous. Many apparently S. Sometimes very plentiful conifer plantations summer.

Mealy Redpoll W scarce, irregular.

Crossbill R B — also irruptive visitor. Great increase in older conifer plantations, fluctuating according to cone crop. Seven in Scots pines 8 Feb. 1960 believed Scottish Crossbills.

Bullfinch R B fairly numerous, widespread. Flocks in winter often feed on heather seeds in upland conifer plantations.

Hawfinch probably R B scarce. Bred Dalskairth 1926, '27. Probably still breeds. Several well-scattered sightings recent years.

Lapland Bunting OW or OP 2, Southerness, 3 Oct. 1979, 3, Mull of Galloway, 3 Oct. 1986. Probably often overlooked.

Snow Bunting W regular small flocks mountain tops, most 100 L. Enoch Feb. 1988. O lower ground or shore, mostly in hard winters.

Yellowhammer R B widespread, moderate nos lowlands, believed decreased.

Cirl Bunting V male, Mull of Galloway 17 Aug. 1969.

Reed Bunting R B widespread moderate nos, locally plentiful marshes S. Decreased upland areas.

Red-headed Bunting V male, Kendoon 29 Aug. 1972. Presumed escaped.

Corn Bunting R B formerly widespread, numerous arable lowlands (e.g. roost 300 near Castle Douglas Feb. 1969). Huge decline, esp. last 10 years, now very scarce.

The above is compiled from information supplied by a large number of reliable observers to whom I express grateful thanks, from my own notes and from various publications of which the most important are: *The Birds of Scotland* (Baxter and Rintoul 1953), *Birds in Scotland* (Thom, 1986) and *List of the Birds of the Stewartry of Kirkcudbright* (Duncan, Transactions of Dumfriesshire and Galloway Nat. History and Antiquarian Society vols 24, 25, 1947–8).

Of a number of birds recorded in the neighbouring counties of Dumfries and Ayr, but not in Galloway, the following seem particularly likely to occur in the future: Cory's Shearwater, Buff-breasted Sandpiper, Water Pipit, Firecrest and Little Bunting; the last three are easily overlooked species.

I have omitted records of rarities which are not 100 per cent certain.